Publisher's Acknowledgements
Special thanks are due to the
Barbara Gross Galerie, Munich.
We would also like to thank the
following authors and publishers
for their kind permission to reprint
texts: *Artforum*, New York; *Arts
Magazine*, New York; **Cornell
University Press**, Ithaca, New
York; **Institute of Contemporary
Arts**, London; **Alice Jardine**,
Cambridge; **Jeanne Siegel**; and
the following for lending
reproductions: **Leo Castelli
Gallery**, New York; *Der Standard*,
Vienna; **Barbara Gross Galerie**,
Munich; **Galerie Lelong**, New York;
the Estate of Ana Mendieta, New
York; **Smith College**,
Northampton. Special thanks to
Chris Rodley, London. Thank you
to Samm Kunce, Elizabeth
Thompson and Shari Zolla for their
research and organizational
assistance. Photographers: **Olaf
Bergmann**; **Jon Bird**; **Rudolph
Burckhardt**; **Diana Church**;
Charles Crist; **Mary Beth Edelson**;
Abe Frajndlich; **Walter Kraner**;
Andre Morain; **Wilfried Petzi**;
David Reynolds; **Cosimo Di Leo
Ricatto**; **Londa Salamon**; **Max
Scheugl**; **Jan Uvelius**; **Susan
Weiley**; **Stephen White**.

Artist's Acknowledgements
Many thanks to Barbara Gross,
Munich; Rhona Hoffman, Chicago;
Christine König, Vienna; Burnett
Miller, Los Angeles; Stefania
Miscetti, Rome; Marie-Hélène
Montenay, Paris; Penny Pilkington
and Wendy Olsoff at PPOW, New
York; Anthony Reynolds, London;
and Jack Tilton, New York.

And many many thanks to Iwona
Blazwick, commissioning editor,
Gilda Williams, Clare Stent, Stuart
Smith and Catherine Pearce at
Phaidon Press.

All works are in private collections
unless otherwise stated.

Phaidon Press Limited
Regent's Wharf
All Saints Street
London N1 1PA

Phaidon Press Inc.
180 Varick Street
New York, NY 10014

www.phaidon.com

First published 1996
Reprinted 2001
© 1996 Phaidon Press Limited
All works of Nancy Spero are
© Nancy Spero.

ISBN 0 7148 3340 1

A CIP catalogue record of this
book is available from the British
Library.

Printed in Hong Kong

cover, **Black and the Red III**
(detail)
1994
Handprinted and printed collage
on paper
22 panels, 50 × 245 cm each
Installation, Malmö Konsthall,
Sweden

page 4, **Running Totem** (detail)
1994
Handprinted and printed collage
on paper
317 × 50 cm

page 6, Nancy Spero in her studio,
71st Street, New York City, 1973

page 38, **Cabaret** (detail)
1991
Handprinted collage on paper
51 × 1118 cm

page 98, **Woman/War/
Victimage/Resistance** (detail)
October 1994–March 1995
Museum in Progress, *Der Standard*,
Vienna

page 110, **Clown and Helicopter**
(detail)
1967
Gouache and ink on paper
61 × 91 cm

page 144, Nancy Spero with her
sister Carol, Boulevard
Montparnasse, Paris, c. 1949

Comparative Images
page 10, **Pablo Picasso**
Family of Saltimbanques
National Gallery of Art,
Washington D. C., Chester Dale
Collection.

page 55, **Francisco de Goya**
Ravages of War from 'Los Desastres
de la Guerra'
Otto Dix
Feeding Time in the Trench

page 62, **Carlo Crivelli**
The Annunciation with St. Emidus
National Gallery, London

page 65, **Robert Rauschenberg**
Factum II
Jasper Johns
Grey Numbers
Jean Dubuffet
Métafisyx
Musée National d'Art Moderne,
Paris

page 72, **Sandro Botticelli**
The Birth of Venus
Uffizi, Florence

page 92, **Giotto**
Arena Chapel, Padua

page 115, **Stanley Kubrick**
Dr Strangelove or: How I Learned
to Stop Worrying and Love the
Bomb

page 139, **Ana Mendieta**
Untitled
Untitled, from the 'Las Tumbas'
series
Untitled, from the 'Volcano' series
Untitled, from the 'Silhueta' series

List of Illustrated Works
Dancing Figure, 1948, *page 8*
Paris Black Paintings, 1954–
1966: **Great Mother and Child
(3)**, 1954, *page 10*; **Two Figures**,
1955, *page 43*; **Hanged Man**,
1958, *page 10*; **Il Mondo**, 1958,
page 43; **Homage to New York (I
Do Not Challenge)**, 1958, *page 9*;
Lovers, 1960, *page 11*; **Great
Mother Birth**, 1962, *page 43*;
Lovers II, 1962–65, *page 11*; **Lovers V**, 1962–65, *page 123*;
Mother and Children, 1962, *page
65*; **Lovers III**, 1964, *page 123*;
Lovers VII, 1964, *page 11*; **Lovers
VIII**, 1964, *page 11*
Les Anges, Merde, Fuck You,
1960, *page 12*
War Series, 1966–68, *pages 12,
13, 54, 83, 114, 115, 124, 125*
Artaud, paintings and drawings,
1969–70, *pages 14, 15, 18*
Codex Artaud, 1969–72, *pages 16–
17, 18, 46, 47, 48, 49, 50–51*
The Hours of the Night, 1974,
page 19
Smoke Lick, 1974, *page 8*
Torture of Women, 1975, *pages
20, 21, 58, 59*
Her Body Itself, 1977, *page 23*
**The Abuse of Women and
Children**, 1979, *page 126*
Notes in Time on Women, 1979,
pages 22, 25, 26, 64
The First Language, 1981, *pages
23, 27, 64, 118, 119, 120, 121*
Torture of Women III, 1981, *page
126*
To the Revolution, 1981, *pages
28–29*
Let the Priests Tremble, 1982,
page 29
Black and the Red, 1983, *pages
30–31*
Chorus Line I, 1985, *page 30*
Mother and Child, 1985, *page 68*
Mourning Women/Irradiated,
1985, *page 31*
Sheela and Wilma, 1985, *page 138*
Sky Goddess, 1985, *pages 32–33*
Vietnamese Women, 1985, *page
136*
Marduk, 1986, *pages 52–53*
**Offering: Hera and Kneeling
Figure**, 1987–94, *page 130*
Sky Goddess/ Egyptian Acrobat,
1987–88, *pages 142–43*
Acrobat Totem, 1988, *page 140*
The Artist, 1988, *page 128*
To Soar, 1988, *page 69*
Waterworks, 1988, *page 69*
The Goddess Nut, 1989, *page 41*
Rebirth of Venus, 1989, *pages 74–
75*
The Acrobat, 1990, *pages 66–67*
**Eve and Serpent/Death
Figure/Woman and Madonna**,
1990, *page 83*
The Goddess Nut II, 1990, *pages
136–37*

Myth, 1990, *page 73*
**Picasso and Fredricks of
Hollywood**, 1990, *pages 132–33*
**Sky Goddess, Bound Figure and
Snake**, 1990, *pages 130–31*
Stylish, 1990, *pages 40, 133*
Untitled, 1990, *page 131*
Victimage, 1990, *page 60*
Westland/Blucher St., Bogside,
1990, *page 70*
The Cabaret, 1991, *page 89*
The Crowd, 1991, *page 61*
Goddess Nut and Torture Victim,
1991, *page 60*
Minerva, Sky Goddess, Madrid,
1991, *page 69*
To Soar III, 1991, *page 69*
Vulture Goddess, 1991, *page 63*
Frieze II, 1992, *pages 34–35*
Masha Bruskina, 1992–95, *pages
57, 100, 106–107*
Mother Italy, 1992, *page 81*
Mourning Women, 1992, *page 141*
Sheela and Vulture Goddess,
1992, *page 81*
**The Ballad of Marie Sanders/
Voices: Jewish Women in Time**,
1993, *pages 82, 84–85, 87*
The Cabaret II, 1993, *page 88*
Homage to Ana Mendieta, 1993,
page 56
Premiere, 1993, *pages 76, 77, 78*
Sacred and Profane Love, 1993,
page 113
The Audience II, 1994, *pages 34–
35*
Black and the Red III, 1994, *pages
36–37, 62, 91, 92, 93*
Manhattan Dancer, 1994, *pages
134–35*
Marlene and Dancers, 1994, *page
90*
Rite of Spring, 1994, *page 129*
Running Totem, 1994, *page 36*
**Woman/War/Victimage/
Resistance**, 1994–95, *pages 102–
103*
A Cycle in Time, 1995, *pages 94,
95*
Black/Red/Green, 1995, *page 36*
Heiratic, 1995, *page 131*
L'Envol, 1995, *page 61*
Phalanx, 1995, *page 127*
Protective, 1995, *page 129*
Raise Time, 1995, *page 70*

Jon Bird Jo Anna Isaak Sylvère Lotringer

Nancy Spero

Φ

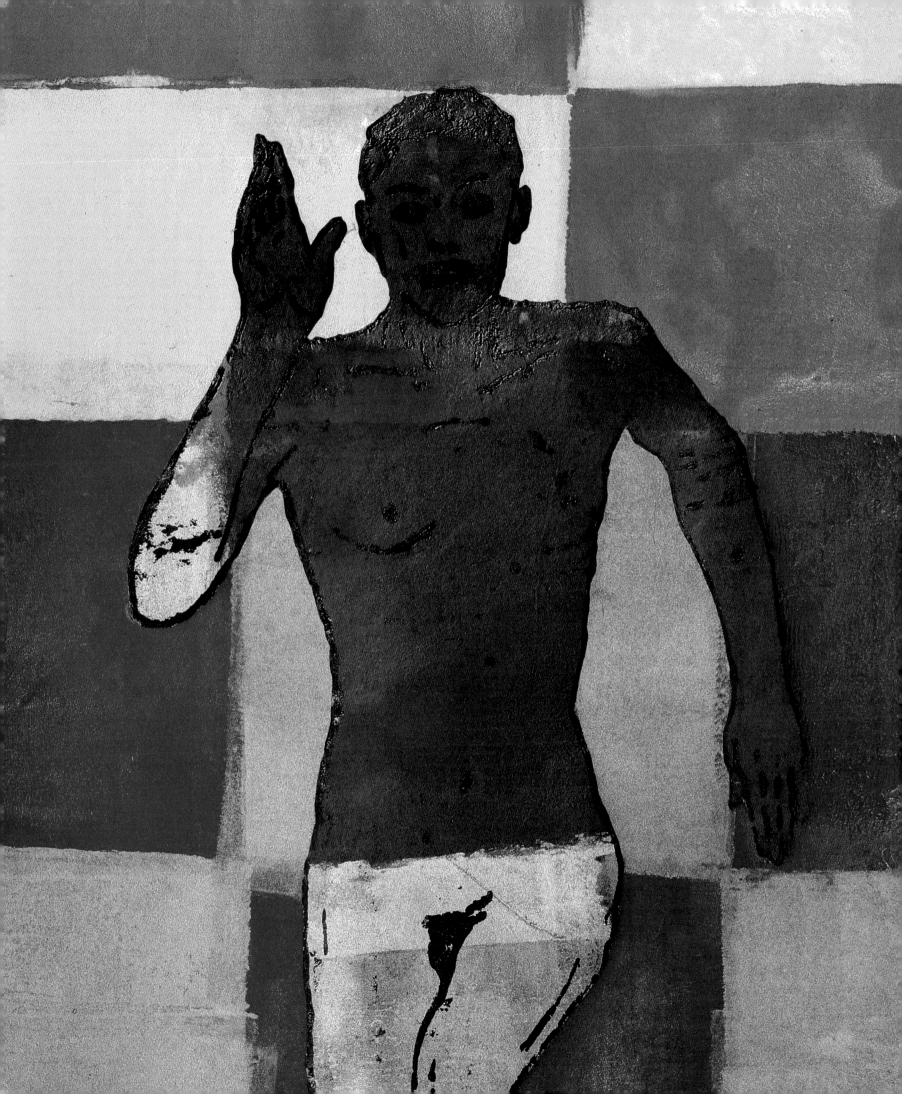

Contents

Interview Jo Anna Isaak in conversation with **Nancy Spero, page 6.** **Survey** Jon Bird Dancing to a Different Tune, **page 38.** **Focus** Sylvère Lotringer Explicit Material, **page 98.** **Artist's Choice** Alice Jardine Gynesis: Configurations of Woman and Modernity (extract), 1985, **page 112.** **Stanley Kubrick, Terry Southern and Peter George** Dr. Strangelove or: How I Learned to Stop Worrying and Love the Bomb (extract), 1963, **page 114.** **Artist's Writings** Nancy Spero Creation and Pro-creation, 1992, **page 118.** Statement about Painting, 1965, **page 122.** The War Series, 1993, **page 124.** Text for 'Rape' catalogue, 1985, **page 126.** On Feminism, 1971, **page 127.** The 'Art World' Has to Join Us, Women Artists, Not We Join It, 1976, **page 128.** Viewpoint, 1972, **page 129.** Images of Women, 1985, **page 130.** The Female Body, 1987, **page 134.** ICA Statement, 1987, **page 135.** The Great Goddess Debate, 1987, **page 136.** Book Reviews, 1989, **page 138.** Tracing Ana Mendieta, 1992, **page 139.** Sky Goddess - Egyptian Acrobat, 1988, **page 140.** **Chronology** page 144 & Bibliography, **page 160.**

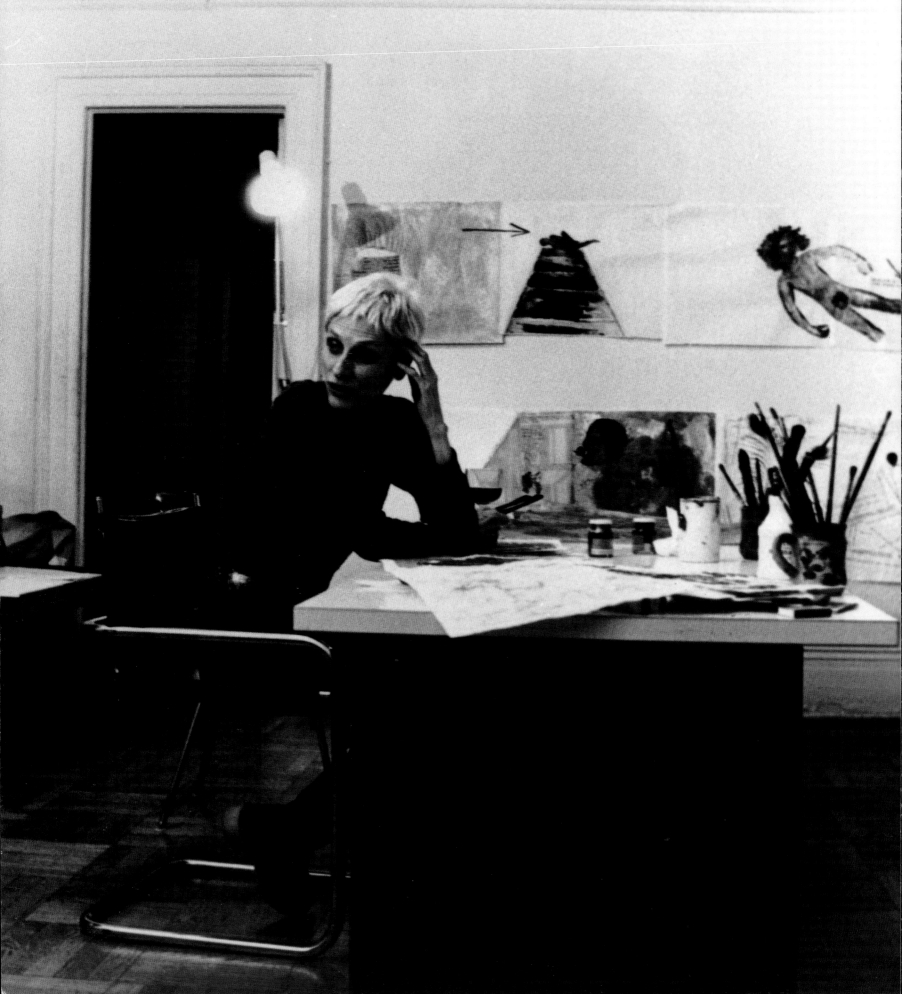

Contents

Interview Jo Anna Isaak in conversation with **Nancy Spero, page 6**. **Survey** Jon Bird Dancing to a Different Tune, **page 38**. **Focus** Sylvère Lotringer Explicit Material, **page 98**. **Artist's Choice** Alice Jardine Gynesis: Configurations of Woman and Modernity (extract), 1985, **page 112**. Stanley Kubrick, Terry Southern and Peter George Dr. Strangelove or: How I Learned to Stop Worrying and Love the Bomb (extract), 1963, **page 114**. **Artist's Writings** Nancy Spero Creation and Pro-creation, 1992, **page 118**. Statement about Painting, 1965, **page 122**. The War Series, 1993, **page 124**. Text for 'Rape' catalogue, 1985, **page 126**. On Feminism, 1971, **page 127**. The 'Art World' Has to Join Us, Women Artists, Not We Join It, 1976, **page 128**. Viewpoint, 1972, **page 129**. Images of Women, 1985, **page 130**. The Female Body, 1987, **page 134**. ICA Statement, 1987, **page 135**. The Great Goddess Debate, 1987, **page 136**. Book Reviews, 1989, **page 138**. Tracing Ana Mendieta, 1992, **page 139**. Sky Goddess - Egyptian Acrobat, 1988, **page 140**. **Chronology** **page 144** & Bibliography, **page 160**.

In the winter of 1994 Nancy Spero and Jo Anna Isaak met and taped these conversations. They projected a selection of slides of the artist's work on the wall and discussed issues the works addressed, the art world and Spero's life when she was making the work.

Jo Anna Isaak This first image is called *Dancing Figure*. I have never seen this work before.

Dancing Figure
1948
Lithograph
24 × 19 cm

Nancy Spero **Oh, it's student work, a lithograph with writing on it. I used a lot of language in those days. It is some frenzied, fiery, apocalyptic kind of dance. I did that at the Art Institute in Chicago. I graduated in 1949 so it must have been in 1948 or so.**

Isaak This is a great work to begin with because it introduces the theme of dance which runs throughout all of your work.
 Let me go to another dance piece called *Smoke Lick*.

Spero ***Smoke Lick* was 1974. We had this terrible fire in our apartment when we were on 71st Street and Broadway and a lot of my work was smoke-damaged. I collaged smoke-damaged paper onto *Hours of the Night*. I called this piece *Smoke Lick* because the smoke was almost like a strange animal with a lot of tongues coming into my studio.**

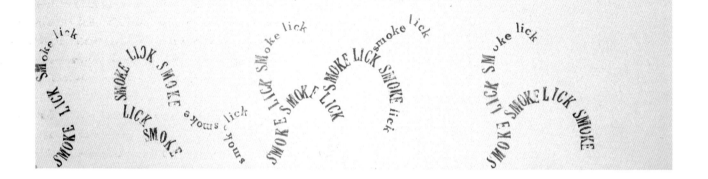

Isaak For me this looked like a Vaudevillian dance routine, a cakewalk with exaggerated steps, or a slinky – you know, the kid's toy.

Smoke Lick
1974
Handprinting on paper
46 × 178 cm

Spero **They are cartoonish. Actually, I was influenced by medieval animal imagery.**

Isaak Why medieval?

Spero **I was interested in making a connection with medieval art, to tie my art to art history *(laughter)*; I still considered myself an underground artist and, at the time, so angry and disconnected from activities in the contemporary art scene. I had been thinking back to medieval images of the apocalypse that showed the sinners and all the horrendous things that were done to them – bodies drowning in rivers, animals with their tongues coming out. That imagery was my rationale for allowing myself to make those grotesque, fantastic, imaginary things.**

Isaak Was that the first time you used tongues?

Spero **No, I had used tongues early in Bloomington, Indiana, in 1958, in a work**

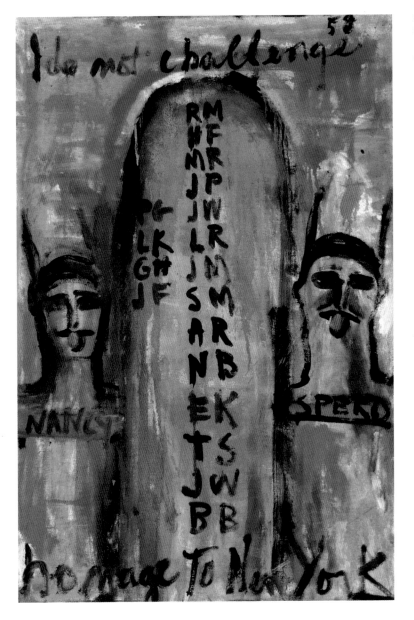

Homage to New York (I Do Not
Challenge)
1958
Oil on canvas
119 × 79 cm

called *Homage to New York*. *Art News* was the big art magazine at the time and it primarily featured New York artists and Abstract Expressionists. I did this painting with a tombstone right in the middle and then on each side are two heads with dunce caps and rabbit-like ears and their tongues are sticking out. And on this phallic-like tombstone in the middle of their tongues are the initials of all the artists who were prevalent then. Some of the initials you can recognize very easily. On top I wrote, 'I do not challenge' and then 'Homage to New York' below.

New York was the centre of the art world and Abstract Expressionism was so powerful then. In Chicago we were always aware of New York. There was a theatre group at the time called Second City: if you were in Chicago, you knew you were in the Second City.

Isaak Oh right. Second city, second class, second sex – it adds up.

Spero Also, I was very resistant to New York because I was a figurative artist. At the Art Institute I really found my milieu. I was a very unhappy girl before that but I loved it there with the other alienated beings, so to speak, the other misfits in society.

Isaak This next work is *Great Mother and Child*.

Spero These are unstretched – you can see how ragged the edges are; this was a real change. I used to work so long on these paintings. You saw that early dancer; then I was working fast and they were much more expression-istic. This is more controlled. I only did a few paintings a year. Leon Golub and I were sharing the studio in Chicago; we have always had a commonality of interests and have always discussed our art. At this phase I think we were looking at a lot of classical and ancient art.

Isaak The painting looks as if it is lit from within. How do you get that effect?

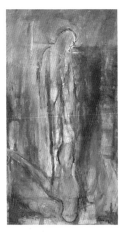

Spero **Underneath is a sized canvas. The paint is gold oil and then to make it ancient-looking I painted it over with black. These Black Paintings got darker as I worked and reworked them.**

The paint is pre-mixed, then put on. I don't scrape it. I did rub off a lot which made kind of a dull grey surface. Sometimes the surface would go rough where the grey paint got greyer and then I would rub out a certain area with turpentine and then redraw it and repaint it. And it got greyer and greyer and muddier. It was very discouraging. That's why I quit oil painting.

Now this is *Hanged Man*. You can't really tell who is the hanged man and who is the executioner. They both look like they have hoods over their faces. This was the beginning of these double images. This was '58. They aren't literally mirror images, but the figures are always attached to each other.

Isaak Well, the Hanged Man is a tarot figure.

Spero **Yes, exactly. This is the beginning of my interest in the mirror image. With *Mother and Child* I was exploring an idea of destiny, and the individual and characters were tied together but with separate fates. I felt that way with the 'couples' paintings also, that the figures are elegiac and lyrical but existential; together, but in this ambiguous space. All of these works are in a non-specific background and the figures melt into it or they come forth or they just exist in space without explanation. A lot of my work seems to have a narrative but there is no narrative, there are only inferences.**

Isaak The ambiguity of these figures reminds me of Picasso's Blue Period, the circus family, or the boy with the horse where everyone is bound to each other but the ropes are not visible. This whole series, the scenes from the Mediterranean, the Lovers, Mother and Child paintings, all the Black Paintings, seem to be a happy period. Was the time you spent in Paris a good time ?

Spero **Yeah, we were there from '59 to '64, although there was a brief inter-ruption in 1960 with the Fuck You series of works on paper, which were very angry. I have these strange creatures, saying *'merde'* and 'fuck you'. These worm-like or snake-like figures are a precursor of the *War Series*; they are screaming and their tongues are sticking out.**

Isaak Just like Caliban, the first thing you do when you start to speak is to curse. It is an appropriate response to being forced to speak in a language not your own. But also I was thinking lately that you are not such an angry young woman anymore *(laughter)*.

Spero **Yes, I shifted and changed. I think that the anger in the *War Series* and the Artaud Paintings came from feeling that I didn't have a voice, an arena in which to conduct a dialogue; that I didn't have an identity. I felt like a non-artist, a non-person. I was furious, furious that my voice as an artist wasn't recognized. That is what Artaud is all about. That's exactly why I chose to use Artaud's writings, because he screams and yells and rants and raves about his tongue being cut off, castrated. He has no voice, he's silenced in a bourgeois society.**

Then, when we came back from Paris, I really reacted to the Vietnam War and to the media coverage of it. I wanted to do something immediately,

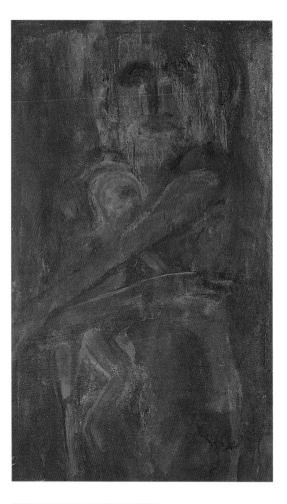

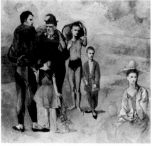

above, **Great Mother and Child (3)**
1954
Oil on canvas
122 × 69 cm

top left, **Hanged Man**
1958
Oil on canvas
206 × 113 cm

left, **Pablo Picasso**
Family of Saltimbanques
1905
Oil on canvas
212 × 229 cm

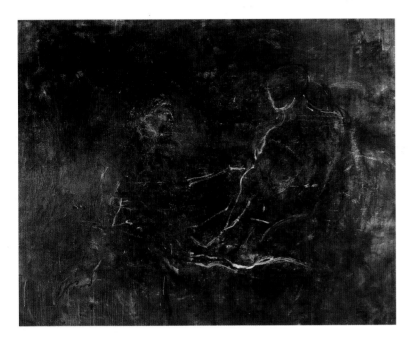

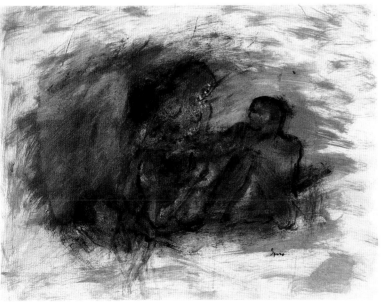

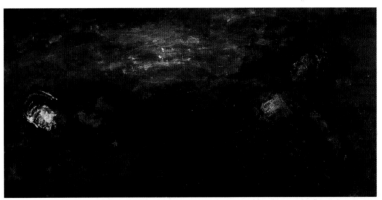

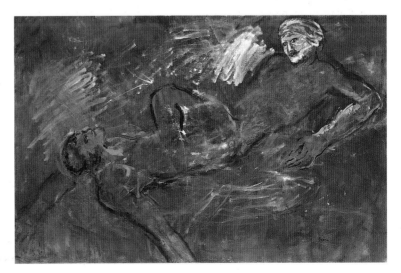

left, **Lovers II**
1962–65
Oil on canvas
164 × 204 cm

below left, **Lovers**
1960
Gouache and ink on paper
44 × 56 cm

below, **Lovers VII**
1964
Oil on canvas
113 × 198 cm
Collection, Vancouver Art Gallery

bottom, **Lovers VIII**
1964
Oil on canvas
132 × 206 cm

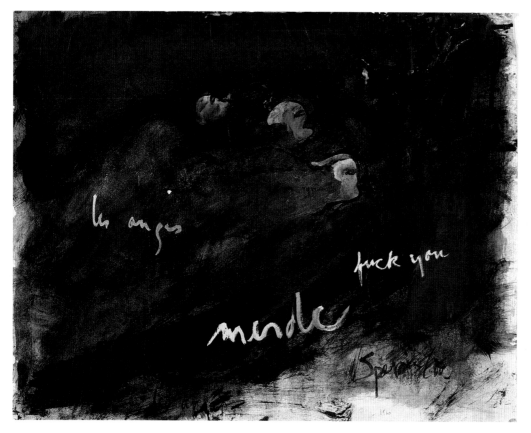

Les Anges, Merde, Fuck You
1960
Gouache, ink on paper
44 × 56 cm

I was so enraged. Coming back from Europe, I was shocked that our country – which had this wonderful idea of democracy – was doing this terrible thing in Vietnam. I wanted to make images to express the obscenity of war.

Isaak This is the motive for the sexual, scatological series of bombs.

Spero Yes, exactly, and all this craziness in '66. The *Sperm Bomb* has to do with male power but the image is rather elegant. I think it resembles testicles.

Isaak It does. There is the whole sexual metaphor underlying war, so why not reveal it?

Spero Most relevant to the Vietnam War was the helicopter. So I started thinking about the Vietnamese peasants, what they would think about when they saw a helicopter and how to visualize this.

Isaak This *Helicopter and Victims*, 1967 looks like a kind of a prehistoric dinosaur figure.

Sperm Bomb
1966
Gouache, ink on paper
61 × 91 cm

Spero There are bloody bodies, skulls and remains. The helicopter is eating and shitting people, just like an efficient war machine.

Now this is *S.U.P.E.R.P.A.C.I.F.I.C.A.T.I.O.N.* This is what I consider the obscenity of the war. I thought the terminology and slogans like 'pacification' coming out of the Pentagon were really an obscene use of language. They would firebomb whole villages and then the peasants would be relocated into refugee camps. This was called 'Pacification and Re-education'. So in this image the helicopter has breasts hanging down and people are hanging on with their teeth, like in a circus act.

Isaak I see, sucking on the tit of the Great American War Machine.

Spero Yes, exactly. Now this is *Crematorium, Chimney and Victims* (see page 83). These creatures are the victims coming around and licking the chimney. I think this had to do with the idea of the oppressor and the victim and the terrible symbiosis of that relationship. This was pre-feminist. Now this is *Eagle, Victim and Medusa Head*; it is slightly larger. At this point I was using Sekishu, a Japanese handmade rice paper. It is very strong and fragile at the same time. I couldn't work on it the way I did the others. So this is when I really started collaging, in the late 1960s, for the *War Series*. I print a lot of images on it now and collage them to the Bodleian paper. The double-headed eagle is a man's head with a tongue and then an eagle's head. There are dismembered bloody victims below.

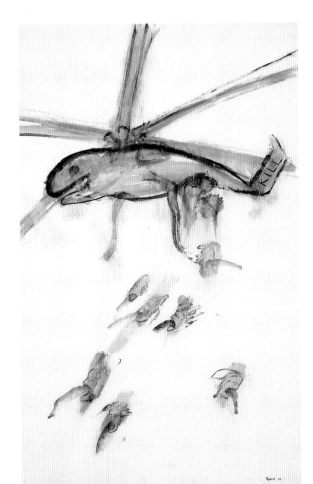

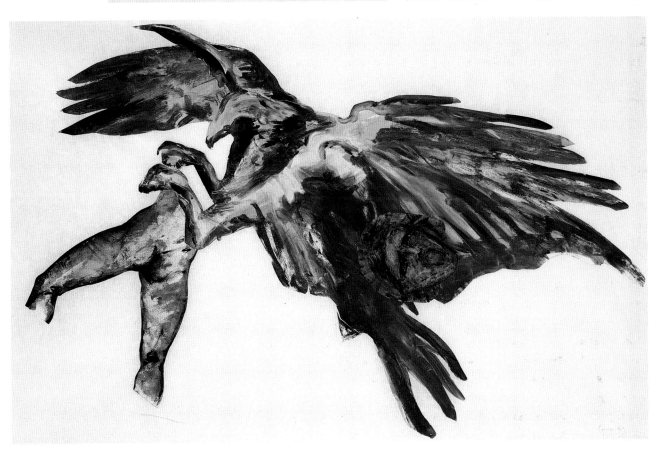

above left, **Helicopter and Victims**
1967
Gouache, ink on paper
91 × 61 cm

above right,
S.U.P.E.R.P.A.C.I.F.I.C.A.T.I.O.N.
1968
Gouache, ink on paper
61 × 91 cm

left, **Eagle, Victim and Medusa Head**
1969
Gouache, ink, collage on paper
64 × 99 cm

Interview

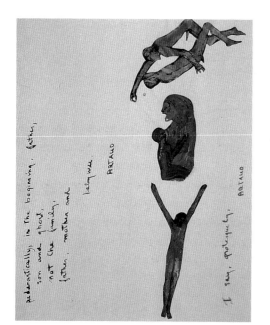

probabilistically, in the beginning, father,
son and ghost,
not the family,
father, mother and

lady... ARTAUD

I say, probably,

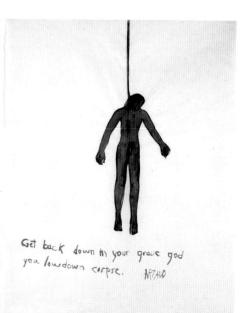

ARTAUD
I couldn't have
borne to know
you alive your
despair

SPERO

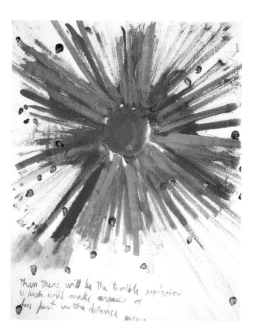

Get back down in your grave god
you lowdown corpse. ARTAUD

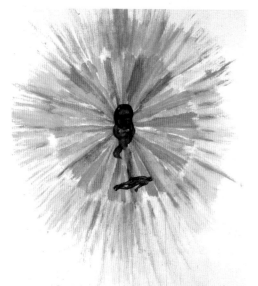

les choses n'ont plus d'odeur, plus de sexe. Arte.

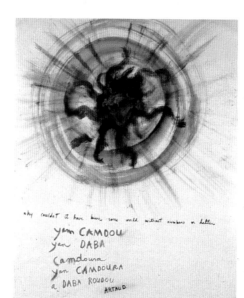

why couldnT it have been some world without numbers or letters

yam CAMDOU
yam DABA

Camdoura
yam CAMDOURA
a DABA ROUDOU
ARTAUD

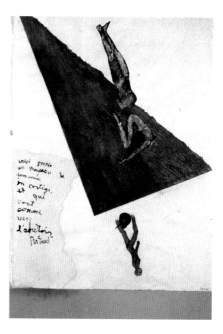

Then there will be the terrible explosion
which will make arraic of
free part in the detonise Artaud

L'enfer est déjà de ce
monde Artaud

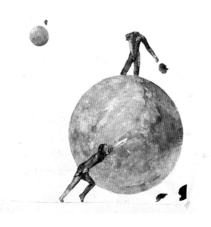

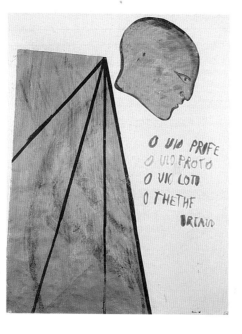

O UIO PRIFE
O UIO PROTO
O UIO LOTO
O THETHE
ARTAUD

voici sortir
un trogédon de
femmes
en coline
et qui
vient
comme
une
l'absolue Artaud

Artaud Paintings

opposite

top row, left, '**Pederastically in the Beginning ...** '
1969
Gouache, ink, painted collage on paper
127 × 64 cm

top row, middle, '**Letter from Spero**'
1969
Gouache, painted collage on paper
127 × 64 cm
Collection, Vancouver Art Gallery

top row, right, '**Get back down ...** '
1969
Gouache, ink on paper
64 × 52 cm

middle row, left, '**Les choses m'ont plus ...** '
1969
Gouache, ink on paper
61 × 51 cm

middle row, middle, '**Why couldn't I ...** '
1969
Gouache, ink on paper
64 × 51 cm

middle row, right, '**Then there will be ...** '
1969
Gouache, ink on paper
64 × 53 cm

bottom row, left, '**L'enfer est déjà ...** '
1969
Gouache, collage, ink on paper
64 × 53 cm

bottom row, middle, '**O Vio Prife ...** '
1969
Gouache, ink on paper
61 × 48 cm

bottom row, right, '**Voici sortir un ...** '
1970
Gouache, collage, ink on paper
61 × 51 cm

right
'**But the sleeper that I am ...** '
1969
Gouache, ink, collage on paper
60 × 50 cm
Collection, Vancouver Art Gallery

following pages,
Codex Artaud I (detail)
1971
Typewriting, gouache, collage on paper
56 × 218 cm

Isaak Dismemberment is another motif that keeps coming up in your work. Your next work was the Artaud Paintings; how did you first become interested in Artaud? Were you reading him in French or English?

Spero A friend of ours, Jack Hirschman at Indiana University, did an anthology of Artaud's writings in translation. He became an Artaud freak. He was tall and dark and he became even more gaunt and more Artaud-like as he worked on the book. He got these other American poets in Paris to do translations of Artaud. They were brilliant, and so the first year of the Artaud Paintings, I used English. Then I decided that, as beautifully done as it was, it wasn't right, that the original French was right. I went to Artaud because I wanted a vehicle to show my anger and he was the angriest poet there was.

Isaak I can't think of a woman writer at that time expressing so much anger, yet it is interesting that Artaud so often speaks in a woman's voice, he even invents imaginary daughters in order to express a woman's pain, or the marginalized, all those outside of language. Julia Kristeva describes Artaud's writing as an 'underwater, undermaterial dive where the black, mortal violence of "the feminine" is simultaneously exalted and stigmatized'. She says that if a solution exists to what we call today 'the feminine problematic', 'it must pass over this ground'. Freedom of speech, freedom of movement, freedom of the spirit involve coming to grips with one's body by going *through* language, going through 'an infinite, repeated, multipliable dissolution, until you recover possibilities of symbolic restoration: having a position that allows your voice to be heard in real social matters – but a voice fragmented by increasing, infinitizing breaks'. I think this is a good description of Artaud's writing as well as the trajectory of your development.

Spero In 1969, in the first series of the paintings, I wrote a letter to Artaud in blood red ink, 'Artaud I couldn't have borne to know you alive your despair – Spero'

In this work, *Pederastically in the Beginning ...* , I am quoting Artaud, 'In the beginning, Father, Son and Holy Ghost. That's a family, father, mother, and Baby Wee ... I say grotesquely'. He was very hateful about the family. In between his description of the family I collaged my images: there on top are the pederasts; Mother and Baby Wee are in the middle. The Mother is very ferocious, like the fierce protective mothers in the Black Paintings. Artaud was mentally and physically ill but so brilliant. He lashed out at everything; that it is just what appealed to me.

Isaak The next work is called *But the sleeper that I am ...*

Spero 'But the sleeper that I am will not fail to awaken and I believe this may be very soon', and then the nonsense words begin where he is speaking in tongues. He did that a lot in his writing.

The first *Codex Artaud* was made in 1971, after two years of the Artaud Paintings. After the Artaud Paintings, I wanted to move into space, so I used these archival art papers that were around the studio and glued them together. They are all different types of paper. The first and the fourth piece are the same, the second is French vellum, a tracing paper.

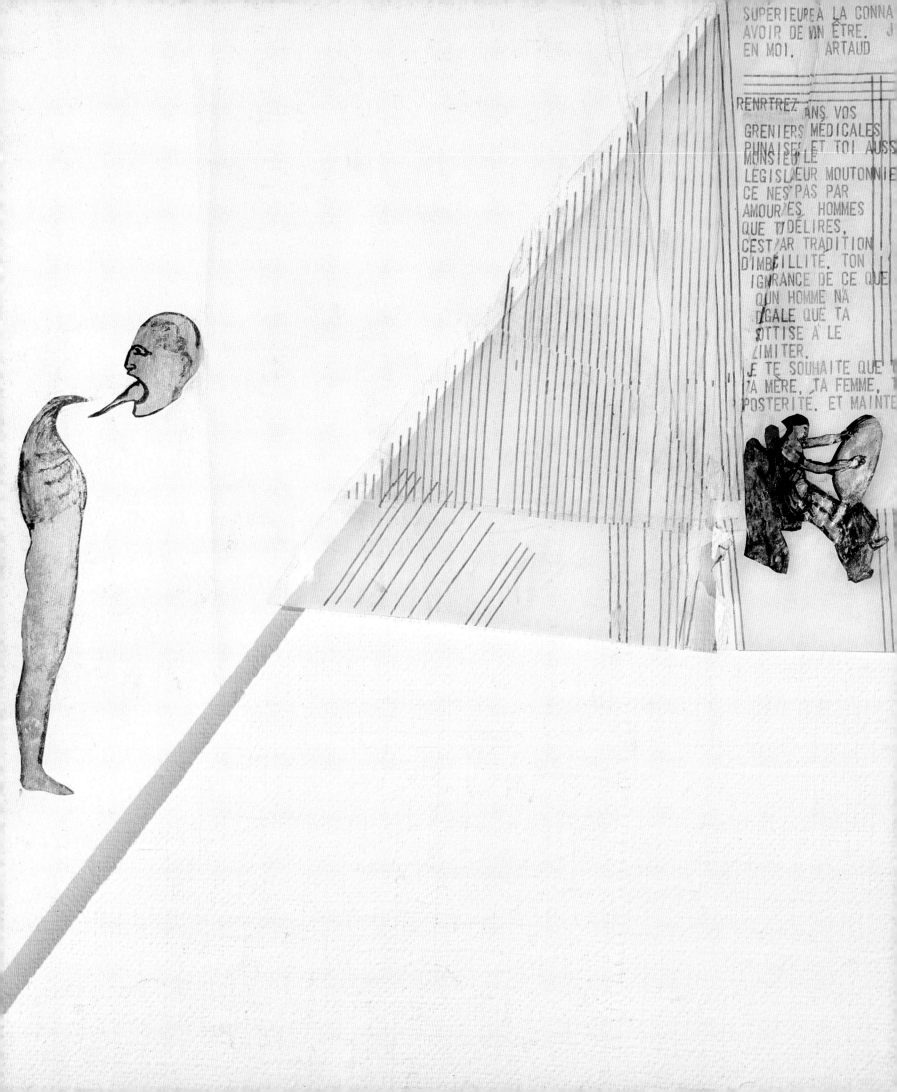

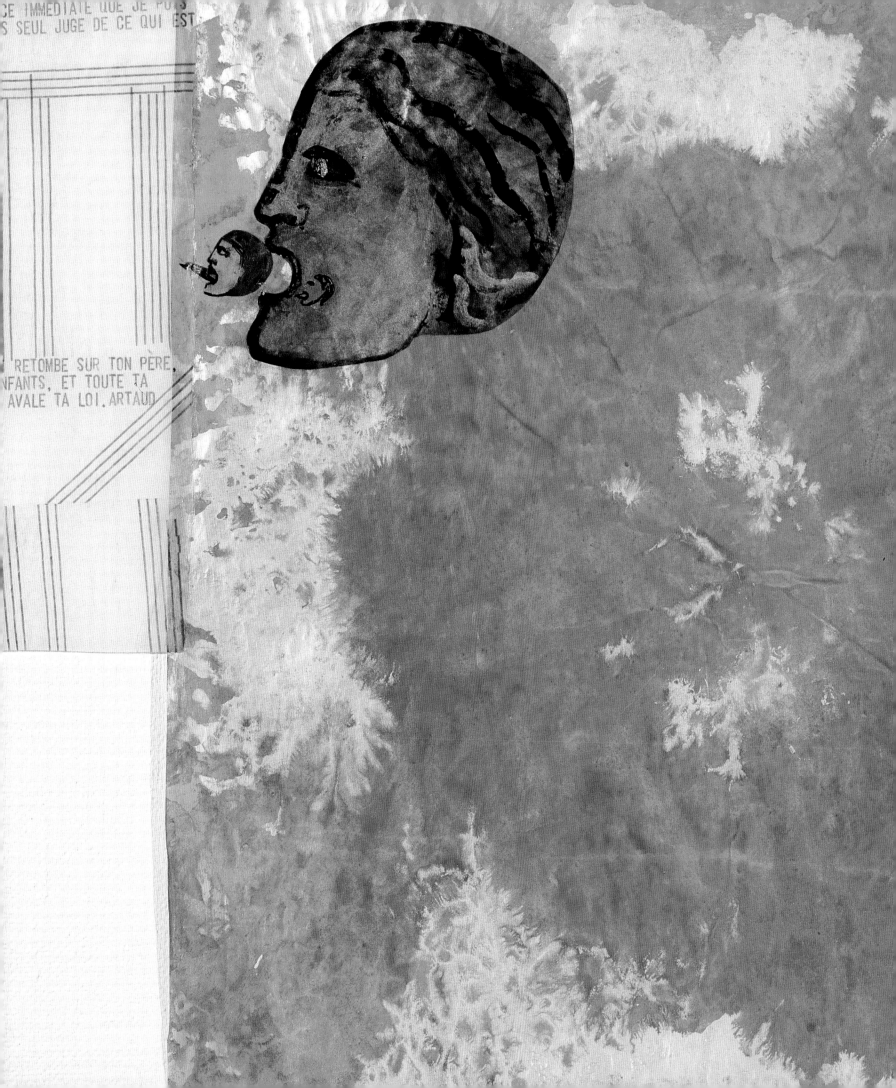

Isaak Is the vellum coloured silver and orange?

Spero **That is the painting. It is like a Rorschach blot, by that I mean I painted the paper and then folded it in two. The typing is on vellum and all those figures are collaged onto it. The left is a mummified figure, one of those strange Egyptian figures, and I added the tongue sticking out. Then there are some Greek classical figures, and then in the last the quotes are about 'before I commit suicide'. It is very ambiguous: 'I want to know if there is another form of being'. I guess he wants to know if there is an afterlife or if a spirit exists after his death …**

Isaak In *Codex Artaud III* there is a figure holding a banner with a head on it …

Spero **The whole thing is about gesture. This image is heraldic, holding a shield up proudly. Those arms come from the poses of Roman bronze statues in Pompeii. The other one is holding a sign like the Chinese had for victims who are going to be executed or tortured with the crimes they have committed hanging from their necks. I got everything from any old source. But it all relates to death. In the *War Series* I have a female figure with four breasts leaning over and a nursing child. I was thinking of Romulus and Remus and the Egyptian goddess. In *Codex Artaud VI* the figure has with four breasts and a penis. Now this turned out to be androgynous because I was responding to the ambiguity of Artaud's sexuality.**

Isaak What is going on in the patterned type?

Spero **That is what I call the Artaud rug. I just used Artaud's name and I repeated it in certain ways. There was a lot of pattern painting going on at the time, pattern painting and Op art …**

Isaak When he talks about the obscene phallic weight of the praying tongue, do you think he is talking about religion or language in general?

Spero **I thought it was about language, sex and religion.**
 Another thing enters into the Artaud work. There is a quotation in one of the last pages in his notebook on pain. I was suffering a great deal from arthritis, and I thought, that is what he talks about, mental and physical pain, I can use this.

Isaak What made you move away from the mythopoeic recording of unrightable wrongs that you were engaged with in the *Codex Artaud* to recording real case histories of torture?

Spero **In '72 I had had enough of Artaud. I thought there is real pain and real torture going on, never mind Artaud. His pain is real, but it is the expression of an internal state. So this was an important step, to disengage myself from Artaud and to externalize this anger. I decided to address the issues I was actively involved in -- women's issues. I wanted to investigate the more palpable realities of torture and pain.**
 The change had to do with my activities within the women's movement and more immediate concerns in my own life. I had been going to AWC (Art

The Hours of the Night
1974
Handprinting, gouache, collage
on paper
11 panels, 284 × 660 cm overall

Codex Artaud III (detail)
1971
Typewriting, painted collage on
paper
51 × 201 cm

Codex Artaud VI (detail)
1971
Typewriting, painted collage
on paper
52 × 316 cm

**Artaud Painting, 'Poète aigri, la
vie bout ... '** (detail)
1970
Gouache, painted collage,
ink on paper
61 × 48 cm

Workers Coalition) meetings. AWC staged all kinds of protests. The men were very outspoken in their complaints, but the women artists were getting an even rawer deal. I felt, you know, I had three kids at home still. Then I heard of something that really rang a bell: WAR (Women Artists in Revolution). WAR was a radical group of women artists who split off from AWC to address the concerns of women artists. It was a very lively time, we wrote manifestoes and engaged in actions and protests. Once we went over to the Museum of Modern Art, eight of us, one woman even had a child of about six or so, dragging along. We marched into the office of John Hightower *[then Director]* and we demanded parity for women artists. He asked us to sit down and we wouldn't sit down. We demanded parity and then we left. Later, I joined the Ad Hoc Committee of Women Artists. We did all kinds of actions, sit-ins and picketing. A whole bunch of us invaded an opening at the Whitney. We went inside and sat down, plop, right in the middle of the museum. It was good fun. I was really restless at that time, so angry and frustrated with my career. Then Barbara Zucker got the idea that we could form a gallery. There were so many unaffiliated strong women artists floating around. Six of us met: Barbara Zucker, Dotty Attie, Susan Williams, Mary Grigoriadis and Maude Boltz. We discussed the idea of an all women's gallery. We all thought it was a great idea. *[AIR, the first women's Gallery in New York City, opened in September 1972 with a group show of its founding members.]*

Isaak The next large work is *The Hours of the Night*.

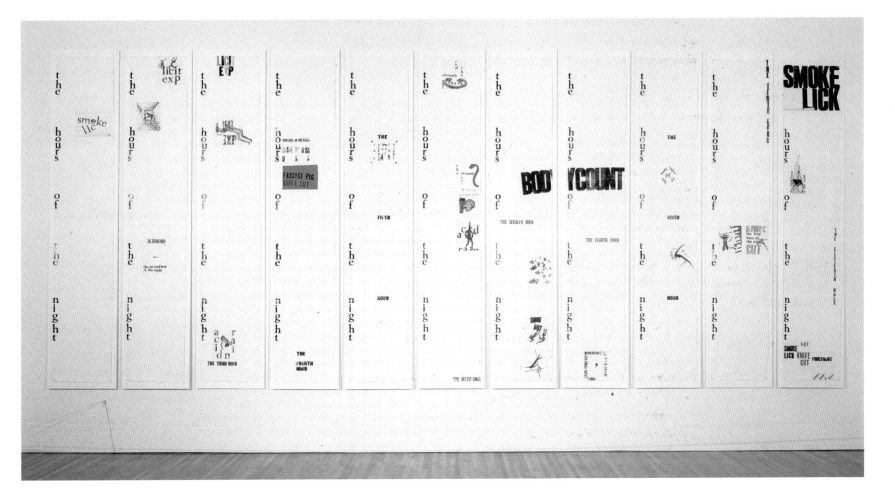

Torture of Women
(*right,* panel I; *below,* panel VIII,
detail; *opposite,* panel IX, detail)
1976
Handprinting, typewriting,
collage on paper
14 panels, 51 × 3810 cm overall
Collection, National Gallery of Art,
Ottawa

EXPLICIT

LAURA RAGGIO
20 years old
SILVIA REYES
19 years old
d: 21 april 1974 both
students and left wing
militants, they were
arrested during a
house search in monte
video. in the same
operation another girl,
DIANA MAIDANIK, received
35 shots when she open
ed the door. although
the authorities claimed
the three girls had
died in cross fire,

URUGUAY

neighbors saw ms. raggio,
ms. reyes and two men
being carried away by
security men. the next day,
the bodies of the two
girls were delivered to
the families, showing –
besides bullet injuries –
signs of beatings and
areas of the skull where
large strands of hair had
been pulled out.

EXPLANATION

Spero **The title is Egyptian and refers to the passage of the Sun God into the underworld for twelve hours, but I made it eleven hours. This had to do with the terrors of the night and the war. I put all kinds of stuff I'd used previously, really cannibalizing my own work. 'Body Count' was printed directly on the paper, as was 'The Hours of the Night'. All the rest are collaged inserts. So that is 1974, when I was doing all sorts of crazy things with language and text – experimenting.**

Isaak Is the panel that begins with the huge yellow letters 'Explicit Explanation' the first panel of *Torture of Women*?

Spero **Yes it is. This is an explicit explanation of hell, the real hell of these women's lives. Now on panel nine I started printing figures, not just letters. This was the first printed figure I used. When I was buying all these alphabets, the guy said to me 'If ever you want to make a drawing, I can make you a plate and you can print it'. That was the beginning …**

Isaak Ah, so this is the beginning of your alphabet of women, your fundamental female lexicon.

Spero **Absolutely. So I printed her over and over inside this grid. Her hands and feet are cut off, she is really cramped; it is like a metaphor for women in jail cells, in prison. Actually, I make these prints from metal plates, and I inked up some dowel sticks and made those lines. The metal plates are for paper only. Now, when I print directly on the wall, I use polymer plates because they are flexible.**

My next work, *Notes in Time on Women*, took three years to do – 1976 to 1979. If we include *Torture of Women*, which was originally planned as part one of *Notes*, then it took five years, but the information gathering had begun long before that. It was like working on a book, a solitary activity. I

THE SUBJECT
WOMEN TO A L
OF SEXUAL ABUSE
RAPE PREGNANT WO
BEEN SO BADLY BE
AT THEY HAVE MIS

DECEMBER 8, 1977, AFTER HAVING ATTENDED A MEETING OF
LATIVES OF DISAPPEARED PERSONS, TWO FRENCH NUNS, SISTE

CIA DOMON AND LEONIE DUQUET, WERE ABDUCTED.. TO DATE,
RE HAS BEEN NO RELIABLE INFORMATION CONCERNING THEIR
REABOUTS, DESPITE OFFICIAL INQUIRIES BY THE FRENCH
VERNMENT.

UDENT IN CAR (in English)
April 1972 I was taken by police; ...
ere was a girl in this room and they forced her to wa
h. For two hours. Then they put electrodes on the
rl. They also beat her. When they finished they pul
d her trousers down. They produced an oily truncheon
th a groove. They put electric wire in the groove, t
put this into the vagina of this girl. They brought

Adriana Gatti de Rey
Student
Lived in Argentina
88888888888888888

Adriana Gatti de Rey, a seventeen-
year-old and daughter of prominent
Uruguayan trade unionist Gerardo
Gatti, disappeared in Buenos Aires
on April 9, 1977, almost a year
after the abduction of her father.
At the time of her disappearance
she was seven months pregnant.
Her boyfriend, Ricardo Carpintero
had previously disappeared on
March 25, 1977. To date, there
has been no news of their whereab
outs.

GIRL (in
Some men
wires we
how long
the back
ed out tr
First the
denly.
vals, st
ing the s
dn't ans
shocks lo
shocks.
en my hea
y started
My mouth
lling.

For three
me these
ey put w
brain and
n my head
question

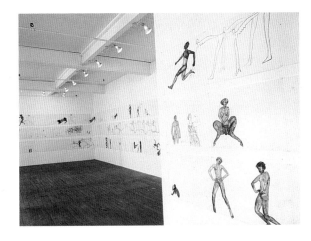

above, **The First Language**
1981
Handprinted and printed, painted
collage on paper
22 panels, 51 x 5791 cm overall
Installation, Galerie France Morin,
Montreal, 1982

opposite, **Notes in Time on
Women** (panel IX, detail)
1979
Handprinting, gouache, collage
on paper
24 panels, 51 × 6398 cm overall

had to sequester myself. Rarely was anybody interested enough to ask to see
my work in those days and I had nothing to show for years. I was stockpiling
images and quotations, handprinting them and collaging them directly on
the paper. Then, in the last few months of work, I put everything together.

Isaak Your account of the process reminds me of Wyndham Lewis's description
of how James Joyce made Ulysses: 'He collected the last stagnant pumpings of
Victorian Anglo-Irish life ... for fifteen years or more – then when he was ripe, as
it were, he discharged it, in a dense mass, to his eternal glory. That was *Ulysses*'.

Perhaps this is the stuff modern epics are made of. The stories are not
taken from the front pages of the newspaper. What you document in the panels
on contemporary history are just incidents in the lives of ordinary women. For
example, there is the story of a young woman medical student, top of her class,
who was denied readmittance to medical school in her final year because she
was Jewish, female, and, as her report noted, 'had a much higher I.Q. than her
male colleagues'. Her case, filed in 1972, dragged through the courts for five
years, like a suit in Chancery.

You begin with a dance: ancient, mythological and contemporary images of
women running in celebration. The celebration seems to be about the freedom
of movement, the ability to dance, to leap athletically, unfettered.

Spero **The women are all dancing after a panel with the words 'Certainly
childbirth is our mortality, we who are women, for it is our battle'. The
passage is from an ancient Aztec book. It could be read as, 'Certainly child-
birth is our *im*mortality', as well; both are true. Artemis interrupts this
celebratory dance, her fist raised. She is Artemis/Apollousa, the destroyer,
the goddess of childbirth. Artemis, 'who heals women's pain', is a frequent
figure in my work. So I have these figures running by. It is the same pose but
the ink is unevenly applied, the handprinting varies, the different colours
and pressures of the ink give the effect of multitudes in motion.**

**Working on this piece was depressing; the history of women was so
horrific, so negative, so oppressive, that I thought, how can I counteract this?
That is how all these depictions of athletic women got started. Gathering all
this information about women, being madder than hell, realizing further my
status as a woman, I decided to make Woman the protagonist, to depict her
as liberated, even if I know this isn't really the case.**

Isaak That makes sense, an image of agency, an image of physical autonomy

Her Body Itself (detail)
1977
Painted and typewriter collage on
paper
51 × 213 cm

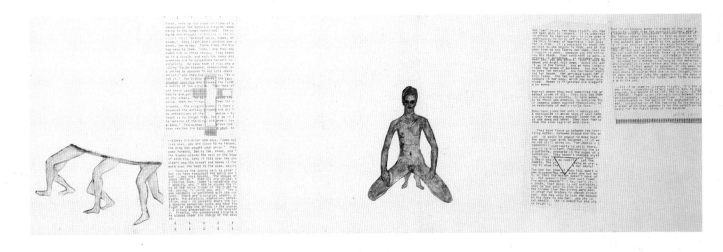

that could stand up against the weight of these accounts that spoke only of women's victimage. Throughout the text, women – ancient, mythological, modern – run, leap, dance, do somersaults, splits, cartwheels, anything they can to break up the 'heavy phallic weight' of the language.

Spero **Once you and I were talking about the printing process I use in which the same figure appears and reappears in an extended narrative format. You mentioned Gertrude Stein's use of repetition and her term, the 'continuous present'. That is a good term for what I'm doing. The history of women I envision is neither linear nor sequential. I try, in everything I do – from using the ancient texts, to the mythological goddesses, to H.D.'s poems on *Helen of Egypt* – to show that it all has reverberations for us today. And then it makes sense.**

Isaak The story of women recorded here is that of women striving for the very bodily freedom you depict.

Spero **I was thinking of documenting images and stories of women through time. I first envisioned *Notes* as a continuation of *Torture of Women* but with other subjects, accounts of women from historical or even pre-historical times, but including the celebratory: dance, power and buoyancy as well. When it says *Part 2: Women, Appraisals, Dance and Active Histories* it meant that *Torture of Women* had been planned as Part I, but I had to separate the two parts because it was too long, there was too much material. There are twenty-four panels in *Notes*. It is huge. By calling it 'notes' I meant jottings and selections, and that made it arbitrary. Totally arbitrary.**

Isaak Actually, it is not arbitrary at all. It is epic. It is organized, like most epics, by the so-called accretion theory of epic formulation in which the author gathers together all kinds of fragments and bits of stories, stories that are already well-known to the community. It is epic in another sense. The epic represents the dominant values of the time – the values, that is, of the rulers of the time. While your subject may be women, you are not pretending that women have any greater purchase on language, power, or the law than they actually do. Most of the language is written or spoken by men; if women speak they often marvel at being allowed to speak and usually they speak of their disenfranchisement. Abigail Adams may write to John Adams in 1776 to ask him to 'Remember the Ladies' as he is making 'a new Code of Law for an independency', but he promptly responds to her letter by saying, 'Depend upon it, We know better than to repeal our Masculine systems'. In the section devoted to black women, Sojourner Truth speaks before the Fourth National Women's Rights Convention, held in New York City in 1853, and says to the crowd – in turmoil because a black woman had been given the podium – 'I know that it feels kind o' hissin' and ticklin' like to see a coloured woman get up and tell you about things, and Woman's Rights'.

Spero **This section is devoted to black women. Throughout these printed stories I collage painted heads of black women onto the paper. Some are of recognizable individuals and some are not. In the centre is a large figure of a young black woman, regal and unmistakably black. When you look closely, you see that she is slightly pregnant.**

Isaak It is a hopeful section. Sojourner Truth's desire to go the polls and vote before she dies leads directly to convictions of Dr. Mamphela Ramphele. Even after her friend and father of her child Stephen Biko, founder of the Black Consciousness Movement, has been murdered, and she herself has been sent into exile for five years, she is confident that her son will not grow to adulthood in a white-ruled society. But the hope and conviction of these black women seems to be blotted out in the next section, in which accounts from Amnesty International, *Matchbox* and the *USLA Reporter* document the torture, rape, murder or disappearance of hundreds of women, many of whom live in countries with American-backed governments.

At this point the scroll seems to hemorrhage; it is the way you have typed it. The individual case histories are printed crowded against each other. Each one is the story of a woman: her name, her age, her job, her family, the town where she lived and the community who knows her fate are all documented there, but it all so dense and intense.

Spero Someone called this a wailing wall, like the Vietnam Memorial in Washington with the names of all those who died in the war. There are so many of them, and their imprisonment, torture and murder takes place in so many countries. They are unknown women, but we cannot pretend we have never heard of them or of the fate of women like them.

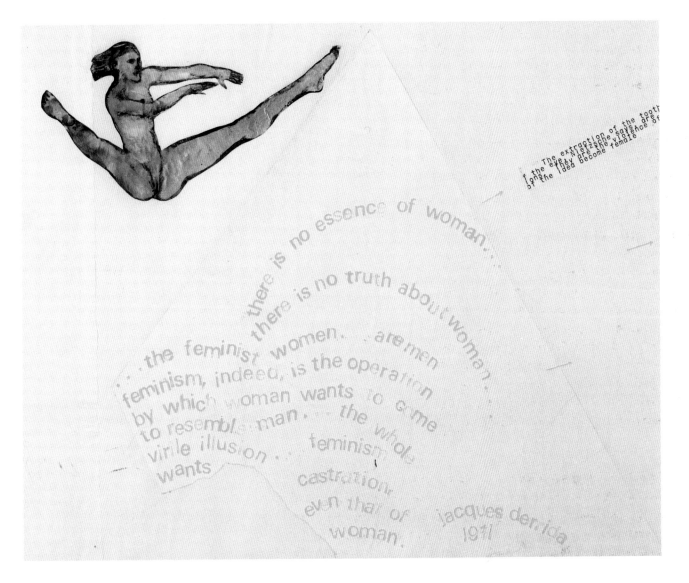

how she was rapt away
by hermes, at zeus' command,
how she returned to sparta,
how in rhodes she was hanged
and the cord turned to a rainbow

sojourner truth

MOTHER OF BIKO CHILD UNDAUNTED IN SOUTH AFRICAN EXILE

dr mamphela ramphele

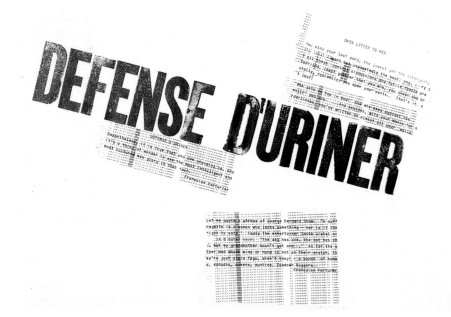

OPEN LETTER TO HER

DEFENSE D'URINER

Françoise Parturier

Notes in Time on Women (panels
XV, XVII, XXI)
1979
Handprinting, gouache,
typewriting, collage on paper
24 panels, 51 × 6398 cm overall

The First Language
(panel XX, detail)
1981
Handprinted and printed, painted
collage on paper
22 panels, 51 x 5791 cm overall

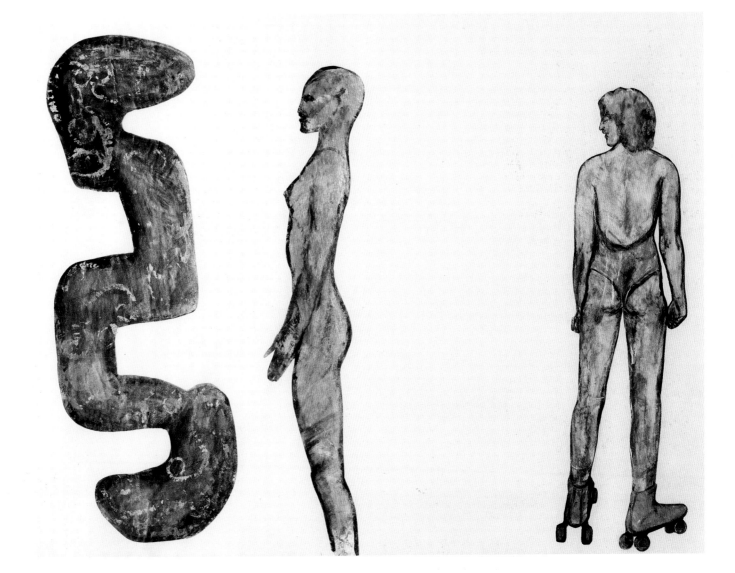

Isaak It seems to be possible to read the dramatic action in the type itself. Text compounds upon text, the print grows in size as if to increase the volume of the message; at its loudest pitch, it blacks out. Afterwards there is a hiatus ... long stretches of blank white spaces speak of the silence, loneliness, emptiness and estrangement that must have followed such trauma. And the next section is about the violence towards women that is in language itself. It seems to function as a coda to the preceding section, as if offering some rationale for the hideousness of the torture of women.

Spero **Yes, exactly. I quote passages from the *Malleus Maleficarum* that compare woman to the Chimera, a beast with a lion's head, a viper's tail, and the filthy belly of a goat. This was a commonplace adage during a severe wave of persecution of women in the sixteenth century. One says a woman was *'une beste imparfaite, sans foy, sans loy, sans crainte, sans constance'*. Nietzsche claims torture itself is female, 'the extraction of the tooth, the plucking of the eye. They are the violence of the Christian idea, of the idea become female'. Then there is the contemporary theoretician Leo Bersani, who compares the penetration of art by criticism to the sexual penetration of two still-warm female corpses who are offering a choice of orifices.**

Isaak You quote Derrida saying 'there is no essence of woman ... there is no truth about woman ... the feminist women are men ... feminism, indeed, is the operation by which woman wants to come to resemble man', but that whole virile illusion is disrupted by a very buoyant gold and black figure of women who is able to do splits while leaping over his words. Your signature head sticking out its tongue runs throughout. In panel IXX, rows of painted heads of women are collaged onto the paper forming a kind of anonymous women's Hall of Fame.

Spero **In panel XXI a sign appears saying 'defense d'uriner': it is forbidden to urinate. That was the feminist Françoise Parurier, working in the 1940s or 1950s, who asks, 'And who pees against the wall?' The answer is, men and dogs pollute the city. It ends with an Indian song from a young girl's puberty ceremony: 'I am on my way running/I am on my way running/ Looking towards me is the edge of the world/I am trying to reach it/The edge of the world does not look far away/To that I am on my way running'. I printed it so that it seems to be raining down upon the dancers. It is an orgiastic dance. Pregnant women, women with their babies cradled in their arms, women waving dildos, women masturbating, women embracing each other dance, leap, kiss, copulate and do acrobatic acts.**

Isaak In the work which follows *Notes in Time on Women* there is no text at all, yet ironically you call it *The First Language*.

Spero **I finished *Notes in Time* in '79. I had used so much text, I decided at this point, no text. It is about body gesture, the language is composed entirely of the female body set in motion. I decided the figures themselves were like hieroglyphics. I worked on *The First Language* for two years. It starts with images I cannibalized from my earlier work. There is war and rape, brutality, but also Dionysiac sexuality, athletic women running, young African women ritualistically dancing, a contemporary woman roller-skating, the whole thing just rolls along.**

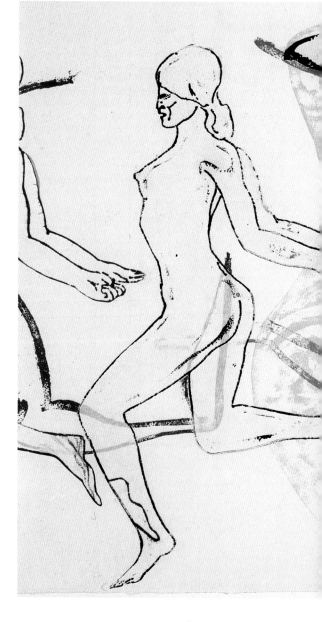

I printed all these figures and then had studio assistants cut them out. The assistants also handprint the plates and I then choose the images and compose the work. I feel very free with this collage technique and the linear format. I have a theme and I can orchestrate it, add stops and then have them running again.

Isaak Yes, you do get a sense of narrative timing, or choreography. The next work is *Let the Priests Tremble*. This I remember very well.

Spero This is the work you exhibited in *The Revolutionary Power of Women's Laughter* show in January of 1983. You also included *To the Revolution* in that show. You recognized the humour and the defiance in the work. That was a very exciting moment. That exhibition provided another context for my work, another insight into what I was doing. Just about that time I had my first commercial show at Willard Gallery; that was in 1983 as well. And I did this mini-retrospective at AIR. I have a lot of shows now and it is not that I am blasé about it, but the importance of these first things – particularly the women's movement in the arts – can't be denied.

above, **Let the Priests Tremble**
1982
Handprinted and printed collage
on paper
3 panels, 158 × 274 cm overall

below, **To the Revolution** (detail)
1981
Handprinting on paper
52 × 288 cm
Collection, Museum of
Contemporary Art, Los Angeles

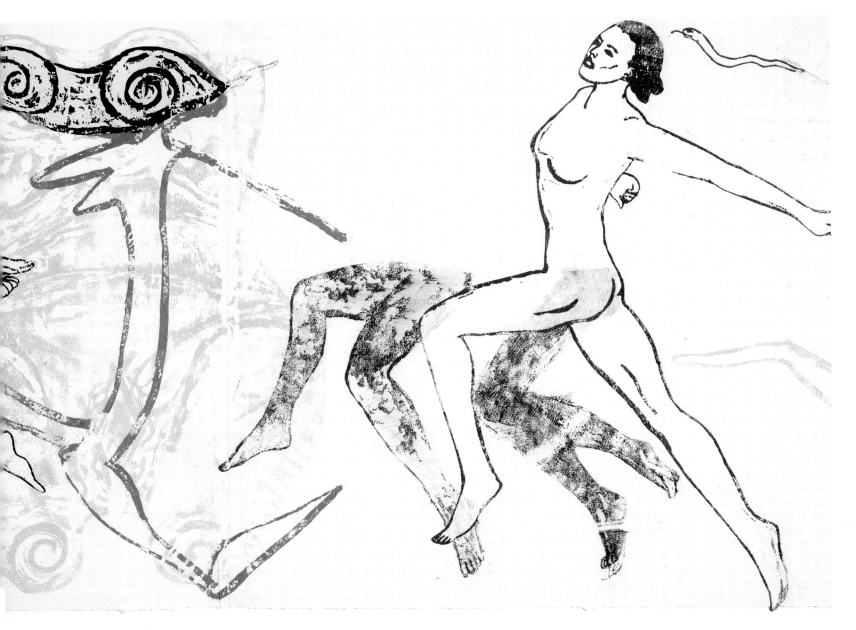

This next one is *Black and the Red,* 1983. This image was taken from an erotic Greek vase. In the Greek version she had two dildos in her hand. They are in the panel on sexuality in *Notes in Time*. When I first started to make these printing plates, I took out the dildos.

Isaak But later on, you put them back in, for example, in *Rebirth of Venus*.

Spero Yes, but the provenance is entirely different, it was a drinking cup.

Isaak Where did the image of the athlete in the second panel of the *Rebirth of Venus* come from?

Spero I did a drawing from a media photo of a black athlete who won a medal at the Olympics a few years ago. She is triumphal. And she is way out of whack proportionally; the back leg is just enormous, even though I worked for days, trying to get her into proportion.

Isaak Well, it serves another purpose in terms of giving her a sense of power and forward thrust. Your work at this point is no longer so angry; it is much more colourful and filled with buoyant dancers and the idea of rebirth.

Spero I had been fighting a sense of victimage, my own and that of other women in *Notes in Time* and *Torture of Women*. But I was thinking, I cannot stay with victimage; there is humour too. That was when you came along and we talked about humour as a revolutionary strategy.

Also at this time I was gaining a certain recognition as an artist. My goal of having a dialogue with the art world was beginning to be realized to a certain extent.

Another thing at this point was that my physical condition was becoming more apparent. You know I often felt very rotten with this arthritis, but now I acknowledged it.

Isaak The *Monsters* diptych (1984) isn't at all up-beat. Are all the monsters women? Are those monstrous breasts?

Spero Yes, she's a monster, she has this terrible head and teeth. And then that woman on the right waving a club is a monster. I got that photo from some sort of riot. There is an image of women's monstrous sexuality. I got that image of the woman with her hands near her crotch from a pornographic magazine, and these monstrous headless torsos are from some book on ancient civilizations. Dr Klaus Vierneisel, Director of Antiquities in the

Chorus Line I
1985
Printed collage on paper
51 × 279 cm

Glyptothek in Munich, gave me a show in the Antiquities Museum and he took it upon himself to look up some of these sources, for which I was very grateful.

This, for example, is the irradiated woman from the *War Series*. I call her 'irradiated' because this imprint was all that was left of a women's body after the bombing of Nagasaki.

Isaak She is an image that endures, something of her remains. She is not erased.

Spero *Mourning Women/Irradiated* (1985) is an image of endurance: an old woman walking over the corpses has escaped and she still keeps going with this cigarette in her mouth. She is with three of these strong athletic figures of women and they are like spirits. In the diptych *Vietnamese Woman* she walks away from the victims; she's a survivor.

Mourning Women/Irradiated
1985
Handprinted and printed collage
on paper
51 × 135 cm
Collection, Philadelphia Museum
of Art

Isaak The next is *Sky Goddess*, done in 1985. Her body forms a canopy over the other figures …

Spero The inspiration for that was the ceilings of Egyptian tombs. And there is an aboriginal figure and an African woman reaching up with her baby strapped around her back. There is the dildo dancer, and a group of aboriginal figures below. In the lower panels I am starting to play with the Sky Goddess. She is starting to move stiffly like a machine, almost reiterating the pose of that women with the baby strapped on her back. She is actually looking for food, there is a famine.

Isaak This wonderful blue figure at the top must be a fertility figure with a fetus in her belly and a long curling umbilical cord. Now we have *Chorus Line I*.

Spero When the American curator, Robert Storr, curated 'Devil on the Stairs', in 1993, at the ICA in Philadelphia, thirty-five artists represented different categories. I was in the 'Body Room' with Louise Bourgeois, Ana Mendieta and Francesco Clemente. Clemente had a painting depicting male figures, with huge penises. The room was small, so on a beam above Clemente's paintings I did the *Chorus Line I*.

Isaak It is as if you have a complete cast of women characters and now all you need to do is play with the many combinations. For example, in *Sky Goddess/ Egyptian Acrobat*, when you print vertically you get narratives reading vertically and horizontally, then the whole thing seems to pivot around the acrobat in the centre. She seems to spin the whole thing around.

Spero Yes. The handprinting and collaging technique is very freeing. This was for a show in Germany; I wanted to do a contemporary piece with eleven bands, like *The Hours of the Night* .

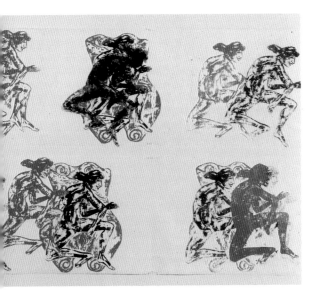

Black and the Red
1983
Handprinted and printed collage
on paper
Diptych, 151 × 280 cm each panel

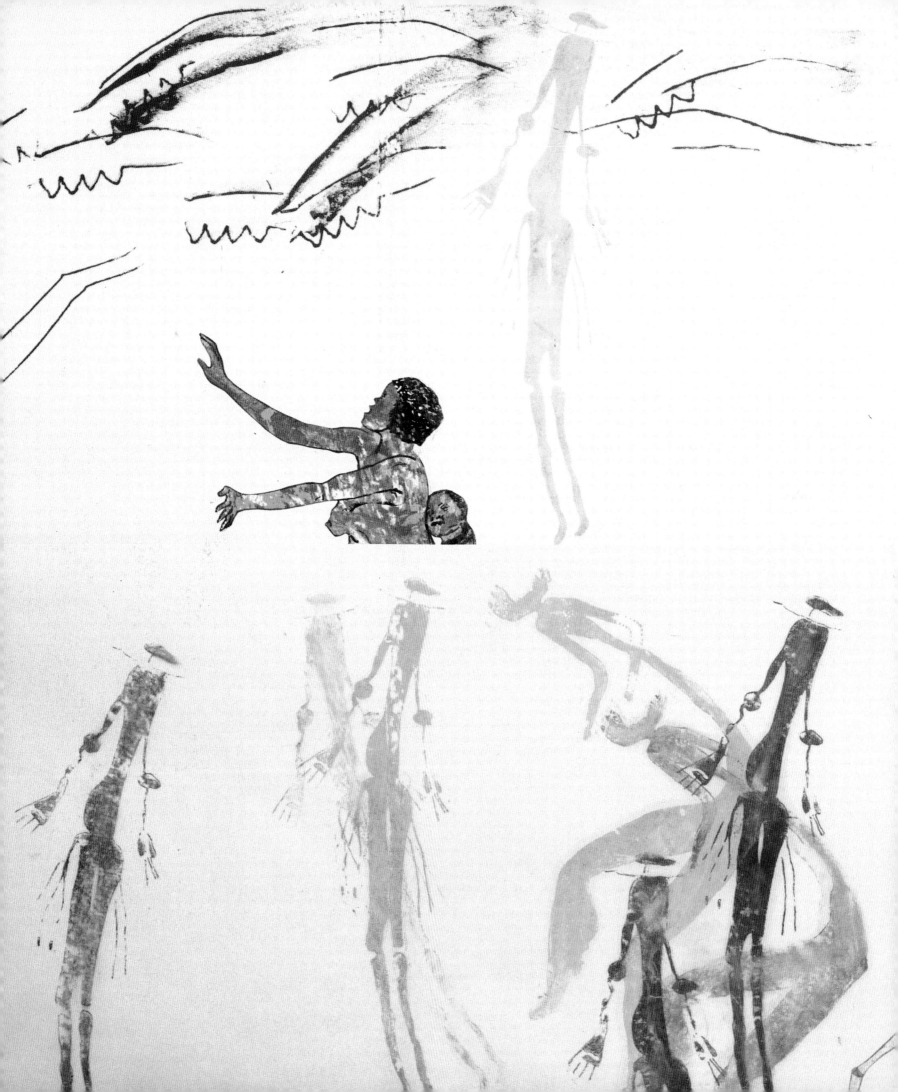

Sky Goddess
1985
Handprinted and printed collage
on paper
6 panels, 51 × 1646 cm overall

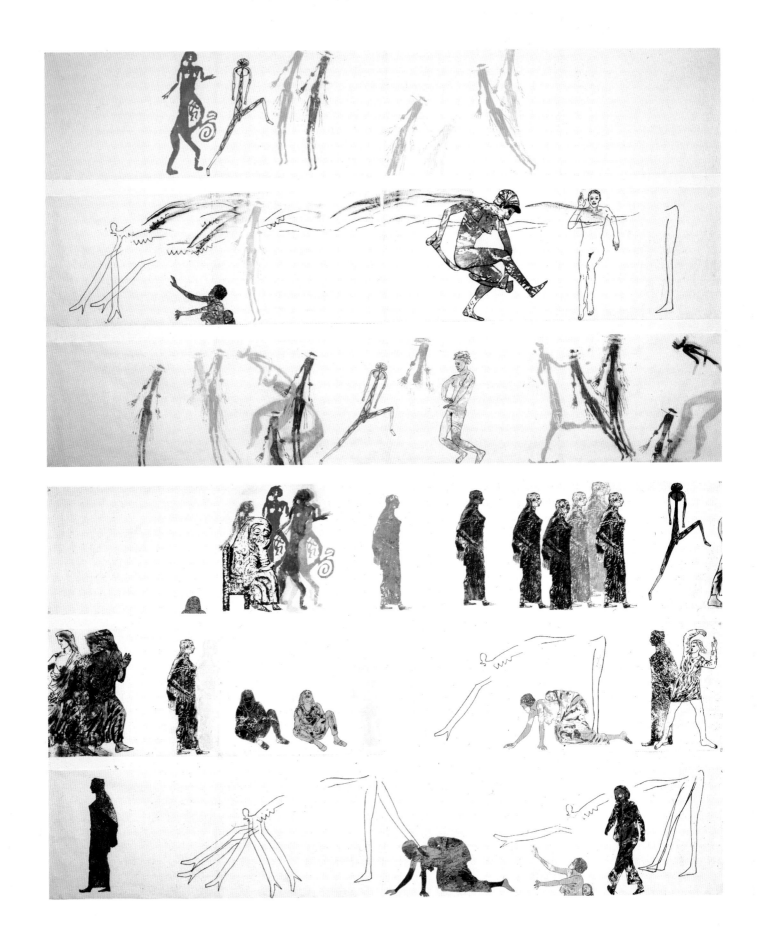

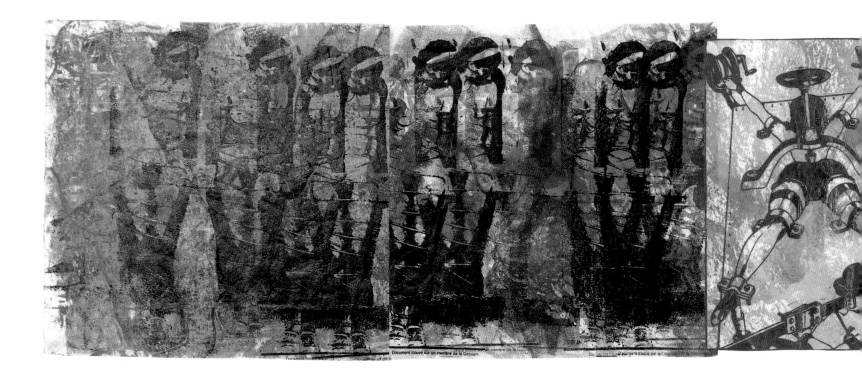

Frieze II
1992
Handprinted and printed collage
on paper
50 × 196 cm
Collection, Vancouver Art Gallery

The Audience II
1994
Handprinted collage on paper
50 × 183 cm

Spero With this next group of works, Leon had found this image in a magazine of a woman about to be hanged captioned *'Document trouvé sur un membre de La Gestapo'* and I took it and had it made into a printing plate. She is bound and gagged; a rope is around her neck and her whole body is bound very tightly and most brutally. One breast is forced up. She is naked apart from half stockings and shoes. Her head is bowed and averted, which means that probably the guy who took this photo watched this hanging. I had this image and I didn't know how to use it. A year or so later I heard a programme on Bertolt Brecht on National Public Radio. One of the things that was read was the 'Ballad of Marie Sanders', it was fantastic! I tracked it down in a book of Brecht's poetry and that is the translation there, 'The Ballad of Marie Sanders, The Jews Whore'. It is a story of a woman who slept with a Jew; she was arrested by the Nazi SS, who cropped off her hair and walked her down the street to her disgrace. In the poem, she is just in her slip, and the drums roll, coming to her death. It says, 'In Nuremburg they made a law at which many a woman wept, who'd lain in bed with the wrong man'. And then there is the stanza: 'The price is rising for butcher's meat, the drumming is now at its height. God alive, they are coming down our street, it'll be tonight'.

I did this as a wall installation in Amsterdam and I met a young Dutch artist there, and he said this is not a poem; this is really a ballad and it has to be shouted. Then he made a loud stamping with his feet and I thought, that is how that poem should be.

Isaak Yes, I remember you printed this directly on the wall at Smith College, it was '90 or '91. I see you have used the Gestapo photograph again in this work called *Frieze II*.

Spero Yes, I juxtaposed it with an image from a French comic book. It is about glamorizing torture, making it sexy. Then on the other side are those mourning women patterned abstractly. In this next work, *Running Totem*,

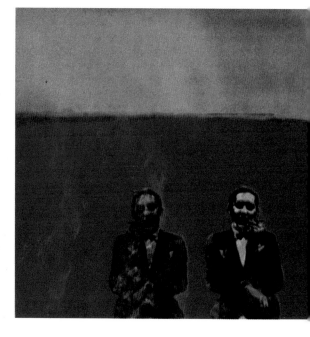

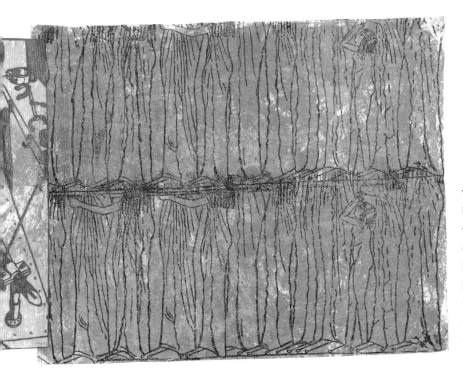

there's a change of style to solid colour. I print the background areas very heavily with a Brayer roller. This technique really comes together in the work I created for the Malmö Konsthall, *Black and the Red III*. I was challenged by the large and airy exhibition space and its simplicity. The Director, Sune Nordgren, wanted to show *The First Language*, possibly because of its pace and tones. I decided to respond to this by creating a new work which had the same dimensions but would explode with intense and vibrant colours and forms. This was an ecstatic and extremely ritualistic work that continued the linear format of *The First Language* around the museum space – the figures continued dancing on the walls.

Isaak Now this last work is called *The Audience II*. This is pretty amusing.

Spero They are all those 1930s women. And she is sitting there smoking and enjoying the show.

Isaak I like the panel where the head goes around the edges as if she is looking down on you. It really suggests intense surveillance. It is also a good work to end on. So much of your work is about the formation of a female protagonist as the universal; in this piece it seems you are now refiguring the audience as female, as if women too can assume the controlling gaze.

Spero Well yes, why not?

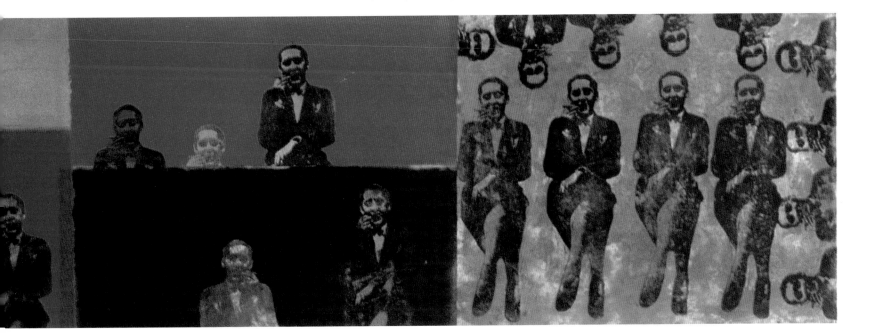

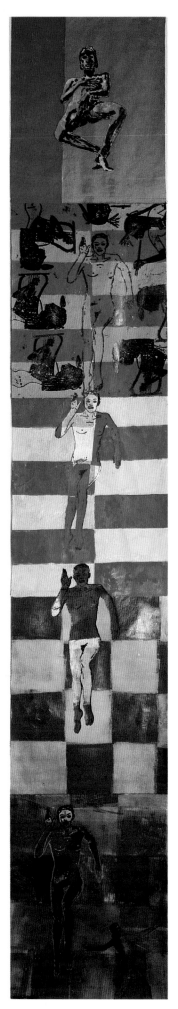

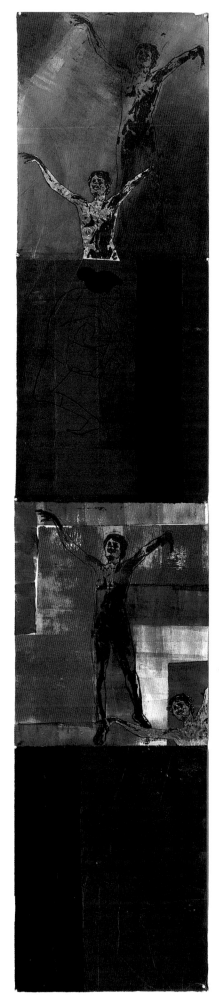

far left, **Running Totem**
1994
Handprinted and printed collage
on paper
317 × 50 cm

left, **Black/Red/Green**
1995
Handprinted and collage on paper
242 × 49 cm

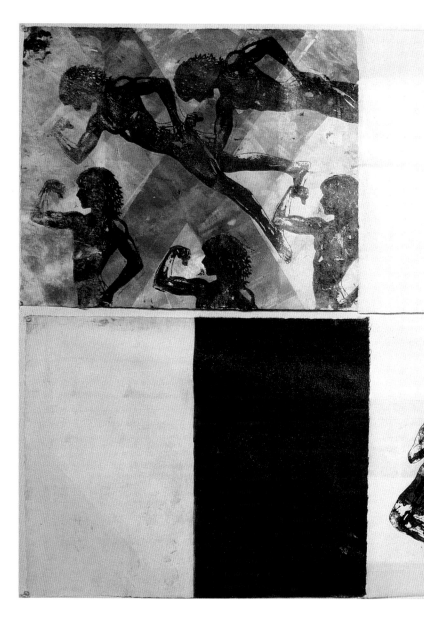

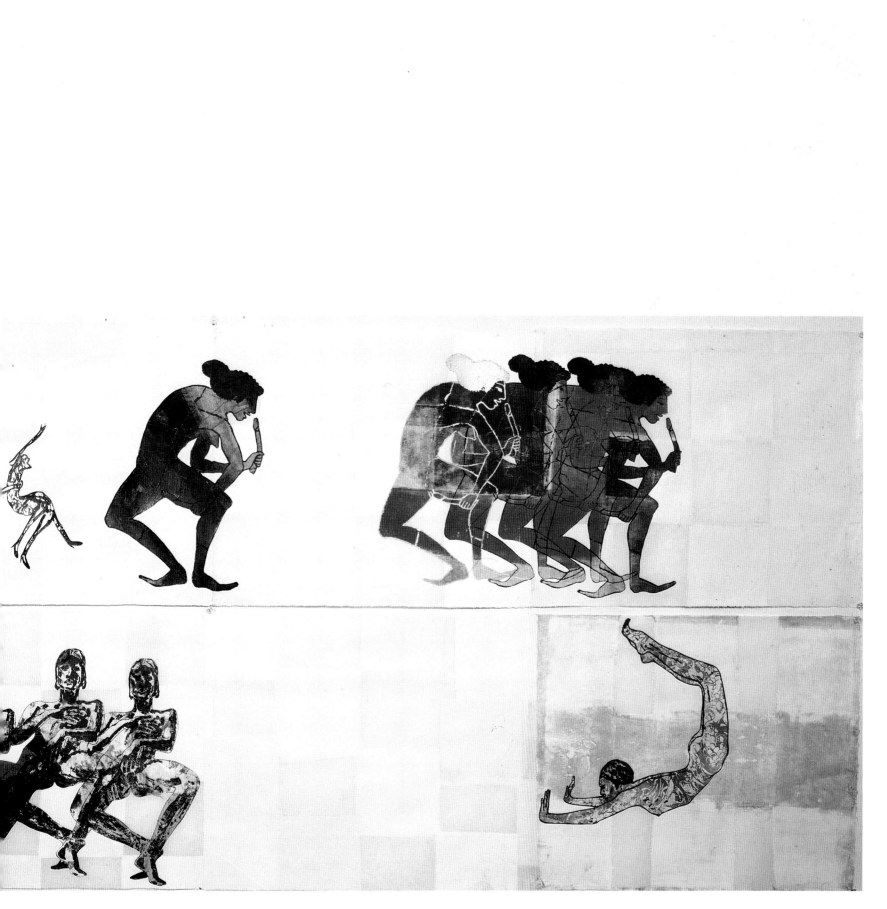

Black and the Red III (detail)
1994
Handprinted and printed collage
on paper
22 panels, 50 × 245 cm each
Installation, Malmö Konsthall,
Sweden

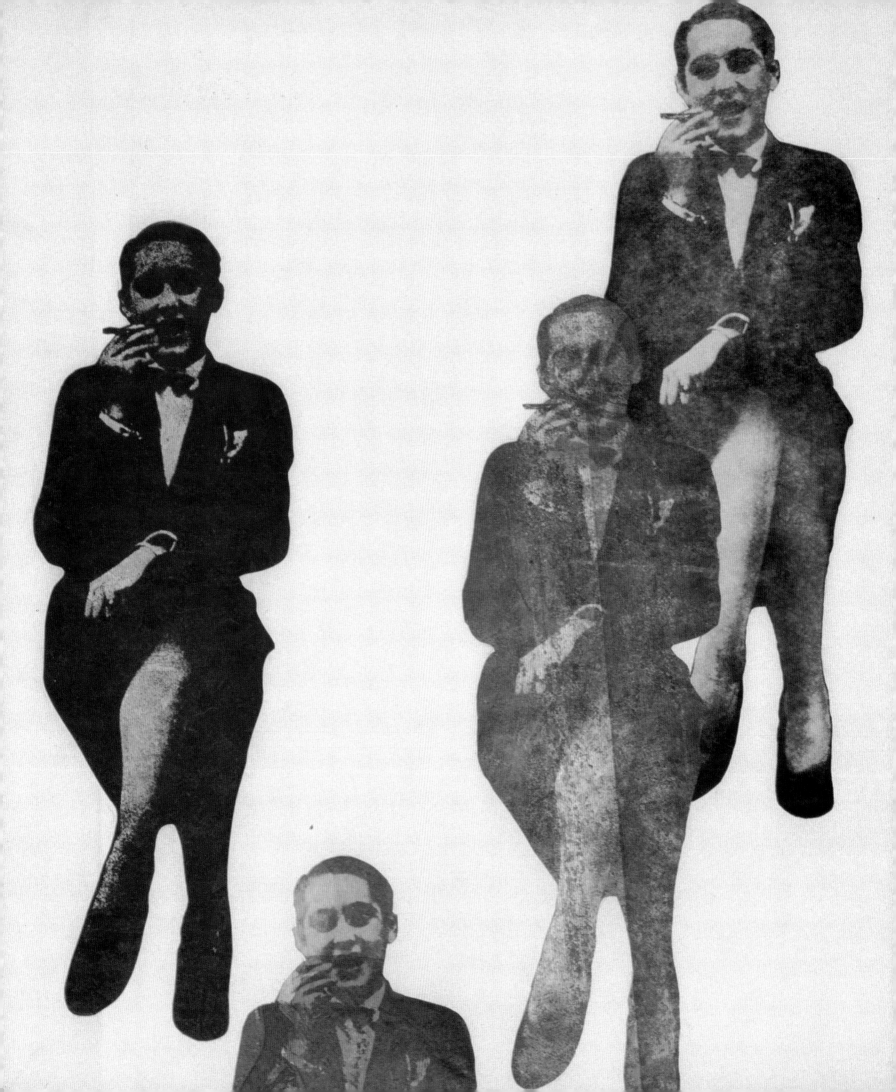

Contents

Interview Jo Anna Isaak in conversation with Nancy Spero, page 6. Survey Jon Bird

Dancing to a Different Tune, page 38. Focus Sylvère Lotringer Explicit Material, page 98. Artist's

Choice Alice Jardine Gynesis: Configurations of Woman and Modernity (extract), 1985, page 112. Stanley

Kubrick, Terry Southern and Peter George Dr. Strangelove or: How I Learned to Stop Worrying and Love the Bomb (extract),

1963, page 114. Artist's Writings Nancy Spero Creation and Pro-creation, 1992, page 118.

Statement about Painting, 1965, page 122. The War Series, 1993, page 124. Text for 'Rape' catalogue, 1985, page 126. On

Feminism, 1971, page 127. The 'Art World' Has to Join Us, Women Artists, Not We Join It, 1976, page 128. Viewpoint, 1972, page

129. Images of Women, 1985, page 130. The Female Body, 1987, page 134. ICA Statement, 1987, page 135. The Great Goddess

Debate, 1987, page 136. Book Reviews, 1989, page 138. Tracing Ana Mendieta, 1992, page 139. Sky Goddess - Egyptian Acrobat,

1988, page 140. Chronology page 144 & Bibliography, page 160.

Introduction

Akhmatova: Oh you who live later, have you heard of Ossip and his wife? And of Anna Akhmatova? I would so much like to know it. One would have to die, to jump a century and to come back.
Nadedja: Or receive a telegram from the future: poems arrived safely. Signed: the border of the twenty-first century.
Lydia: Anna Akhmatova: complete works.
Akhmatova: And tell me, you who live later, do you know who Mandelstam really was? Akhmatova? And Pasternak? Gurmilev? Tabidze? Tsvetayeva? Do you know who (among us) was loyal, who was betrayed, who was a traitor, who saw the doors of the sky open? Will this be visible later in our poems? Has the history of truth begun?[1]
Hélène Cixous

It's usual to commence a critical or theoretical text with an appropriate quotation to set the scene, as it were, for the argument to follow, to acknowledge previous authorities, and to get around the difficult business of beginnings. An equally problematic moment arrives at the closure, which is perhaps why the Introduction is usually written after the Conclusion. So you start where you end, a retracing of where you've been in order to know where you are going. This coming and going amongst the text is a strangely appropriate experience when writing on the work of Nancy Spero who, for forty years, has been making her scrolls and installations from a constant excavating of the narratives of history and mythology. Spero's discourse of the feminine represents an archeological burrowing that restores the past to the present in order to imagine a future. The quotation that introduces this text poetically describes the necessity for remembering in order to go forward. The French feminist author and literary theorist Hélène Cixous is one of the few writers for whom the distinction between theory and artistic production is successfully blurred in a sensuous delight in the play of the text, in her recognition that the understanding that comes from the aesthetic is as valid as the speculations of philosophy or the analysis of critique, and that 'knowledge' is intimately related to power and the subject. Her writing is a constant reminder that we should always listen for the unconscious of the text which, for her, is the evidence of the body in language, and how language writes the body. Cixous offers a way to bring the work of Nancy Spero into a critical text through a rhetoric of desire and the body. Spero appropriates figures from literary, documentary, mythological and archaic sources in order to record the ambivalent relation between the sign, 'woman', and women as historical subjects. This is a recognition of shared

Stylish (detail)
1990
Handprinted and printed collage
on paper
Diptych, 52 × 278 cm each panel
Collection, Vancouver Art Gallery

Goddess Nut
1989
Handprinting and collage on
paper
7 panels, 280 × 52 cm each

histories, experiences and memories lived at the level of the social and the psychic, of everyday realities and the patterns of interiority that form the fantasies and desires of the maternal and sexual female body.

Interpretation always starts with a question. Freud would have us believe that the question of origin is always the repressed in any enquiry into meaning, that knowledge and art are the culture's response to loss and the trauma of separation. There is also a violence to interpretation, a desire to possess the object that is always just beyond reach, which can be as mild as scratching an itch, or as extreme as the unleashing of our most murderous intentions. Mythology interprets this as a matricidal fantasy and history confirms the awful truth of this impulse. The analyst and philosopher Julia Kristeva, writing about the psychoanalytic drive behind interpretation, warns against the tendency towards circularity – to produce the object that the theory has already pre-selected. Against this, she suggests the possibility of the object's unknowability, that it resists theoretical incorporation and opens up theory to its own inadequacy and partiality.[2] It seems to me that these dangers always and necessarily accompany the writer for whom the object of study is the image, for, whereas we may be reasonably sure of the construction of the verbal sign, it is not at all evident how this applies to the visual.

What are the appropriate and convincing concepts and terms for analyzing the meaning of the work of art? The Dutch art historian Mieke Bal argues for an interpretation that 'reads' works of art as 'texts', not to reduce the visual to the verbal but, rather, in order to understand the interplay between word and image in the concept of 'visual textuality'.[3] Visual textuality is an apt expression for the complex relations of form, content, viewer and context that constitute the visual field in which Spero's works exist and are perceived. What I hope to do in my text is to develop an interpretation that is adequate to her practice, acknowledging the specificity of the visual, and to simultaneously make a claim that, in any critical or evaluative schema, these constitute some of the great works of the post-war period. What follows, therefore, is an engagement with her work on a number of levels in terms of historical and cultural reference, formal and technical innovation, thematic concerns, viewer/work relations, etc. These readings are not made, however, in order to contain the work within the safety of theoretical exposition but to trace its dangerous contours and extraordinary ambition: to inscribe the difference of the feminine as presence within the visual field.

Identity in Transition: Codex Artaud to Torture of Women

Sometime during the summer of 1969, Spero acquired a copy of Jack Hirschman's anthology of the poems of Antonin Artaud. Spero, her husband, the painter Leon Golub, and their three sons had been living in New York since 1964. Spero and Golub met at the Art Institute of Chicago where they both studied during the late 1940s. After completing their training they travelled to Italy, and then lived in Paris from 1959 to 1964. This period of the 1960s represents a transitional stage for Spero: from convention-bound but richly

expressive oil paintings on the themes of 'lovers', 'mother and child', 'family groups' through the severe and naturalistic Etruscan and Tarot paintings; the small-scale and rapidly executed gouache drawings and paintings of the *Vietnam War Series*, to the sketchily drawn and collaged Artaud Paintings which were the springboard for the proto-typical scroll, the *Codex Artaud*, worked on throughout 1971 and completed in 1972.

During these years Spero constructed a fragile artistic identity out of the political and social nexus that framed the practice of radical avant-gardes in New York. For a woman artist, particularly in her own case with the legacy of, and commitment to, the figurative tradition that characterized post-war artists trained and practising out of Chicago, the personal had to become political if there was to be a way round the gender and subject hegemonies that then determined the art world's institutional structures. Many of the so-called alternative practices and spaces that were initiated as a result of early examples of cultural and identity politics – anti-war and civil rights activities, the Women's Movement – were, for their instigators and followers, hardly alternative to other possibilities but the sole out-lets for production and an engaged and receptive dialogue. The pragmatics of organization and communication took place within the context of a developing theoretical and critical discourse exploring the social, historical and psychic forma-tion of subjectivity under patriarchy. The artistic parameters were formed by the dominant aesthetics of Pop art on the one hand, and on the other by the breakdown of the physical-object paradigm in

the move from Minimalism to Conceptualism, and the varieties of media and performance works. Crucial for the definition of an oppositional iconography was the recognition of sexual differ-ence in and across representation expressed in Lacan's formulation: 'images and symbols for the woman cannot be isolated from images and symbols of the woman ... '[4]

Living uptown in New York on West 71st Street, Spero's everyday activities were divided between the domestic, the studio (a blurring of the traditional boundary as at this time she was working from their apartment) and the networks and affiliations that constituted her experience and exploration of a burgeoning feminist politics. This was to include the Art Workers Coalition and Women Artists in Revolution, which met regularly at the 'Museum', a loft space on Broadway, and the Women's Ad Hoc Committee formed by the critic Lucy Lippard in 1971. (The Art Gallery Guide gave Spero the assignment of writing-up the picketing of the 1970 Whitney Biennial for its systematic exclusion of women artists.) In the winter of 1971, from out of the Ad Hoc Committee, a group formed

top left, **Two Figures**
1955
Oil on canvas
112 × 51 cm

top middle, **Il Mondo**
1958
Oil on canvas
208 × 94 cm
Collection, Vancouver Art Gallery

top right, **Great Mother Birth**
1962
Oil on canvas
173 × 112 cm

Members of the AIR gallery, New York, *l. to r.*, *back row,* Mary Beth Edelson, Sarah Draney, Nancy Spero, Donna Byars; *middle row,* Rachel Bas-Cohain, Dotty Attie, Anne Healy; *front row,* Pat Lasch, Clover Vail, Ana Mendieta, Daria Dorosh

which included Spero, Barbara Zucker and Susan Williams to discuss the feasibility of a 'women's alternative gallery'. This resulted in the opening of AIR (Artists in Residence) at 97 Wooster Street, SoHo, New York, in September 1972. The following year Spero exhibited sections of the *Codex Artaud* and AIR continued to be her primary exhibition space throughout the 1970s. As a transitional phase, the years between the mid 1960s and mid 1970s marked the closure of an identity, from the sense of alienation that motivated her appropriation of the anguished texts of Antonin Artaud as metaphors for her own sense of angry disempowerment, to the compassionate and powerfully evocative expressions of women's distress and the body in pain, *Torture of Women*.

Codex Artaud and *Torture of Women* introduce a major theme in the unfolding series of works that constitute Spero's practice over the next two decades: a semiotization of the female body spanning a register from pain to pleasure, mourning and loss to an uninhibited recognition of the capacity for joy. The dialectic of pleasure and pain runs throughout the scrolls, totems, prints and installations, symbolizing the universality of the negation of the feminine principle. This theme dominates in the early works but also consistently reappears in the phantasm of the victim as 'other', marking a specific moment in history (Marie Sanders, Masha Bruskina, Ana Mendieta), or as the generalized symbol for the effect of power upon the body: women tortured, bound, fleeing, irradiated, a cry of pain or resistance echoing across traditions and cultures from pre-history to the present. However, these are always narratives of action and reaction, of power inscribed upon the body and the body as the symbol and source of empowerment, a shattering of social and historical constraints in a celebration of the territory of sexuality, the maternal, the power of the feminine.

How is the body figured in the text? What complex and varied combinations of individual experience and psychic life, social history, aesthetic order and structures of representation produce the work in its specificity and semiotic possibility? For Kristeva, any interpretation that seeks the feminine in the text must look to the period of early infancy which is dominated by the mother-child relation. This pre-history of the subject she terms the semiotic 'chora', defined by the proximity of the maternal body as voice, breast, face; the source of protection, warmth and nourishment. The maternal body is the object of the infant's libidinal and psychic investment, an enveloping world that provides the earliest form of spatial experience. Prior to the separation that is the necessary condition for symbolization – the system of language which depends upon the organization of an external relation of subject to object (initiated by the 'mirror phase') the semiotic chora is the space of primary narcissism, of the internal organization of the instinctual drives. However, this is a space suffused with orality. The infant's expulsion of breath is the first vocalization, a cry for succour which is closely followed by laughter – the other primary vocalization. At this stage neither the cry nor the laugh signify any relation of exteriority, but instead mark the initial stage in the gradual process of stabilization: the

long journey of psychic and social organization that maps the formation of the subject.

There is no outside to the mother/infant dyad, her face is the surface for the infant's projections as the infant/mother symbiosis slips towards autoeroticism. Kristeva records that infant laughter frequently results from the linking of the mobile body with vision – a sudden action or the arresting of movement – a sequence of instants that constitute the rhythmic quality of the chora and its spatial and temporal dimension. 'Laughter is the evidence that the instant took place, the space that supports it signifies time'.[5]

In these formulations of the semiotic as a mode of resistance to the symbolic, Kristeva constantly stresses the troubled binding of mother and child in the pre-Oedipal phase, of the pleasure and pain which define this interaction: of the presence of 'jouissance' and 'abjection'. Anterior to language, the semiotic chora responds to the rhythms and pulsions of the sexual body, emphasizing the subject-in-process against any notion of fixed identity. As a conceptualization of the extreme states of subjectivity, the semiotic characterizes the collapse of signification found in psychotic discourse, but also figures in the transgressive and disruptive examples of the creative imagination 'at play'. Kristeva analyzes the texts (a term that stands for the semiotic structure of both the literary and the visual, of word and image) that subvert the conventions of meaning by dwelling upon the breakdown in the signifying system when the body enters the text; of the bliss or the horror experienced when we face the evidence of our own psychic capacities for love or violence and the

institutionalization of this conflict across the social body. Underlying this reading of the social through the disruptive and transgressive texts of artistic avant-gardes is the dissolution of language and representation through the signs of sexual difference: the securing of boundaries and hierarchies through the marginalization of the feminine – specifically, the repression of the power of the mother, of the sexual and desiring maternal body.

For example, in analyzing the semiotic as a presence in certain forms of language specific to Modernism, Kristeva argues that the function of rhythm and the obscene in the writings of both Celine and Artaud is to record the trace of an 'archaic, instinctual and maternal territory'. The patterns of the text – a combination of word-play and syntactical elisions – free meaning from reference, obscuring the object and implying an impossible desire (for love, transcendence), the rhythm of the phrase echoing the repetitiveness of a drive to 'wipe out sense through non-sense and laughter'.[6] In Kristeva's interpretation, an obscenity in Artaud lacks an objective referent, but signals the explosive force of an instinctual body.

Spero spent a four-year period immersed in the texts of Artaud, producing a scatological inventory of the body dispersed across images and texts, learning a grammar and a syntax of gesture, rhythm, space, line and colour; a vocabulary of collaged and printed texts and 'hieroglyphs' on pasted-together sheets of Japanese rice paper. Evidence of a technique of collage is first to be seen in the late *War Series* and gradually comes to dominate in the small Artaud drawings and paintings, culminating in a working method

Codex Artaud
1972
Gouache, painting and
typewriting collage on paper
29 panels overall
Installation, Institute of
Contemporary Arts, London, 1987

resolved in the *Codex* that has persisted over a twenty-year period. Artaud's tortured prose provided a voice through which Spero was able to express her own sense of exile as a woman in pain in the strange and alienating country of male artists and institutions. This was lived as a stifling of her creative imagination in the everyday brutalities and indifference of the New York art world in the 1960s prior to the support provided by the Women's Movement, and in the actual bodily pain of progressive arthritis – another everyday reality that has been the discordant accompaniment to her life over the past thirty-five years.

Between July and September 1946, following his release from nine years incarceration in various asylums and having been subjected to near-fatal electro-shock 'therapy', Artaud worked on a series of poems which were published in 1947, illustrated by eight of his own drawings, and titled *Artaud the Momo*. 'Momo' is both Marseilles, his birthplace, and slang for 'idiot' or 'simpleton'. It is also the incorporation of the 'other' into the self, of a return to language – reçovering his voice – after the incoherence of insanity and the torture of electro-shock treatment. A composite of delirium and anger, Momo evokes the unfathomable depths of interiority, of the self at the edge of an abyss that gapes onto the underworld (which is the sexually abjected and grotesque body), and of a death which has to be confronted and embraced in order to find a life for the creative imagination. (Artaud's pain also resonated for Cixous. In *The Body in the Text* she describes writing as 'going to the realm of the dead ... writing is violent'.[7]) Despite the misogynistic elements in Artaud, it is

his openness to the feminine – Kristeva's 'semiotic' – that reinscribes the maternal body. This is signified through a combination of imagery and the pulse of the language – its texture and flow – which together threaten and undermine the symbolic order. However, this is no reinvention of a non-cultural essentialism, nor the abandonment of reason in a retreat into psychosis, collapsing the boundaries between fantasy and actuality. As with the notion of an *écriture feminine* and Spero's claim for a visual equivalent in a *peinture feminine*, the semiotic exists within the symbolic as language, as body, as sexuality, but marking a difference. Carrying the trace of the archaic maternal body, traversed by the instinctual drives, the semiotic processes prepare the entrance into meaning and significance, into language. But language is constituted through a process of splitting from the maternal body, a breaking of the mother/infant relation by the entry of a third term – the phallus, which represents the place of the father in the symbolic order. This is the moment of castration that initiates a desire that can never be fulfilled:

'Castration means first of all this – that the child's desire for the mother does not refer to her but beyond her, to an object, the phallus, whose status is first imaginary (the object presumed to satisfy her desire) and then symbolic (recognition that desire cannot be satisfied'.[8]
Codex Artaud figures the heterogeneity of the body and the shifting of sexual identity. In her uneven and fragmented printing of Artaud's texts, Spero graphically renders his speech as expressive of a soul in hell, of the symbolic order insistently undermined by the semiotic body: human, animal,

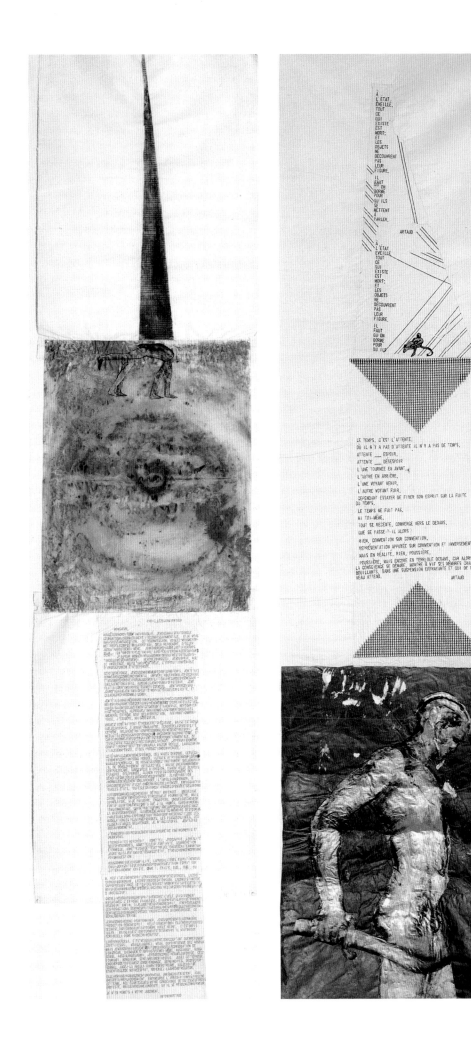

far left, **Codex Artaud XX**
1972
Gouache and typewriting collage
on paper
222 × 53cm

left, **Codex Artaud XXI**
1972
Typewriting, painted collage on
paper
174 × 52 cm
Collection, Vancouver Art Gallery

above, **Codex Artaud XXVII**
1972
Typewriting, gouache collage on
paper
108 × 43 cm

below, **Codex Artaud XIII**
1972
Typewriting, gouache collage on
paper
130 × 62 cm

opposite
Codex Artaud VIII
1971
Typewriting, painted collage on
paper
38 × 251 cm

Codex Artaud XXV
1971-72
Typewriting, painted collage on
paper
61 × 488 cm

Codex Artaud IX
1971
Typewriting, painted collage on
paper
46 × 305 cm

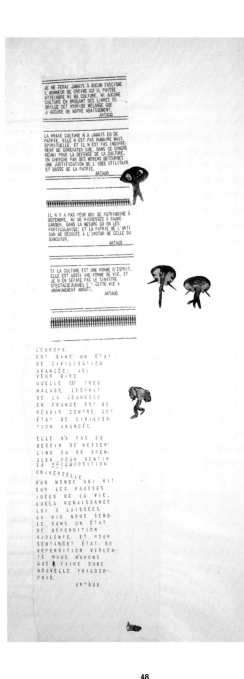

the phallus is here a mobile signifier for both voice (the tongue) and sexuality. Language is structure – it has form and substance – but also a 'prison house'. Spero assembles Artaud's texts in geometric and fractured patterns that suggest concrete poetry in the attention paid to the form of the content as well as the content of the form. There is also, of course, the reference to Conceptual art, a connection that runs throughout her work in the challenge it makes to the institutional framing of meaning, perhaps most evident in the installations, but also in the extended format of the scrolls and the relationship they establish between the viewer and the work. The formal functioning of the texts in the *Codex* and their dispersal across the paper ground, interrupted and overlaid with appropriated and invented collaged figures which exhibit a bewildering array of gender and human/animal possibilities, vividly affirm the partiality and flexibility of sexual identity, and the powerful presence of fantasy in the construction of subjectivity. Artaud's prose, for Kristeva, affirms the heterogeneity of meaning and signification found in poetic language. The effects of rhythm, intonation and expression – at their most radical and inventive, threatening the syntax itself – carry the beat of the maternal body and the instinctual drives. In her approach to the signification and potential of the female body, Spero's lexicon of trans-historical and trans-cultural, real and mythological images of women represents an unmasking of the power of the stereotype, a displacement of fixed categories and value hierarchies in favour of an aesthetics of heterogeneity. What is intimated in this direction in the early scrolls becomes

explicit throughout the later works: that the meanings reside in the relationships.

In a detail from *Codex Artaud VI*, what at first glance appears to function as design – a decorative and densely ordered geometric area – is revealed on closer inspection as the alliterative and dispersed repetition of the poet's name: AAARRRTTTAAAUUUDDD ... The visual form collapses the syntactical nomination into the phonetic equivalent of a shout or scream, no longer the sign of identity or authorship, a subject position within culture, but the expression of body as voice. This element is formally balanced by a clearly legible area of text: Artaud's own account of his arrest in Dublin and transfer, via a series of psychiatric institutions, to the asylum at Rodez:

SEULEMENT DE SEPTEMBRE 1937 A AUJOURD'HUI IL M'EST ARRIVÉ QUE J'AI ÉTÉ ARRETÉ. MIS EN PRISON À DUBLIN. DÉPORTÉ EN FRANCE. INTERNÉ AU HAVRE. TRANSFERÉ DU HAVRE A ROUEN. DE ROUEN À SAINTE-ANNE À PARIS. DE SAINTE-ANNE À VILLE-ÉVRARD. DE VILLE-ÉVRARD A CHEZAL-BENOÎT ET DE CHEZAL-BENOÎT À RODEZ. TOUTES MES AFFAIRES M'ONT ÉTÉ PRISES PAR LA POLICE ET TOUS MES PAPIERS ON ÉTÉ PERDUS. ARTAUD

(Only from September 1937 to today I was arrested and imprisoned in Dublin. Deported to France, interred at Le Havre. Transferred from Le Havre to Rouen. From Rouen to the hospital at St. Ann of Paris. From St. Ann to Ville-Evrard. From Ville-Evrard to Chezal-Benoît and from Chezal-Benoît to Rodez. The police took all my possessions and all my documents were lost. Artaud.)

Artaud is here controlled by the text,

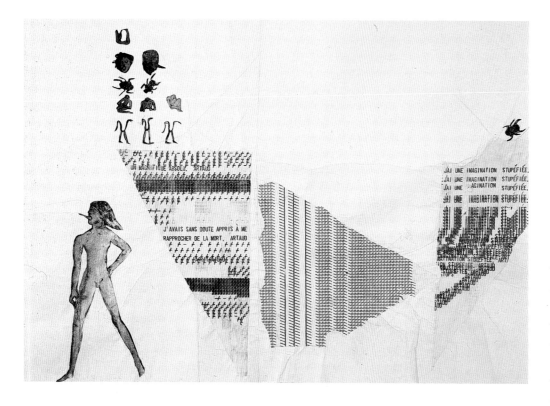

Codex Artaud VII (detail)
1971
Gouache and typewriting collage
on paper
52 × 381 cm

Codex Artaud VI
1971
Typewriting, painted collage
on paper
52 × 316 cm

reduced to a function of exchange in a system of surveillance and incarceration, a system that, literally, speaks the subject. Juxtaposed with these passages are two drawn and collaged images: an extraordinary hermaphroditic body which seems to be constructed from the grafting together of the lower halves of two separate bodies, one multibreasted, the other with a phallus which is threatened with castration by a menacingly hovering, detached head. Next to these forms we encounter a three-headed serpent, each head displaying a protruding phallic tongue. Language

is imaged as the body, the tongue the signifier for the voice. In another detail from *Codex Artaud VII* a self-consuming serpent in a figure-of-eight pattern encircles a staff above the tiny drawing of a mirror image of sexually-joined male and female figures. A larger collaged element of three ambiguous forms with heads and phallic tongues, each sack-like body inscribed with an Artaud text, floats beneath two sheets of disjointed typing, ending with the words: *JE N'AI PLUS MA LANGUE*.

Here Spero combines theologies of gender with the origins of historical time. The serpent encircles the 'tree of life' of the Great Mother Goddess (in the mythologies of Mesopotamia, Egypt and ancient Greece), the act of self-consumption symbolizing the cycle of death and renewal. As Anne Baring and Jules Cashford argue in *The Myth of the Goddess*[9], images of the Goddess in every culture are generally accompanied by a serpent as signifier of the moment of consciousness. (In the Sumerian myth of Marduk and Tiamat – a recurrent theme in the scrolls – the serpent adopts the form of the Goddess herself.) The three phallically-headed forms suggest both brute matter in a state prior to sexual differentiation,

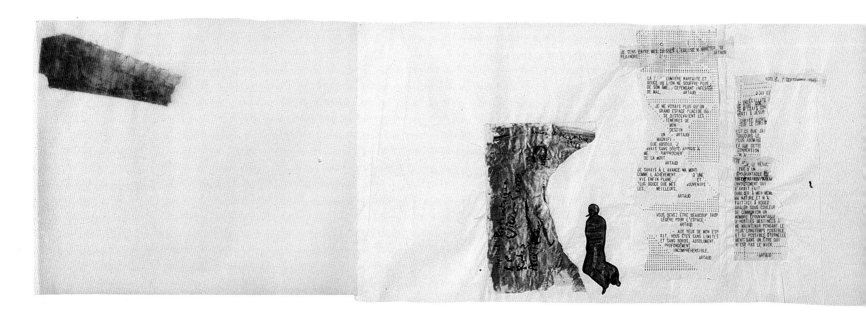

and also the outline of a child wrapped in swaddling clothes: 'an allusion to the earliest period of the existence of a person or thing'.[10] If we accept that the autobiographical is always a narrative sub-text to the work, then the constant imaging of a tripartite form has to include an embedded reference to Spero's own experience of the mothering of three sons. But during this period in her life she was also experiencing the most extreme alienation as an artist: she is both the maternal body, but also the child prior to symbolization, the object of another's desire, 'deprived of individuality, subjectivity and a place in society'. Artaud covers the lack that defines the relation to the phallus, the Law, the moment of symbolic castration:

'The father is present only through his law, which is speech, and only in so far as his Speech is recognized by the mother does it take on the value of Law'.[11]

The denial of sexual difference signified by the hermaphroditic body also carries the biblical connotation of the primary undifferentiated creature discussed in Mieke Bal's reading of Genesis 1–3.[12] Unnamed, inactive, this 'earth creature' sleeps and then awakens into differentiation and language – the recognition of 'her' sexuality is the first expression in the poetry of *ha-'adam*: 'If the woman is the first to be signified, the man is the first to speak'.[13] The next step, from sexual difference as the sign of separation to the recognition of the body, is effected by the introduction of another term – the 'serpent': 'an ambivalent creature, ontologically, morally, as well as narratologically. It is an animal, but it talks. It is the first being to confront another one, the differentiated woman, but it uses the plural verb form, hence it addresses the man, too ... '[14] Bal argues that in the woman's response to the words of the serpent there is the first act of independence and the assertion of a powerful subjectivity, the moment of exchange that breaks the monolithic power of Genesis 1 and initiates dialogue and narrativization.

These images – heterogeneous, contradictory, richly connotational – return time and, again throughout Spero's oeuvre, their anterior meanings (pre-existent cultural narratives), carry over into new contexts and associations which in turn generate fresh narratives, a process which is fundamental to her practice as a whole. In the text/image relationship and in the dissemination

Codex Artaud VII (detail)
1971

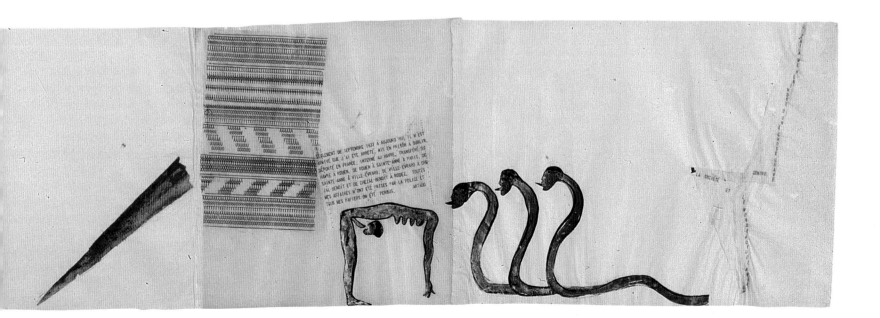

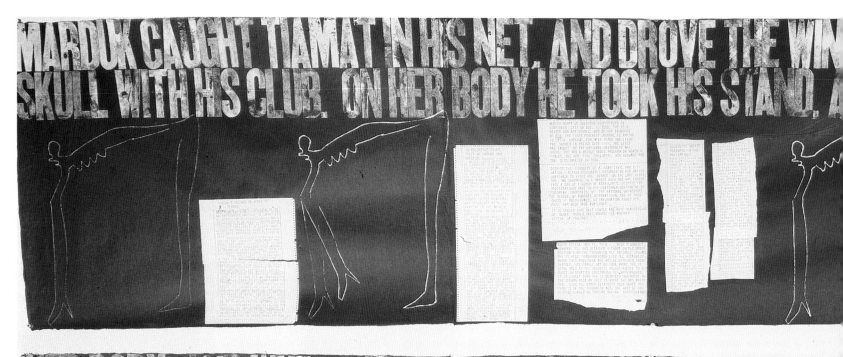

MARDUK CAUGHT TIAMAT IN HIS NET, AND DROVE THE WIN
SKULL WITH HIS CLUB. ON HER BODY HE TOOK HIS STAND, A

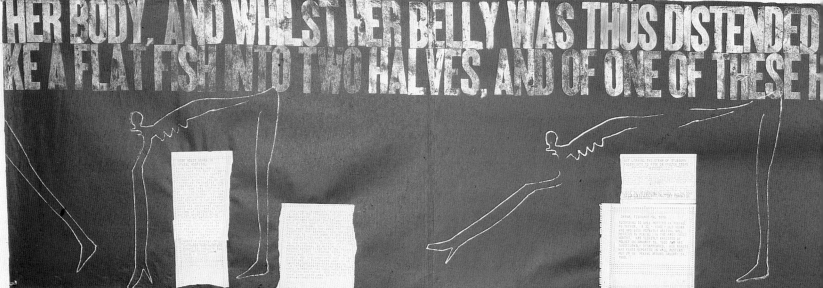

HER BODY, AND WHILST HER BELLY WAS THUS DISTENDED
KE A FLAT FISH INTO TWO HALVES, AND OF ONE OF THESE H

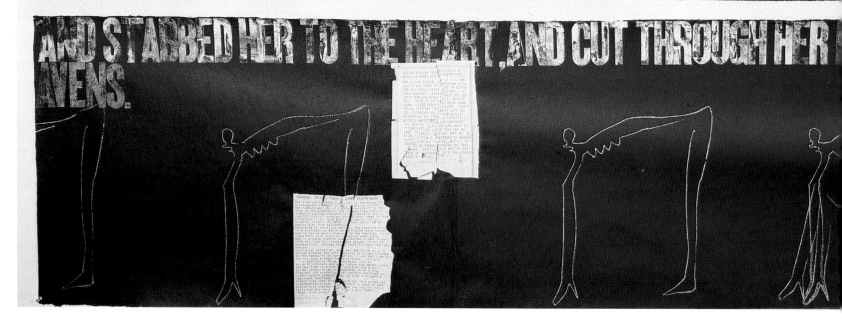

AND STABBED HER TO THE HEART, AND CUT THROUGH HER I
AVENS.

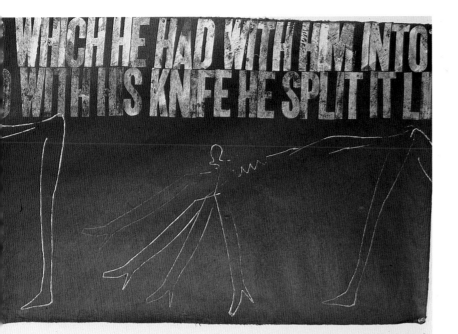

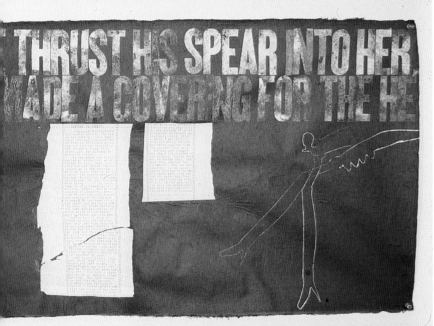

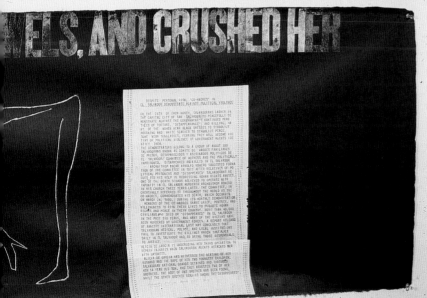

Marduk
1986
Typewriting and handprinted
collage on paper
Triptych, 61 × 914 cm overall

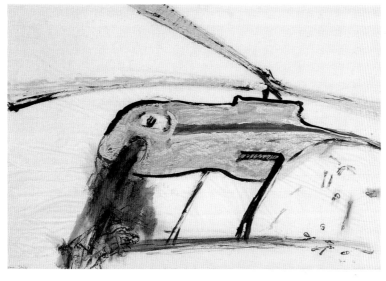

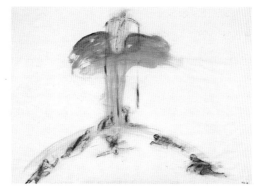

of this structure across the work, we are made aware of visual narratives and the visuality of narrative, of how the work is textualized by the activity of semiosis: of the mobility of signs and the circulation of meanings.

Besides her consistent interest in myths of the Goddess across cultures, the texts of the Judeo-Christian scriptures also hover at the margins of Spero's work as evidence of a dialogue between body and voice, flesh and word. The repetitive interplay between the historical and the contemporary attests to a belief in the archaic as the mythic structure through which the most fundamental experiences are coded. The Hebraic scriptures construct the body as the locus for belief in the relation to a metaphysical referent. God is written on and in the body, forcefully present in moments of extreme physicality when the boundaries between interior and exterior are blurred. These are the sacral moments – transgressive or transcendent – when the semiotic body is most intensely present and most profoundly the substantiation of another reality: of childbirth, wounding, sexual pleasure, menstruation, excretion, death. These phases of acute embodiment, of the dominion of the body, evidence an incontestable reality. Extreme sentience denies the symbolic order; language is reduced to its most basic and indexical function, a pure existential expression of 'abjection' or 'jouissance'.[15]

Spero's work documents the expressive range of the gestural female body as metaphor for physical and psychic experience, from torture, mourning and death to birth, sexual pleasure and transcendence. On the pleasure/pain axis, the suffering

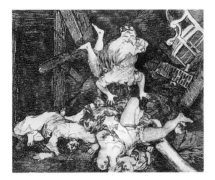

far left, **Francisco de Goya**
Ravages of War from 'Los
Desastres de la Guerra'
1820
Etching
Approx. 21 × 15 cm

left, **Otto Dix**
Feeding Time in the Trench
1924
Etching and acquatint
19 × 24 cm

body tends to dominate in the early works and then figures as a return to the real at various periods over the last two decades. In the *War Series* (1966-70), particularly the defecating phallic bombs and helicopters; *The Ballad of Marie Sanders*, which combines a Brecht poem about the fate of a woman who slept with a Jew with the image of a bound, naked woman; *Victimage* – a dyptich of torture; the installation *Homage to Ana Mendieta*; and the two museum installations, *Masha Bruskina* (Whitney Biennial, 1993) and *Jewish Women in Time …* (Jewish Museum,1993), the disruptive effects of violence upon the body are explicitly portrayed.

Many of the images in the *War Series* contrast the powerful depiction of war as pornographic violence, in which the technologies of destruction become grotesquely anthropomorphized and victims seek their own obliteration, with the denial of injury, pain and death signified in the euphemistic renaming of these acts in official terminology. In this language of pure ideology, the body is repressed in the active redescription of actual events as the inevitable outcome of a 'just' or necessary cause. It is hard to find other representations in the history of art that convey such furious condemnation – perhaps Goya's *Disasters of War*, Otto Dix's etchings of trench warfare, or an earlier tradition, one referenced by Spero herself, the medieval *Beatus Apocalypse of Gerona* depicting the wars of angels and demons and the horrific fate of non-believers. Executed in a graphic style that combined extreme delicacy and expressive range with, at times, an almost physical assault upon the white ground of the paper, these drawn and painted scenarios carried the indexical traces of Spero's response to the war in Vietnam.

Spero has made and remade *The Ballad of Marie Sanders* as paper print, scroll and museum installation, combining the image of a tortured, naked and bound female body, taken from a photograph originally found on the body of a dead Gestapo officer, with a poem by Bertolt Brecht. It is as if the body physically absent from the earlier scroll, *Torture of Women* (1974-76) – an unremittingly bleak cataloguing of the systematic infliction of pain but where the body is a function of narrativization rather than visualization – is now, appallingly, before us in an image of agonized vulnerability. As Elaine Scarry argues in *The Body in Pain*:

'*In both war and torture, the normal relation between body and voice is deconstructed and replaced by one in which the extremes of the hurt body and unanchored verbal assertions … are laid edge to edge. In each, a fiction is produced, a fiction that is a projected image of the body: the pain's reality is now the regime's reality*'.[16]

In *Codex Artaud* and *Homage to Ana Mendieta* we encounter the extremes of Spero's imaging of voice and body. In the *Codex* the modalities of voice are represented in a typographic cadenza of suffering and alienation, whereas, with Ana Mendieta, voice is the body. The most primitive and universal index of identity – the handprint – becomes the allegorical scraping of bloodied flesh down the wall surface, tracing a pattern of humiliation and despair.

The relation between individual suffering, social responsibility and regimes of power constantly provides a political framework for the work,

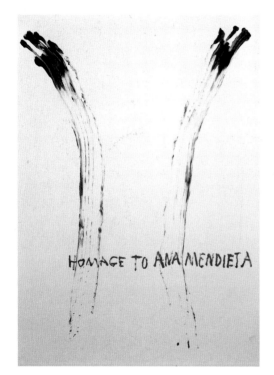

Homage to Ana Mendieta
1993
Ink on wall
Installation, Whitney Museum of
American Art, New York

reflected and transformed in the redemptive possibilities of liberated female bodies dispersed across symbolically charged, 'democratic' spaces. In *Torture of Women*, the *Brecht Ballad, Masha Bruskina* and in the recurrent iconography of oppression, Spero images the effects of instrumental reason and the structures of patriarchal domination upon the female body in its particularity and universality. In *Minima Moralia*, Adorno argues that the body after Auschwitz is stripped of sensation, reduced to an endless twilight zone of mere survival. There is no possibility of affirmation when pleasure is the commodification of the body, irrespective of qualification. Despite his political pessimism, Adorno still saw in the work of art's 'sensuous immediacy' the promise of redemption, of a utopian core that was a testament to another horizon of possibility.[17] Spero's most sustained imaginative exploration of the repressive and institutional effects of power upon the body – *Torture of Women* – places the anguished personal accounts of female victims from the prison houses of totalitarian regimes alongside a visual narrative of imaginary creatures and figures. Contrasting descriptive horror with this bestiary of fantastic and mythological figures, Spero introduces allegory as symbolic evidence of the capacity of the imagination to transcend the imprisoned body.

The features of *Torture of Women* – the uneven and broken accounts taken from the documents of Amnesty International typed on a bulletin typewriter, the collaged images combining found and adapted elements (for example, the Sumerian myth of Marduk and Tiamat; a fusion of an Egyptian hieroglyph with the three-headed serpent from

Codex Artaud; a photograph of an IRA fighter subtly altered to suggest a female persona) and the spacing between image and text – combine to create the signifying structure of each scroll. However, for the work to be fully 'textual', its sensuous immediacy must suggest another set of signifiers, an allegorical 'correspondence' between the particularity of aesthetic means and the readings those means set in train as interpretations the production of meaning in the interplay between the work and the world. In this and related works, Spero addresses pain as isolation – of the terrible aloneness of the tortured, the wounded, the dying. The space of the paper over which her narratives unfold becomes a protected space for the expression of the fears and desires prohibited by social convention: here truths can be stated. *Torture of Women* attests to the fact that, for some, to speak the truth is to risk everything. Each account, however, is also a testimony to resistance and survival. As the torturer seeks the negation of the self – the concentration of pain obliterates the capacity for representation, the world is the body in its most detailed and corporeal expression – the voice remains the sole extension of the self beyond the body. Space contracts to the limits of the body, or the body's limits expand to fill the infinite space; time is the eternal present and the distinction between interior and exterior dissolves. It is no longer language that speaks the subject; rather the subject collapses into the pure utterance – the cry or scream. But Spero's subjects do not collapse. As her first explicitly feminist work, *Torture of Women* is an art of witness, a stoic memorial to the violence and abuse done by men

Masha Bruskina/Gestapo Victim
1994
Handprinted and printed collage
48 x 66 cm

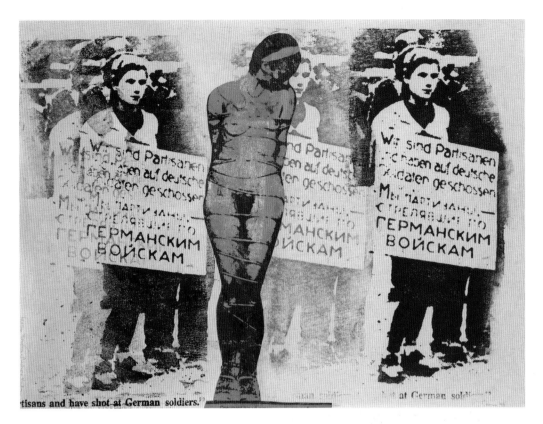

to women. Her art is a kind of surgery: it cuts to the bone and we are wounded by the image. Kafka wrote: 'I believe that we should only read those books which bite and stab us ... Books must be the axe to break the frozen sea within us'.[18] Spero's angry works bite and stab, but also offer a redemptive promise of healing and freedom.

Amongst her more recent scrolls, *Victimage*, a vertical diptych from 1990, provides one of her most relentless depictions of pain's objectification of the body. The left-hand panel contains a single, centrally positioned image derived from a Turkish illustration of the equivalent of a 'thumbscrew', only here a woman's breasts replace fingers. The adjoining panel combines a prostrate, manacled body derived from a French comic book, a porno-graphic picture of a bound, seated woman, legs splayed, and the torture victim from the *Brecht Ballad*. The starkness of the off-white paper ground offers no illusionistic space for the viewing eye to escape the content; we are voyeurs to a scene of explicit sexual violence. Space here is surely the absence of objects, of negation. When working out the functioning of the death instinct, Freud argued that, as the unconscious was ruled by the pleasure principle, there could be no represen-tation of death in the unconscious. Symbolization results from the fear of loss, of the psychic necessity to control absence and accommodate separation. Kristeva argues, in *Black Sun*, that if death is unrepresentable in the unconscious there must be another level of the psychic apparatus where it is registered, which is the imagination: 'Consequently, death reveals itself as such to the imaginative ability of the self in the isolation of signs ... The

self eroticizes and signifies the obsessive presence of Death by stamping with isolation, emptiness or absurd laughter its own imaginative assurance that keeps it alive, that is, anchored in the interplay of forms'.[19] In Spero's 'interplay of forms', the woman's body is the unbearable evidence of a loss which has to be denied — either through a reinvestment in another erotic object, or in the very real expression of a matricidal fantasy: the torture or obliteration of the maternal body. The various representational forms — cartoon illustration, naturalistic drawing, photographic documentation — trace the mime of cruelty from the real to the symbolic. In another small work from the following year, *Goddess Nut and Torture Victim* (1991), the double-narrative structure of *Torture of Women* (text and image: flesh and spirit) is condensed into an ideograph of maternal protection and solace. The contrast between the delicate linearity of the Sky Goddess arching over the flat, deep tonal block that encloses the recumbent victim

...torture was considered to produce probatio probatissimi, 'the proof of all proofs', and its practice was meticulously regulated and codified... the 'question' was divided into different degrees ordinary, extra ordinary, preparatory, and preliminary torture was administered in a special chamber by a civil servant who also served as the public executioner.

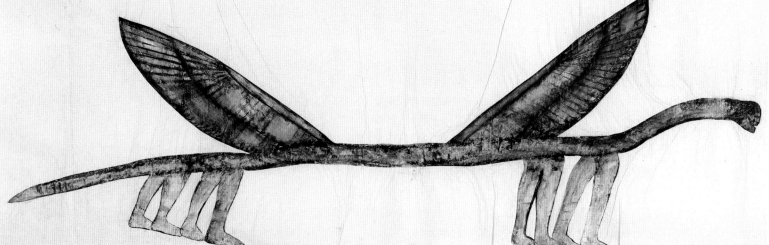

AT THEIR WORD THE WORD WHICH TORTURES THE SPIRIT
THE SICK WOMAN WAS TURNED INTO A CORPSE
THE CORPSE WAS HUNG FROM A STAKE

Torture of Women
(panels, *top to bottom,* III; IX;
XIII; *opposite,* XIV; X)
1976
Handpainting, typewriting,
collage on paper
14 panels, 51 × 3810 cm overall
Collection, National Gallery of Art,
Ottawa

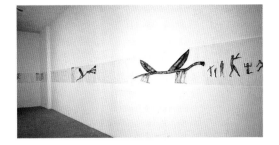

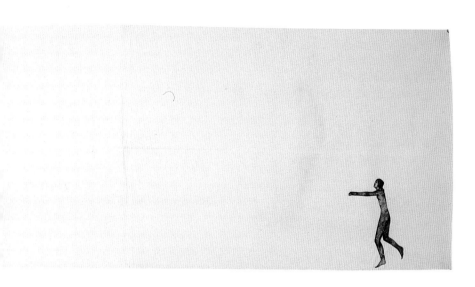

FASCIST PIG

KNIFE
CUT

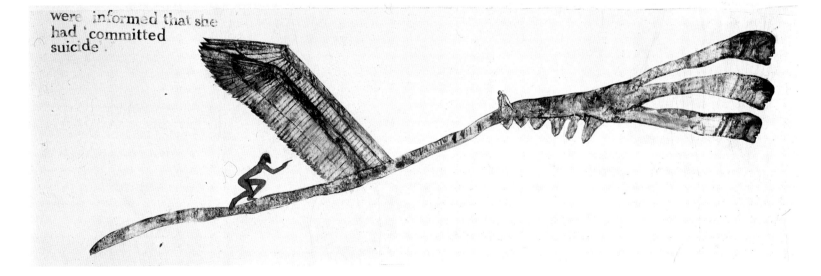

were informed that she
had 'committed
suicide'.

Goddess Nut and Torture Victim
1991
Handprinted and printed collage
on paper
50 × 62 cm

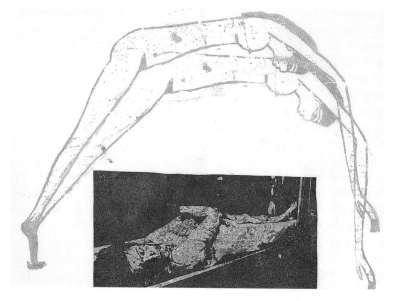

works as a formal equivalent for the values of space and light against darkness and containment. A dead body appears intermittently in Spero's work from the *War Series* to the installation at the Jewish Museum (1993), generally taken from a photosource of Holocaust victims, the Warsaw Ghetto, or the war in Vietnam. As the dancing body signifies life and plenitude across the scrolls, so these images of the isolation and finality of death provide evidence of an essential humanity. But we are always reminded of the power of the imagination to transcend the trapped body, of the possibility of being – otherwise.

Space – Vision – Work

Jon Bird: What about technique, did you feel that this was changing and developing?
Nancy Spero: Maybe, between Notes in Time *and* The First Language.
Bird: How would you characterize these changes?
Spero: I was beginning to work with an expansive concept of space. Not merely spreading out in space so that the viewer couldn't see everything at once, but the possibilities of peripheral vision as a disruption of a way of looking at art. I was very interested in doing something wild and different ... figures that couldn't be caught by the male gaze.[20]

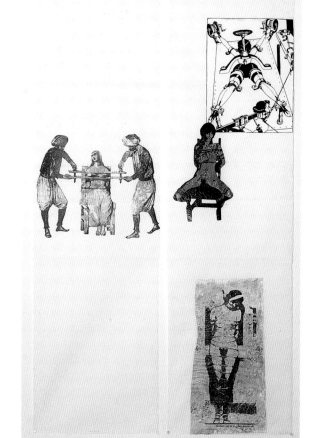

Victimage
1990
Handprinted and printed collage
on paper
Diptych, 210 × 51 cm each

'To perceive is first of all to perceive a figure against a ground'.[21]
Yve-Alain Bois

Figure/ground relations are of fundamental importance in Spero's work. Space signifies: it has narrative and formal value, it is bounded and architectural, or it is unbounded and suggestive of either the 'infinite' (the implication of endless extension as with some of the installations), or of the 'void' – the concept of inner space or the loss of the self threatened by the presence of the death drive. With the introduction of historically specific images or references, pictorial space also signifies the space of social relations. Formally, space becomes charged in the figure/ground and viewer/work relationships, either broken into the short repetitive or staccato-like phrases which serve to animate the gesticulating bodies, or as long intervals which function mimetically as stillness or silence: a pause in the narrative. Space, therefore, is both real and metaphorical. Often these spaces can best be described as 'liminal', spaces of ambiguity and ambivalence. Liminal space falls between the social spheres of the public and the private, the local and the global, economy and culture – in anthropological terms the spaces for ritual and rites of passage which depend upon the suspension of social codes and conventions for the exchange of meaning. Liminality, in this sense, can be connected with the notion of the 'carnivalesque', as another presence encouraging the inversion or suspension of normative behavioural and social patterns. Kristeva, reading Bakhtin, suggests that the carnivalesque is essentially dialogical: 'composed

of distances, relationships, analogies and non-exclusive oppositions'.[22]

Kristeva follows Bakhtin's study of Rabelais and the roots of the poetic word in carnivalesque discourse, producing a theory of poetic language as spatial, the articulation of thought through difference defined by the co-ordinates of writing subject, addressee and exterior text.[23] In this model, any word or unit expresses the literary structure of the text, links with other units across the text, and links to the cultural and historical pre-text, a relationship which, for Kristeva, redefines literary theory as the study of the text's 'intertextuality'. Bakhtin's tripartite model emphasized the role of the speaking subject open to historical and social forces and relations, arguing that the carnivalesque's absorption into language produces a text of ambivalence and multiplicity which transgresses formal linguistic and social codes. Kristeva suggests that the modern avant-garde novel is intertextual and is, in a sense, 'unreadable'. The key passage in Kristeva's essay presents the carnivalesque as an anarchic sub-text within official Western culture, rooted in the spectacular forms of popular culture. Essentially Dionysian, the structural relations of carnival – high and low, birth and agony, food and excrement, praise and curses, laughter and tears – reveal the underlying structure of the culture's unconscious, that is, sexuality and death. Kristeva distances carnival from the more common term used to describe the unsettling of official culture – 'parody' – which still functions within the law. Carnivalesque laughter is fundamentally rebellious and deeply serious, it inscribes the body as desiring and excessive, as the scene of pleasure (jouissance) against the regulating authority of the Law.[24]

The carnivalesque suggests one interpretive analogy for reading the semiotic activity across Spero's scrolls. However, the conceptualization of subject-object relations in the phenomenology of Maurice Merleau-Ponty provides an appropriate framework for considering the specificity of the figure/ground relationship and the place of the viewer in the circuit of meaning. For Merleau-Ponty, representations of spatiality and temporality are fundamentally linked to the body. The concept of external space is dependent upon our immanent corporeality, our sense of the body as the location and organizing principle for our relation to the external world. The dominant spatial structure of Western representation – fixed-point perspective – both recognizes and misrecognizes this embodied subject. Vision is prioritized over the body; detached and objectified, the seeing-subject is located and idealized, a position of power which produces a specific, gendered, representational field. Mieke Bal refers to the concept of vision as a site of danger in Freud's theory of the moment of castration anxiety – the recognition of the mother's 'lack': 'Clearly, then, the importance of visuality as the experience that generates castration anxiety is gender-related. For men would have a definite interest in controlling vision'.[25] A concept of space and figure/ground relations defined by an embodied subject denies the possessive impulse of traditional perspective, emphasizing instead the fragmentation and interaction between subject and object. Vision is, essentially, constituted through a visual field determined by a horizon and the relations of objects to that horizon and a

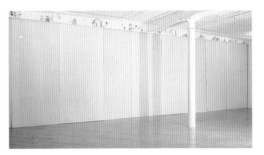

The Crowd
1991
Handprinting on walls
38 × 1463 cm
Installation, Josh Baer Gallery,
New York

L'Envol (detail)
1995
Handprinting on glass and walls
Installation, 'Femininmasculin –
Le sexe de l'art'
Centre Georges Pompidou, Paris

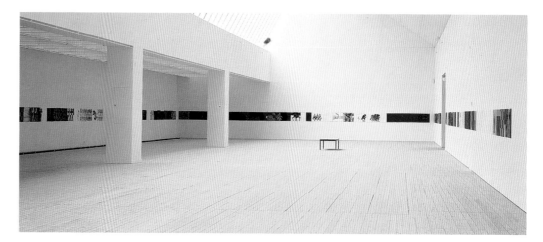

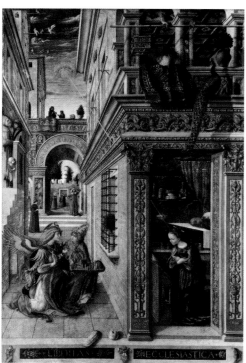

Carlo Crivelli
The Annunciation with St. Emidus
1486
Egg tempera on panel transfered
to canvas
207 × 146 cm

perceiving subject. The subject is implicated in a relation of seeing and being seen, a 'generalized visibility' which determines the optical field as relational rather than objectifying (with the voyeuristic connotations this implies). Body-image is, for Merleau-Ponty, the mediating term explaining the interaction between the embodied subject and the external world. I do not have a perspective on my own body in the way that I perceive other bodies, but I know its corporeal schema, its capacity, potential and limitations. (This is important in recognizing the 'autobiographical' as one of the pre-texts influencing the format and narrative structure of the work. Without over-privileging the signs of authorship, we can read the work for the trace of the subject – how corporeal experience (as symptom) for Spero comes to be figured as fantasy (symbol) in the work as an imaginary escape from that very corporeality that is so insistently present.)

The sense of the body's limits is formed in the early stages of childhood and Merleau-Ponty draws upon both Freud's and Lacan's accounts of the stages in the infant's development of a sense of space and location. As Elizabeth Grosz argues, Merleau-Ponty's foregrounding of the body-as-subject and rejection of the structuring binary oppositions of Western thought in favour of a third term, as the space between oppositional terms as a way of thinking the nature of perception, has been usefully related to a feminist critique of 'phallogocentrism' and the claim for the maternal as the repressed within philosophical discourse.[26] Experience for Merleau-Ponty is only comprehensible in the sense of a subject as an embodied, corporeal entity.

It is in these conceptualizations of space, vision, intertextuality and the body that the full radicality of Spero's formal and thematic structures can be addressed. In a sense they are combined in the notion of embodiment as the key motif in her work. This is not only the body as the semiotic imprint of the historical and contemporary experience of memory and oppression and the promise of utopian release; in the infinite variety and pliability of bodily gesture and movement and in the inscription of sexual difference upon the body can be read the expressive range of corporeal existence and psychic fantasy: of what it is, and might be like, to live, feel and dream as a woman.

In the scale and format of the scrolls and in the architectural expansiveness of the installations – their internal spatial divisions and figure/ground relations – the perceptual role of the viewer is made an explicit element within the aesthetic field. Despite their two-dimensional nature, there is something here of Minimalism's focus upon the phenomenological context of the viewing subject, the work and the institutional space as the structuring field for aesthetic meaning. Spero's interest

in the disruptive potential of peripheral vision is made manifest in the demands made upon the viewer by the scale, narrative flow and complex figure/ground relation of each work. Scale here is not to be confused with size – the actual dimensions of each scroll or installation (although with the latter, even size is a relative rather than a fixed term) – but is a function of the internal relations, linear, image-text or image-image, colour, density of surface, etc., and the external configuration: the space of the work and the work in space. For example, the magisterial *Black and the Red III*, installed in the Malmö Konsthall, Sweden (September-October, 1994) is first of all perceived as an overall division within the modernist architectural space of the museum; it is environmental in the manner in which it traverses all the gallery walls, thereby encompassing the viewer, locating the perceptual field and creating a visual horizon – a 'zip' in the otherwise unbroken wall surface. This artificial horizon line was established slightly below the normal eye-level which, in turn, skewed the relations of scale determined by the body in space. The airy interior of the Konsthall further reinforced the horizon-like quality of the installation as the division between earth and sky, the edge of the world as the transitional stage where, metaphorically, the narrative action of the scroll unfolds. (The movement is initiated with an isolated image of an ancient Indian tomb figure and then developed by a stylized group of Egyptian female musicians, a liminal space in which the Goddess and all the feminine deities and principles assist their earth-born sisters in reclaiming the body as a site of pleasure.) Areas of intense colour were

interrupted by the most subtle shades, occasionally fading into the overall surface, creating a rhythm and a beat, patterning the work as a whole. The experience was both spatial and durational, a relation of subject to object reflected in the internal relations and divisions.

Spero has always recycled her images and now has a lexicon of over three-hundred figures that forms the visual vocabulary from which she constructs her narratives. Towards the late 1980s she began increasingly to overprint the images and the grounds to produce densely and intricately worked surfaces suggesting texture and materiality. This process refers back to her obsessive reworking of her oil paintings in the late 1950s-early 1960s but disinvested of the historical tradition of the activity of painting. In the earlier scrolls, for example, *Notes in Time*, overprinting or sequential printing connoted bodily movement, a metaphorical expression of the body's vitality and freedom. In later works this can become an act of partial erasure; the image is made and then made again, then again, and so forth. But whereas the paintings, particularly the group of paintings she made while living in Paris and known as the Paris Black Paintings, tended towards a total obliteration of the image in the dense tonalities of the ground, the printed image retains the trace of its own genesis. Art-historical references are again suggested in the works of both Rauschenberg and Johns, for whom the trace functions as a primary aesthetic device. Spero's relationship to the major post-war avant-gardes has always been circumscribed by her personal history and aesthetic concerns. These include her training in the

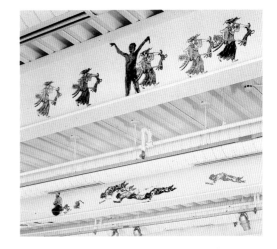

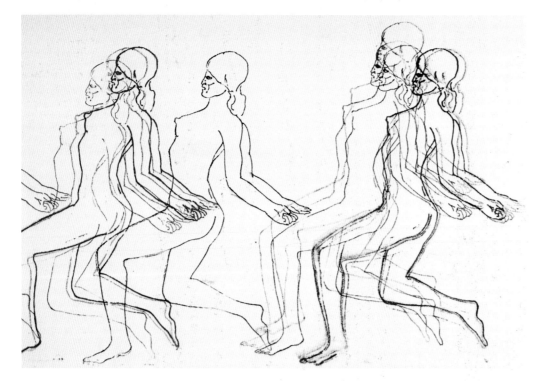

figurative tradition of Chicago artists, an interest in Jean Dubuffet (she and Golub recall hearing him speak when they were both students at the Art Institute) and frequent trips to study the ethnographic objects in the Field Museum. The collective cultural identity of the Chicago art world was also formed out of an antagonism to the hegemony of New York, a context which formed her own rejection of the dominant post-war movements of formalist Abstraction and Pop art. Add this to the experience of marginality as a woman artist and any trace of 'influence' has to be seen as a 'reaction formation'.

The importance of peripheral vision as a mode of looking invested with symbolic meanings transfers the subject/object relation from that

constructed by the 'gaze' – a disengaged and controlling act implying immobility – to the 'glance', a sideways and shifting scanning suggestive of movement and temporality. The dictionary defines the gaze as 'a steady or intent look; to stare'; whereas the glance is 'a swift oblique movement; also the flash or gleam' (*Shorter Oxford English Dictionary*).

Much has been made theoretically of the imperial and gendered history of the gaze. Norman Bryson describes the gaze and the glance as the two opposed modes of looking that define the historical relations between viewing subject and work of art. For Bryson 'the gaze of the painter arrests the flux of phenomena, contemplates the visual field from a vantage-point outside the modality of duration, in an eternal moment of disclosed presence',[27] whereas the glance implicates the viewer both temporally and corporeally. The glance is additive, made up from a multiplicity of momentary visual connections with the work which deny totality; in fact, the glance is a look that delights in a subversive delay which compromises the whole notion of a representation based primarily upon order and hierarchy. The dream of pure mimesis rests upon a denial of the body – to be lost in contemplation before a work that disguises the process of signification in an (imaginary) access to the 'real'. The glance reveals the process of looking as a process involving the viewer's active engagement with the work and thus open to its affective potential. In this respect, the glance might be seen to fulfil a carnivalesque role, creating a rupture in the visual field through which new meanings can enter.

Although I have been arguing that it is the

Notes in Time on Women (detail)
1979
Handprinting, gouache, collage
on paper
24 panels, 51 × 6398 cm overall

 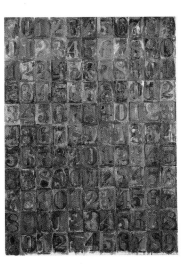

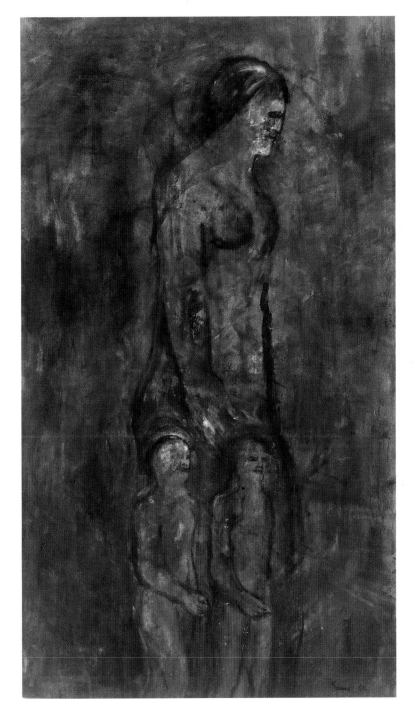

above

Jean Dubuffet
Métafisyx
1950
Oil on canvas
116 × 89 cm

Robert Rauschenberg
Factum II
1957
Combine painting
158 × 90 cm

Jasper Johns
Grey Numbers
1958
Oil on canvas
170 × 126 cm

left, **Mother and Children**
1962
Oil on canvas
195 × 110 cm

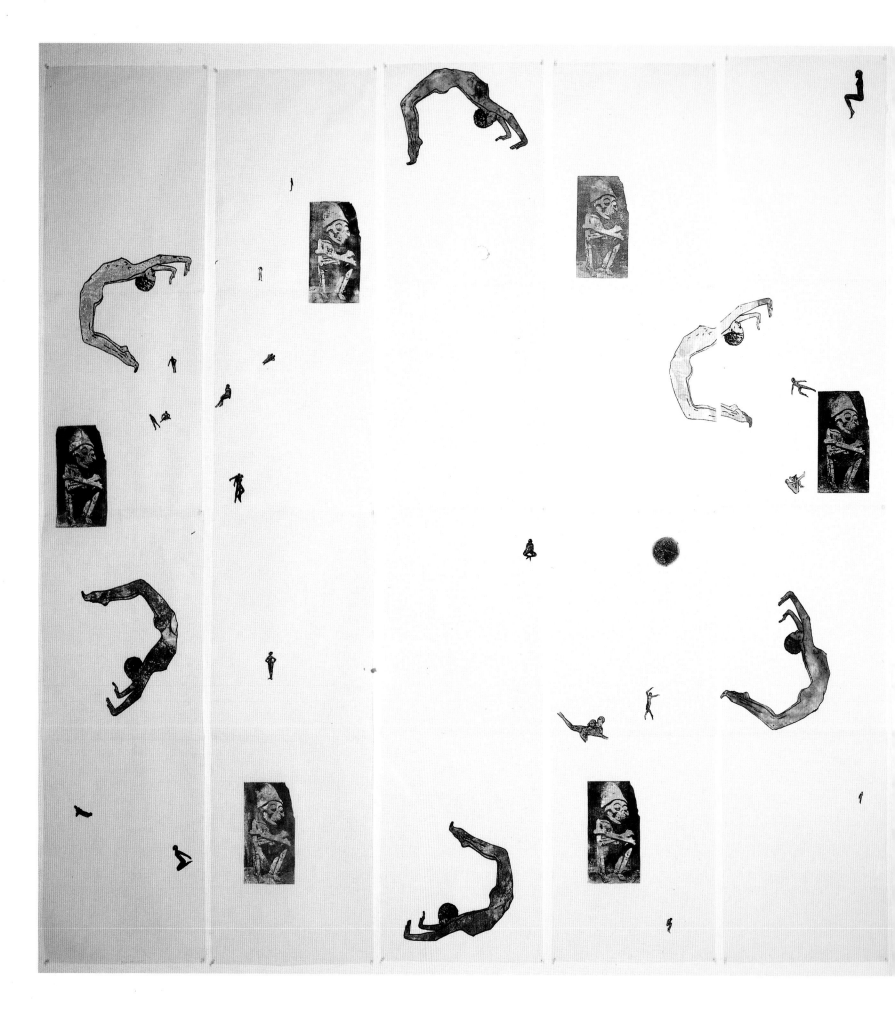

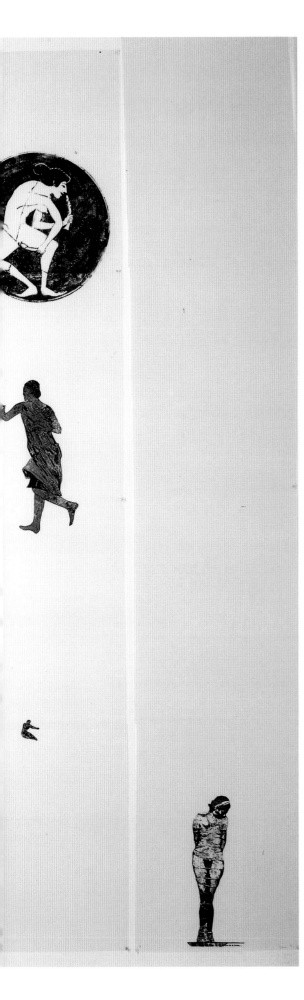

The Acrobat
1990
Handprinted and printed collage
on paper
7 panels, 279 × 386 cm overall
Collection, Smith College,
Northampton

extended horizontality of the scrolls that formally
constructs a different subject/object relation, the
glance is equally invoked in works that have a more
conventional overall format. In *The Acrobat* (1990)
the figures are dispersed across seven vertical
panels to create a centrifugal movement composed
of two alternating images – a female gymnast per-
forming a backwards flip taken from the pose of an
Egyptian acrobat on the temple at Carnak, and a
pre-Columbian carving of a crouching skeleton
with crossed arms. The two far right-hand panels
provide a counter to this rotational activity. Panel
VI bears one of Spero's most familiar images, her
adaptation of a fifth century BC Greek dildo dancer,
above a running figure. (Another autobiographical
reference is suggested in Spero's recollection of
how, in the period when she was first exhibiting
the scrolls unframed – simply push-pinned to the
gallery walls – she used to take her work to exhi-
bition rolled up and carried under her arm, an
image that metonymically connects with the dildo
dancers' action and the figure in *Notes in Time on
Women*, briskly walking along with a gigantic
phallus tucked under her arm.) On the final panel
the isolated image of the naked, bound woman
from the *Brecht Ballad* is positioned at the base of
the vertical strip of paper. Interspersed apparently
randomly across panels I – VI are tiny static and
dancing figures drawn from her lexicon of images
of the female body, a cross-referencing of narra-
tives from over a twenty-year period. The acrobat
presents a circular rhythm around a central space,
a flickering movement of action and repose – the
activity of dance, the stillness of death – arrested
at the periphery by a single figure reinforcing the

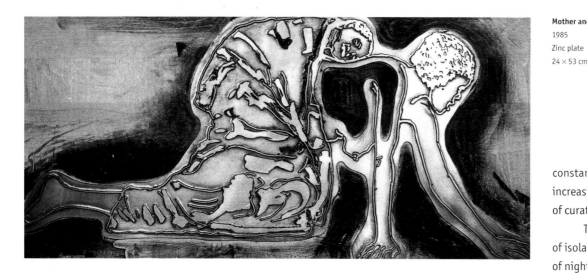

Mother and Child
1985
Zinc plate
24 × 53 cm

vertical. Symbolically, there is a lacuna in the visual field, a pictorial geometry that escapes the centring gaze and draws the viewer's eye towards the margin, while thematically, sexuality and death are the semiotic parameters of the corporeal body: the dildo dancer mocks the phallus, the acrobat denies the mortality of the body, but the body in pain attests to the persistence of the real.

The scrolls and installations are the result of a collaborative process, a working out and working through, enacted either in the studio or on-site. The debilitating effect of her arthritis makes the physical activity – the labour of work – almost impossible for Spero. However, her openness to dialogue and assistance during most of the stages of the work's realization is a process not simply born of necessity, but also the expression of a politics of engagement and community. Her feminism and long-term involvement with political groups and actions emphasizes the fundamentally social character of her practice, a commitment to change at the level of representation and social structure while all the time accepting their intimate relationship in the production of meaning. Similarly, the interplay between her practice and Leon Golub's is only partially registered in the thematic dialogue running through their work for over thirty years. What informs this exchange is a

constant, critically supportive discourse which is increasingly recognized publicly in the tendency of curators to exhibit them together.

The studio, then, is not the traditional space of isolation and seclusion (except during the hours of night when, since early on in their relationship when they first became parents, they have continued to work), but, rather, a site for collective activity: the productive apparatus for the making of work and the variety of tasks ensuing from the practice of two senior artists. 'Making' is a complex procedure which includes compiling the books and files of reference material; the 'appropriation' of imagery and its translation into the outline drawings which are then made into zinc or rubber plates; the preparation of the English handmade Bodleian paper into a standardized format of approximately 20 inch x 9 feet (51 x 274 cm) lengths; the roller-printing of backgrounds and images which are then cut-out and stockpiled, and the placing and re-placing of image on ground prior to the final fixing into position.

Spero: A lot of it is a visual play, the meanings that are generated by the individual figures and their juxtapositions – a matter of concept and sensibility. I really don't like to work with a total preconception of a finished piece, I find the process is very tense and exciting.

Bird: What determines when a work is finished?

Spero: It's a kind of logic, the visual look of it and the rhythm – the meaning it has for me.[28]

The final phase, the determination of image-placement – what makes the work in its particularity – is completed during the periods of quiet and relative solitude, usually late at night.

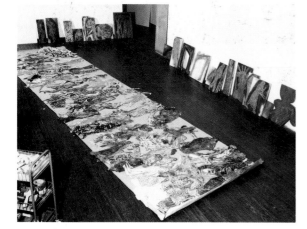

Nancy Spero's studio, zinc plates, cut-out and printed figures, New York, 1986

The studio is the location for a form of artistic production that is essentially performative: it is spatial, durational and staged, a series of discrete actions that together constitute the history of the work. A procedure is established, a ritual marked by the rhythm of bodies interacting in the process from conception to realization. The process itself is intertextual – from the initial stages of fabrication flow any number of visual narratives.

The surface on which these actions are inscribed is the horizontal – the floor is the ground for the preparation and organization of each scroll. (The floor is also significant for a crucial phase in the evolution of Golub's paintings – the scraping down and erasure of the image to produce the specific surface quality.) This is different for the installations, although in some cases the preliminary structure and relationships are determined in advance. Malmö, for example, was a combination of printing on paper completed in the studio, and wall-printing directly onto the walls of the museum. Making the work in this manner is to act within the paradigm of a certain kind of modernist painting, post-Pollock, signifying a physical relation to, and with, the work, and a scale determined by the architectural frame of the wall. The normal operation of the paradigm shifts the emphasis from the body in the horizontal plane, to vision – the eye – in the vertical. This movement – horizontal to vertical/ floor to wall – is a process of disembodiment, of the dominion of the spectacle over the corporeal. However, Spero's articulation of space within the pictorial field – the theme of embodiment – and the viewer/work relation imply not so much a sublimation of the corporeal in the optical as the projection of the body into the optical field.

Installations: Freeing the Body

Since completing her first installation – the 6-metre *Waterworks*, set in a 1930s water filtration plant in Toronto in 1988 – this has become a major aspect of her practice and the context for the realization of some of her most ambitious works to date. In general, the installations are temporary, although two have been permanent commissions: *To Soar III* in the Harold Washington Library, Chicago (1991), and *Premiere*, printed across the interior walls of the foyer of the Ronacher Theatre, Vienna (1993). (A third work, the *Brecht Ballad*, was intended as a temporary installation in Wuppertal, Germany, in 1991, but is still in place.) Two works have been made on the exterior of buildings: an image/text piece on a building in Derry, Northern Ireland, as part of the Four Cities Project (1989), and *Minerva, Sky Goddess, Madrid* on the roof and parapet of the Circulo de Bellas Artes (1991).

Mostly, then, the installations have been printed onto the interior walls and architectural surfaces of museums and galleries, cultural

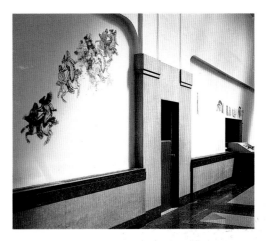

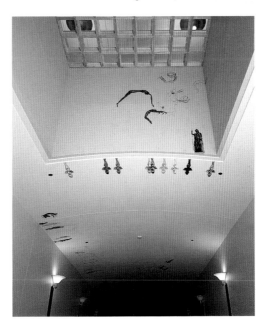

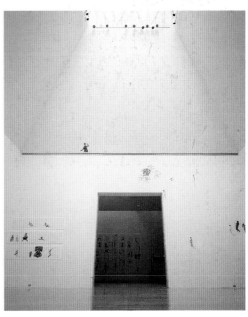

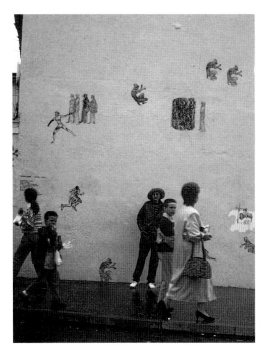

above left, **Westland/Blucher St.,**
Bogside
1990
Handprinting on wall
Installation, Derry, Northern
Ireland

above right, **Raise Time** (detail)
1995
Handprinting on walls
Installation, Sackler Museum,
Cambridge, Massachusetts

institutions whose primary ideological function is
the framing of objects and viewers within regimes
of visibility invested with historical and social
meanings. Into these spaces redolent of masculine
power and authority, from donor patrons to the
display of canonical works, Spero introduces a
miscellany of cavorting, running, leaping, sexual-
ized bodies, a feminine subversion of the dominant
order concealed behind the facades of cultural
tradition and hierarchy. Besides their narrative
intentions and the constant interplay between the
cultural text of the site and the metaphorical text
of the body, Spero's installations reveal the spaces
in which identities are produced and legitimized.
This was most evidently and problematically the
case with the Derry installation. There are few other

geographical regions where the politics of place
are so clearly and insistently the fabric of everyday
life and communal relations and oppositions, or
where the social is so evidently constituted through
spatiality. To make a mark or draw a line in social
space here is to express a politics, a religion, a
position for or against colonial history, a symbolic
identity. There is also, of course, a tradition of
political and sectarian visual semiotics transcribed
across the public arena laying claim to, or demar-
cating, territory. To cross a boundary was often to
venture from safety to danger in spatialities where
the relations between the real, the imaginary and
the symbolic were constantly shifting. Into this
over-determined context, Spero introduced a design
of repeated and dispersed historical and contem-

porary female figures: a caryatid, a crouching woman, a Hiroshima victim, an athletic running figure and the Celtic fertility goddess Sheela-na-gig. Included in this company were two site-specific images, one taken from a contemporary photograph of a Republican women's protest march over strip searches, and a poem by the Irish writer, Roisin Cowman. This intermingling of the past and the present, the mythological with the historically specific, victimage alongside resistance, sexuality and death, represented an allegorical map of the cultural forces and conflicts that are the narrative of Northern Ireland. Predictably, perhaps, allegory collided with the *realpolitik* of everyday life and Spero encountered a mixture of sympathetic support and hostile rejection.

Spero: I try to select images that might be appropriate for the situation. This was to honour the women of Derry, but there was so much anger. There was a small group who controlled this wall; they had claimed the territory and others in the neighbourhood would have liked to have painted murals because it was a really desirable wall. In Derry you can never be sensitive enough. How could I, as an outsider, really know how appropriate it was to do what I was doing?[29]

Issues of social space, institutional meaning and the production of knowledge have been at the centre of the now extensive critique of the museum.[30] Owing much to the work of Michel Foucault, this has produced a model of analysis which constructs the museum as a space for the production and legitimation of cultural 'master' narratives unfolding through the architectural and classificatory organization and presentation of selected objects, mostly to a passive audience. As a cultural arena, the museum claims for itself a democratic role; as a particular form of cultural capital it serves the interests and aspirations of a selective public – a structure which can be placed within a broader signifying system of social relations, cultural positions and political economies.[31] For Foucault, spatial metaphors were best able to express the relations between power and knowledge: 'Once knowledge can be analyzed in terms of region, domain, implantation, displacement, transposition, one is able to capture the process by which knowledge functions as a form of power and disseminates the effects of power'.[32] Into these spaces, Spero's installations introduce the issue of sexual difference, of the jouissance and abjection of the body, historical memory and fantasy, in allegories of freedom and transcendence.

Rebirth of Venus, installed on the upper walls and columns of the huge glass cupola of the Schirn Kunsthalle, Frankfurt (1989), was Spero's appropriation of a myth of origin to celebrate female sexuality and the maternal body as a site of pleasure. Venus was the Roman adaptation of the Greek goddess Aphrodite, whose name derived from the circumstances of her birth out of the sea (*aphros* is the Greek for 'foam'), of the moment of separation of Heaven and Earth. The embodiment of desire, attended and clothed by the Graces (Euphrosyne – 'joyous', Aglea – 'brilliance', and Thalia 'flowering'), Aphrodite offered the promise of a physical and spiritual pleasure that was both transgressive – of custom and tradition – and transformative. The daughter of Heaven and Sea, Aphrodite was, in many traditions, both first child

and the founding mother goddess. She was also the sign of an impossible desire, of the longing for the merging of heaven and earth, the re-union of what had to be separated for the world to begin. Predating but constitutive of the Greek, the Egyptian myth of origin has Isis and Osiris, two of the four children of the sky goddess, Nut, and the Earth God, Geb, lovers in their mother's womb. Catastrophically separated, Isis forever searches for her brother to restore their pre-natal unity. Osiris becomes the first king of Egypt, only to be incarcerated in a chest and floated down the Nile by his jealous brother, Seth. Wandering the length of the Nile, Isis eventually finds Osiris, who is revived by the beating of her wings. They merge and Isis conceives a son, Houros. But the cycle continues: Seth again finds and dismembers Osiris, scattering the fourteen parts of his body throughout the land. Finally Isis recovers all the pieces except the phallus, which Seth had thrown into the waters of the Nile where it was swallowed by a fish.

There are other variants to the myth of origin (for example, the Mesopotamian goddess Inanna-Ishtar, who presided over the civilizations of the early Bronze Age) but the key elements, the association of femininity, sexuality and fluidity, a quest, a lost or wounded body and the impossible longing for reunion, reach across the centuries and narrative traditions, describing a powerful fantasy of psychic desire. (In the psychoanalytic account, this longing for union is translated as the expression of an impossible mourning for the maternal object.) Spero is one of the few artists working today who seems to be able to intuit the hermeneutic value of the archaic, of how the

symbolic meaning of cultural myths and archetypes resonates with the structures of the unconscious and the role of fantasy in everyday life. (These connections are made explicit in *Myth* (1990), in which she combines ancient and contemporary representations of femininity across cultures, deconstructing sexual stereotypes as she recodes the female body as a signifier of presence and potential.) The oldest and most recurrent myth centres around the mystery of beginnings and the overdetermined roles played by real or imagined participants: gods and goddesses, or the tripartite relation of the Judeo-Christian tradition. In *The Interpretation of Dreams*, Freud argued that symbolism is a fantasying of the body and it is the work of culture to construct the symbolic relation – Sophocles' *Oedipus Rex* provides the narrative for the fantasy fundamental to our formation as subjects. Myths disguise and reveal; they possess the structure that, in Lacanian theory, also characterizes the linguistic basis of the unconscious – metaphor and metonymy, equivalent to the processes of condensation and displacement in Freud's account of the dream-work. Frequently 'dream-like' in their associative relations and representational diversity, Spero's narratives attest to the work of art as the creative imagination's capacity to sublimate a powerful and ultimately uncontrollable force – figured as the sexual/maternal body – into symbolic form.

The classical springtime ritual of bathing as the symbolic renewal of virginity is translated in the Judeo-Christian tradition into what Erich Neumann describes as the patriarchal sexualization of the feminine.[33] This is the Aphrodite who floats

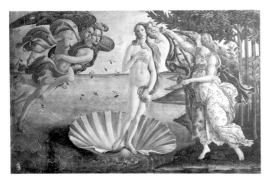

Sandro Botticelli
The Birth of Venus
c. 1485
Oil on canvas
172 × 278 cm

Myth
1990
Handprinted and printed collage
on paper
4 panels, 218 × 213 cm overall

upon the sea on a shell in Botticelli's painting *The Birth of Venus* (in Greek, the word for a scallop-shell, *kteis*, also meant the female genitals). Basing his interpretation upon the song of Demodonus in the Odyssey ('truly a wonder to behold'), which had been translated into Italian by the poet Poliziano in the fifteenth century, Botticelli's allegory, signifying innocence and sensuality, initiated a tradition of Western idealizations of the feminine, a fantasy of masculine desire. Kenneth Clark, never one to miss the opportunity for images of idealized femininity, describes Botticelli's Venus as: 'not at all the amorous strumpet of paganism, but pale and withdrawn ... his image of the Virgin Mary'.[34]

These myths and histories provide the cultural pre-text for Spero's interpretation of the mother goddess (a theme that first emerges in the Paris Black Paintings), a triumphant shattering of the passivity of the feminine in a narrative of active and eroticized bodies laying claim to a new identity. The actual space of the Kunsthalle, with its glass dome framing the sky, provides an equivalent architectural setting for the ritual of Aphrodite's birth – a metonymic connection that simultaneously severs the conventional associations of the maternal body with the ground plane, the Earth, and the order of nature. Aphrodite/ Venus, in Spero's recreation, is an athletic figure bursting through a headless and limbless Inuit fertility icon, to confront the viewer head-on. (In the scrolls, this much-repeated image directly confronts the viewer and illusionistically enters the viewing space. However, because of the height of this installation, all the viewer/work relations are redefined.) By juxtaposing an image from the early period of an ancient culture – a schematic rendering of the female torso – with her drawing based upon a modern olympic athlete, but sufficiently generalized to signify the active female body rather than the specific signs of culture, Spero metaphorically straddles the centuries to make an ideograph of female sexuality, not as 'lack' but as empowerment. The Graces accompanying Venus extend the associative chain in the direction of a rebellious celebration of difference as athletic, running figures and a line of dildo

following pages, **Rebirth of Venus**
1989
Handprinting on wall
Installation, 'Prospect '89', Schirn
Kunsthalle, Frankfurt

Premiere
1993
Handprinting on walls
Permanent installation, Ronacher
Theatre, Vienna

dancers project the movement away from the Goddess to encircle the dome. This horizontal rhythm is modulated by the appearance of Artemis, the great healer, above the line of figures, and the Celtic goddess of fertility and destruction, Sheela-na-gig, below. At the opposite point to Venus, a ferocious (carnivalesque) African fertility totem is printed four times, closing the circle. In the original source this was a male figure, but Spero has reascribed gender, the crude signs of difference imply the ambivalence of sexuality as both presence and absence, yet another graphic reminder that neither sex possesses the phallus. These elements are printed, isolated or in combinations, across the interior surfaces, creating surreal meetings of image to image and viewer to image around the architectural space. These imaginary configurations de-stabilize and eroticize the museum space as the orderly management of culture, introducing a disruptive semiotics of the body linking the archaic memory of the maternal with fantasies of sexual desire. The temporary nature of the museum installations also confounds the host institutions' imperative to conserve and protect. Implied in the activity of creative production is the moment of erasure; what is done will be undone, a symbolic return to a 'virgin' state: the unbroken expanse of the white gallery walls. In the most profound sense, Spero's figures refuse to know their place.

A very differently inflected Venus articulates the permanent installation *Premiere* in the foyer of the Ronacher Theatre, Vienna. The same fertility icon is now split by the figure of the black dancer Josephine Baker, whose raised arms appear to thrust the two halves of the image apart. A sky goddess bridges the sundered form while a second sky goddess, the mirror image of the first, hovers above, and the disembodied head of the dancer floats in space slightly to one side. Positioned directly above the ticket booth, this group provides the thematic and rhythmic focus of the work as a whole: a narrative which plays with the codes of gender, the 'exotic', and the performance of femininity as masquerade.

The Ronacher was originally a variety theatre and throughout its history was a location for popular rather than 'high' cultural pursuits. At the time of making the installation, the theatre had been closed for almost a decade for extensive renovation. The severe neo-Classicism of the foyer contrasts with a richly embellished baroque interior. Originally the relief columns creating the wall divisions in the foyer were free-standing, and the walls opened directly onto the street, an alighting place for carriages in the nineteenth and early twentieth century. The architect's restoration is an example of intertextual Postmodernism; the interior presents the audience with a series of historical and architectural references and enigmas with the blue of the infilled walls mimicking what was originally daylight. Spero has added to these playful contradictions her own spatial riddles and games, printing figures emerging from behind columns and running across and peering over architectural details, while the overall design emphasizes the ethereality of the walls in an ascending movement of figures from the performing arts, a heavenly cascade of mythological and historical reference and allusion. Pre-historic and

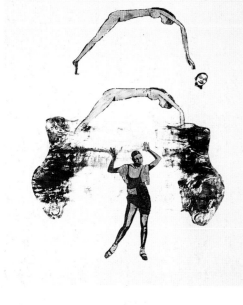

Premiere (detail)
1993

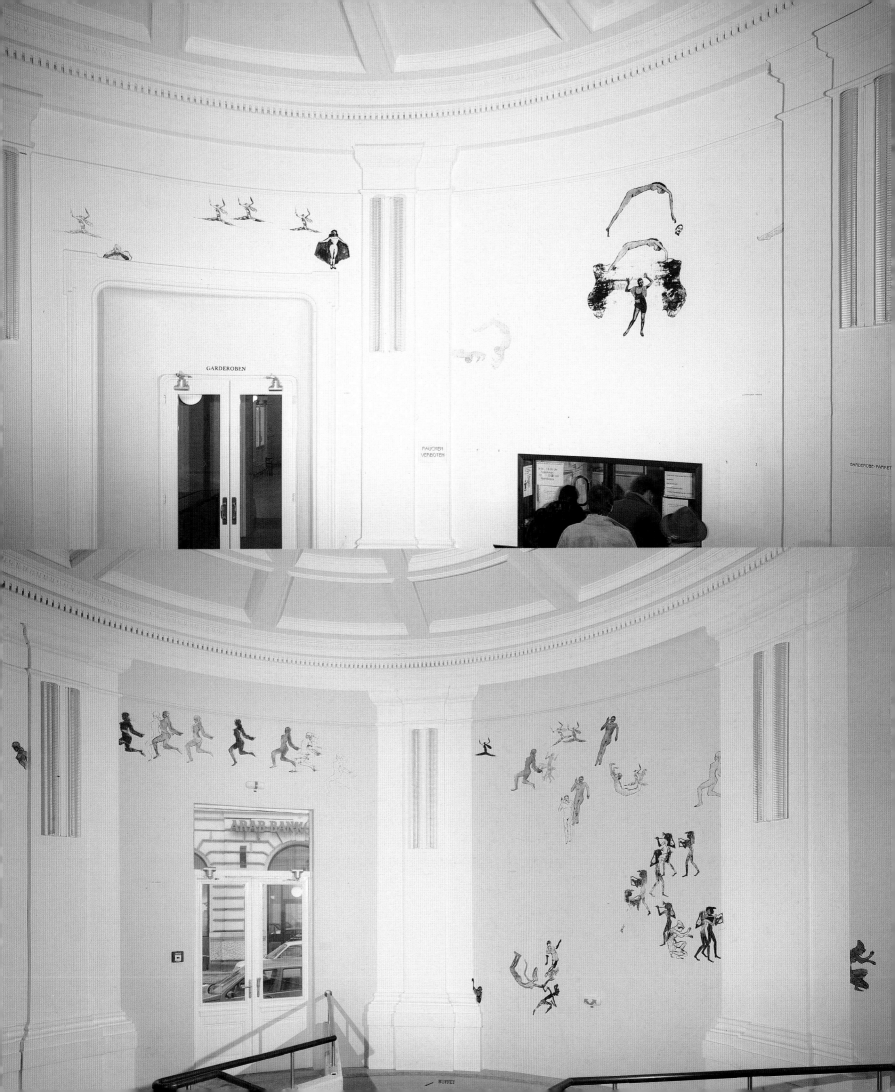

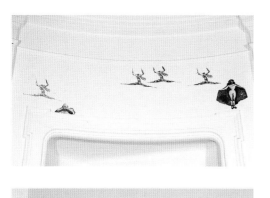

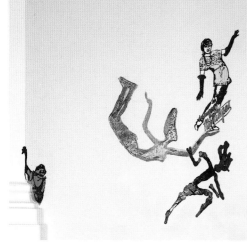

Premiere (details)
1993
Handprinting on walls
Permanent installation, Ronacher
Theatre, Vienna

Aboriginal dancing figures cavort, musicians from Egyptian tomb frescoes serenade, and acrobats and athletes leap and tumble across space, all intermingling with the real women who at one time or another, performed at the Ronacher. In these nuances of colour, line, form and space, Spero has created a work of extraordinary beauty. But, as with all her works, a reflexive glance introduces unsettling readings, a disturbance flickering across this seductively decorative arena.

Variety theatres and music halls were traditionally places for forms of popular entertainment that could, on occasion, become sites for the expression of class antagonism, or the carnivalesque rejection of social codes and conventions. The stage can be the mediating space between fantasy and reality where the class origins of the performer, the class and gender constitution of the audience, and the projection of desire and, particularly in relation to Josephine Baker, stereotypes of race and sexuality, circulate as constantly shifting signifiers creating uncertain and potentially transgressive meanings. Describing the contradictory exchange between singer, song and audience in Parisian clubs in the 1930s, particularly encoded in the performance of singers like Piaf or Mistinguett (who appeared at the Ronacher and is included in *Premiere*), Adrian Rifkin writes:

'But if the insult to "les gens du monde" *(society people) or* "de la haute" *is essential to the appeal of the song, it can also, with the singer's history, subtend a different articulation to a popular audience, who can read it as an insult made on their behalf, an expression of the relation of rich and poor, a widening of the gap in favour of the poor. In*

the music hall this must have been an element of Mistinguett's satin-covered vulgarity, that dressed up the "common" to banalize wealth, yet made just a spectacle of the often rather anti-bourgeois, slangy lyrics that were written for her'.[35]

Mistinguett appears in *Premiere* lightly attired in a short dress and long black gloves with her familiar signature cutting across the bottom of the figure. In this section Spero has created an imaginary tableau. Mistinguett is held in the palm of the hand of a somersaulting abstracted figure derived from an Egyptian acrobat, a bodily movement echoed in the third element – an impressionistically rendered Aboriginal shadow dancer. Just as the gold-leafed image of Josephine Baker refers to the goddess of *Rebirth of Venus*, so the signifiers link the acrobat's hand to the shell in the Botticelli painting, a connection visually reinforced by the positioning of Mistinguett's legs to mirror the stance of Venus/Aphrodite. In close proximity to this tableau, Spero plays visual games with the architecture as another black-gloved figure, Toulouse-Lautrec's drawing of the aging performer, Yvette Guilbert, appears from behind a false column, her gesture imaginatively substituting a theatre curtain for the column as she performs the action of opening the show. (Yvette Guilbert also appears as her younger self in another Toulouse-Lautrec illustration, peering over the mantlepiece.) In this detail the viewer is presented with a complex intertextuality of real and imagined characters, a *synecdoche* for the semiotic richness of Spero's work in general.

Toulouse-Lautrec's drawings and prints of Yvette Guilbert and other performers have become

key motifs in signifying one aspect of femininity within the modernist tradition: the spectacle of a sexualized and available Bacchanalian female body. This repetitive trope of male desire concealed the economic reality behind many female performers' turn to prostitution. Repressed male desire saturates the spaces and histories of the stage as the real and symbolic space for enacting myths of female sexuality. (Overdetermined in striptease, which acquires the status of performance the closer the act gets to narrative.) These spaces, in fact, function like myth, revealing and concealing, a structure reflected in Spero's play with figure/ground and architectural relations and semiotically dense images. For example, the gloves of Mistinguett and Yvette Guilbert are clearly fetishistic. Psychoanalytically, the fetish functions as the disavowal of sexual difference, of the covering-up of an absence with presence, connected by Freud to primary narcissism, the stage prior to symbolization and the separation of the subject from the mother. For Yvette Guilbert, the gloves, which had been an essential aspect of her masquerade, her representation of the feminine, become in Toulouse-Lautrec's iconography the sign of his identity.[36] Spero pictures Mistinguett with gloves, but also with her signature; she is body and language and, like all her co-performers, occupies a position in the narratives of women's history and desire: Spero insistently returns the body to women as the celebration of difference. Josephine Baker, Mistinguett, Yvette Guilbert, along with the other 'real' performers, Lilien Harvey, Loie Fuller, Otero, join their mythological counterparts in a carnivalesque celebration of archaic, instinctual and maternal territory. Her irreverent attitude to the signs of sexual difference makes the fetish function within a semiotics of the maternal body, sexual pleasure and language, which symbolically shifts from absence, or the psychic violence of separation, to an idea of freedom and fulfilment. *Premiere* gives back to the performers their performance; no longer the spectacularized body on display for another's gaze, they dance to a different tune.

La Peinture Féminine

Bird: Does the concept of 'la peinture féminine' *still apply to your work?*
Spero: I think it does. However, I do feel it's an uneasy formulation, not just applied to subject matter, but also the placement of myself and my categorization as an artist.[37]

Spero is not alone in her unease over a concept which has been linked with the exclusion of 'woman' from a language which structures sexuality in relation to the phallic term, offering the possibility of escape for the feminine through the archaic, maternal body. In her sympathetic critique of Kristeva, Jacqueline Rose has argued for the crucial role played by fantasy in the construction of psychic identity, while also recognizing the dangers inherent in the fantasies projected onto a body prior to entry into the symbolic order of language:

'And yet what could be a place without identity, other than a falling into the realm of the unnameable, body without language, a realm to which women have often and so oppressively been confined?'[38]

Spero's reference to a *peinture féminine* is adapted from Cixous' essay 'The Laugh of the Medusa', where she calls for a mode of writing – *l'écriture féminine* – derived from the difference of women's experience of sexual pleasure.[39] This is a practice of writing invested with spatial metaphor, allusion and intertextual reference, the inscription of a libidinal economy in the text. Writing the feminine is to occupy the spaces in between the dominant social and cultural discourses (Cixous uses the metaphors of 'flying' and 'stealing'), a form of textuality which is hybrid and heterogeneous. Cixous' phrase 'writing in milk' is not to be taken as a literal expression of the productivity of the maternal body, but rather as an attempt to find a symbolization for the repressed imaginary. In another essay, she writes: 'I would like to write like a painter. I would like to write like painting'.[40] In a sense, Spero paints like writing. In the narrative relations she constructs across the scrolls and installations, the body is inflected by different cultures, histories, mythologies and politics, traversed by different desires and forms of abuse: utopic and dystopic, fantasies of identity inescapably bound to the language of the body.

If her lexicon of trans-cultural and trans-historical images are the vocabulary for the scrolls, then colour, line and space are the grammar and syntax. There is an immense variety of graphic signs in the texture, linearity and colour relations, from the scratchy and metalicized figures and handprinted texts of *Codex Artaud*, to the magisterial unfolding of the heraldic *Black and the Red III*. There is a marked change in her expressive repertoire around the mid-1980s from relationships of

line, form and space contained within a limited and carefully controlled colour and tonal range, to an increasing emphasis upon overprinting of the figures onto strongly coloured and textured grounds. The chromatic rendering of the figure alternates between transparency and broken outline, connoting a kind of spectral and fleeting presence (I'm reminded of the title of a Milan Kundera book, *The Unbearable Lightness of Being*), to the almost palpable sense of the corporeal body defined in rich colours and contrasts tending towards the 'hotter' end of the spectrum.

Bird: What does colour mean for you?

Spero: I've thought about colour on and off for a number of years. Some years ago we were in Spain and saw some old banners in the museums, and the heraldic designs and contrasts stayed in my mind. With Black and the Red III, *I really wanted to transform the wall, to use colour to create a radical shift in the ground – something blatant and kind of vulgar that was eye-riveting … In the Malmö scroll I printed a dancing figure over a ground of red and black squares which effectively forces it away from the ground, so it's another way of playing with space delineated by colour.*[41]

Space, which signified as an element within the composition – as interval – or the absence of form suggesting rhythm and movement from the syncopation of dance to the infinite space of solitude, silence and death, becomes in the smaller works and *Black and the Red III*, identical with the picture plane as surface. In some examples, the illusionistic modulation of light breaking-up the printed surface creates the effect of low relief and material weight or mass. For example, *Sheela and*

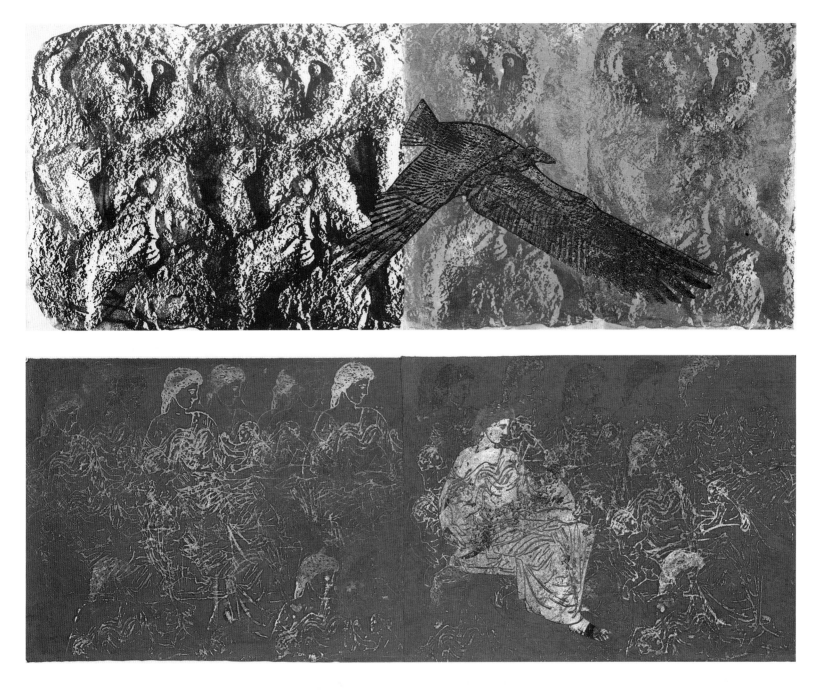

Vulture Goddess (1992) conjoins the Celtic symbol with the goddess of death and regeneration. Spero has printed a linear, winged form over the repeated image of Sheela derived from a rough stone carving of the medieval period, the edge of the print overlapping the paper's edge giving the appearance of weight and solidity to the flat surface, an effect further enhanced by colour-fading across the Sheelas from red to blue. Space is thus forced out of the picture plane, which reads as a surface for the inscription of the outlined vulture goddess.

A similar foregrounding of surface occurs with *Mother Italy* (1992). Thematically this is

Mother Italy
1992
Handprinted and printed collage
on paper
49 × 128 cm

another myth of origin: the founding of the city of Rome symbolized by the seated Roman mother goddess Cybele holding the infants Romulus and Remus, an image taken from the Alexander Tomb in Rome. Spero repetitively overprints the image onto a deep blue/black ground, a spidery tracing that fades and emerges, alternately defining the image and obscuring it in the dense lattice of linear and tonal contrast. The intricate and abstracted patterning of the surface is suggestive of fine lacework, although another reading could be chalk notations on a blackboard in a process of mark and erasure. Historically referencing the frescoed surfaces of classical villas, *Mother Italy* inscribes the maternal body upon a surface which functions as a *tabula rasa* for archaic memory.

Jewish Museum/Malmö Konsthall: Suffering and Redemption

'Even when there is nothing left but silence and the murmuring of despair, I believe there is still hope'.[42]
Hélène Cixous

Spero: The first time I really used colour as a background was at the Jewish Museum. I wanted to create a fiery section that would be a contemporary equivalent to the descent into hell, a ladder-like structure littered with bodies, with a hard-edged outline to contain it.[43]

In 1993 Spero was one of a number of artists invited to make an installation for the opening of the renovated Jewish Museum in New York. *The Ballad of Marie Sanders/Voices: Jewish Women in Time* (a title that combines a reference to two previous works, the *Brecht Ballad* and *Notes in Time on Women*) was a text and image installation that connected thematically with *Torture of Women* and other images of female victimage. The Brecht poem was complimented by a poem of the Noble Prize-winning Jewish poet, Nelly Sachs: 'That the Persecuted May Not Become the Persecutors'[44] and, running across the foot of

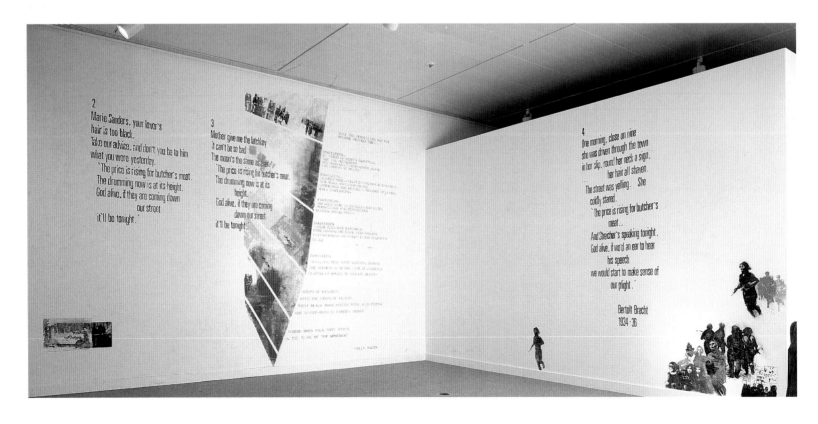

one wall, a phrase from the final stanza of a poem by the contemporary Jewish poet, Irene Klepfisz: 'Death Camp'. Interspersed with these texts were images of suffering, death and resistance: the bound woman with the *Brecht Ballad* and fragmented photo-images documenting Jewish women in history – victims of the Warsaw Ghetto and the concentration camps, women being arrested by Nazi soldiers, Israeli soldiers, a women's demonstration in Israel 'reclaiming the night', and Israeli and Palestinian women peace activists.

In her extraordinary meditation upon the vulnerability of the human body, Elaine Scarry argues that pain and the imagination are equally anomalous states. If pain is remarkable for being objectless, then the imagination is only realizable through its objects. Scarry turns to the Hebraic and Christian scriptures, and to the writings of Marx, to uncover the discursive framework of Western systems of belief and their material self-expression. Central to these theologies and epistemologies is a reflection upon the creative imagination's obsession with 'the relation between body and image, body and belief, body and artifact', and she continues:

'... the scriptural (exposes) with startling clarity the depth of moral and psychic categories that are eventually invested in material culture. To the question, "What is at stake in material making?", the Hebrew scriptures answer, "Everything"'.[45]

A Jewish theme appears sporadically throughout Spero's work, from explicit references to the Holocaust and the insignias of Nazism in the *War Series*, and the recurrence of scriptural iconography and the image of the Serpent, to

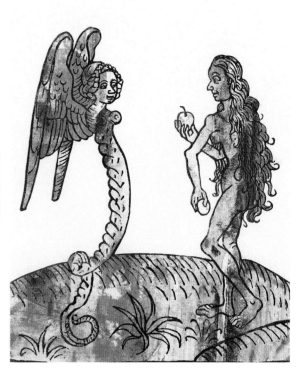

left, **Crematorium, Chimney and Victims**
1967
Gouache, ink on paper
91 × 61 cm

right, **Eve and Serpent/Death Figure/Woman and Madonna**
(detail)
1990
Handprinted collage on paper
51 × 279 cm
Collection, Vancouver Art Gallery

the various forms of the *Brecht Ballad*, and two installations – the Jewish Museum and Masha Bruskina for the 1993 Whitney Biennial. As Hélène Cixous has noted, an identity as woman and Jew creates a double exclusion or 'othering' from the dominant culture, and a particular vulnerability to the Law.[46] To read Spero's work reflexively, paying attention to the dialectical movement between the visual narratives of the scrolls and the cultural and historical (including art-historical) pre-texts, the textuality in the work and the image/viewer relation, is to recognize the 'other' in the work in a form of sacrilization of the body, a constitutive embodiment that encodes a fundamentally ethical relation to the world. The Jewish Museum installation returns to the theme of the voice as the body's witness, a literary and visual poetics documenting the continuity of oppression, and of the psychic necessity to confront separation, emptiness and death. Spread across three walls of a room in the museum, forming an enclosure, *The Ballad of Marie Sanders/Voices: Jewish Women in*

opposite and following pages,
The Ballad of Marie Sanders/
Voices: Jewish Women in Time
1993
Handprinting on walls
Installation, Jewish Museum,
New York

THAT THE PERSECUTED MAY NOT
BECOME PERSECUTORS

3

Mother give me the latchkey
it can't be so bad
The moon's the same as ever.
`The price is rising for butcher's meat.
The drumming now is at its
height.
God alive, if they are coming
down our street
it'll be tonight.´

FOOTSTEPS—
IN WHICH OF ECHO'S GROTTOES
ARE YOU PRESERVED,
YOU WHO ONCE PROPHESIED ALOUD
THE COMING OF DEATH?

FOOTSTEPS—
NEITHER BIRD—FLIGHT, INSPECTION OF ENTRAILS,
NOR MARS SWEATING BLOOD
CONFIRMED THE ORACLE'S MESSAGE OF DEATH—
ONLY FOOTSTEPS—

FOOTSTEPS—
AGE—OLD GAME OF HANGMAN AND VICTIM,
PERSECUTOR AND PERSECUTED,
HUNTER AND HUNTED—

FOOTSTEPS
WHICH TURN TIME RAVENOUS
EMBLAZONING THE HOUR WITH WOLVES
EXTINGUISHING THE FLIGHT IN THE FUGITIVE'S
BLOOD.

FOOTSTEPS
MEASURING TIME WITH SCREAMS, GROANS,
THE SEEPING OF BLOOD UNTIL IT CONGEALS.
HEAPING UP HOURS OF SWEATY DEATH—

STEPS OF HANGMEN
OVER THE STEPS OF VICTIMS,
WHAT BLACK MOON PULLED WITH SUCH TERROR
THE SWEEP-HAND IN EARTH'S ORBIT?

WHERE DOES YOUR NOTE SHRILL
IN THE MUSIC OF THE SPHERES?

NELLY SACHS

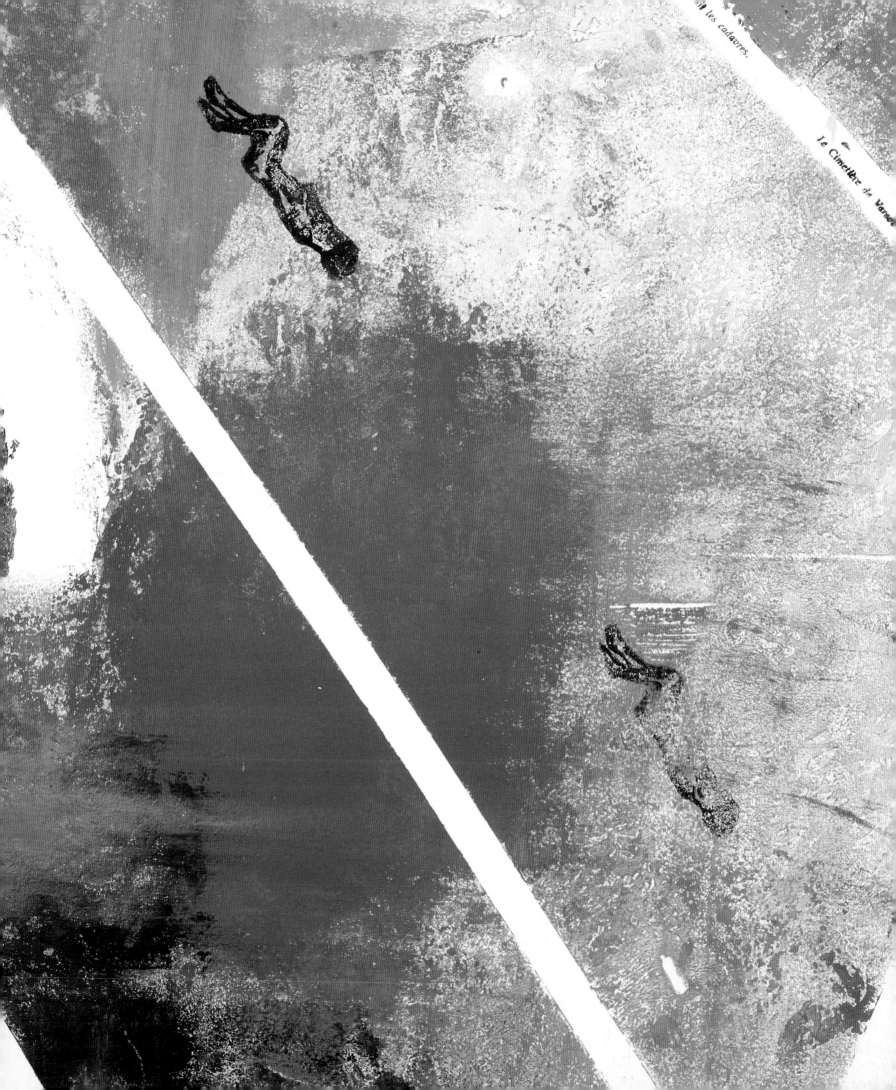

Time drew the viewer into a memorial space in which the complex image/text relations displaced any notion of a fixed or stable identity for the viewing subject; we are inscribed in these narratives as we are complicit with these histories. This is not a simple binary choice of guilt or innocence, but rather a matter of keeping the memory while recognizing the necessity to find a voice to express the inexpressible, even if this is articulated as tears, laughter or silence. In the loss of faith and certainty that envelops all Postmodernisms, Spero is exemplary amongst those artists (Golub is another) committed to the redemptive possibility of the work of art, of finding a signifying form for lost, erased or repressed meanings in the allegorical body.

The linguistic structure of each of the poems in the installation works to foreground the body in the text and the position of the reader/viewer. The 'meat' metaphor running through the *Ballad*, the repetitive stanza's signifying the sound of danger and the collective address interpellating the reader in the narrative, are echoed in the word, 'footsteps', which introduces each verse in the Sachs poem, the corporeal imagery, and the final lines' direct address to the reader/viewer. The third text, the concluding line from the Klepfisz poem, ' ... when I pressed through/ the chimney/ it was sunny/ and clear/ my smoke/ was distinct/ I rose quiet/ left her/ beneath', is a deeply sombre evocation of the body obliterated in the ovens of the concentration camps. In the process of reading these desperate and melancholy lines, we metaphorically become both victim and persecutor, an extreme instance of recognizing the other in the self. Complementing the poetic rhythm and imagery of the literary text, the visual narrative also makes demands upon the viewer — of reading vertically and horizontally, close-up and at a distance, standing and looking up, crouching to read the Klepfisz line and the double image that is positioned to conclude the poem visually. The isolated and overprinted figures traverse and emerge from an inconsistent spatial ground, defined either as surface for the roughly-textured 'fiery' printing of the central section, or as depth where the groups of figures illusionistically break the picture plane, advancing into the viewer's visual field. In the considered placing of image and text, space can also be read as emptiness, or negation. In the opening section (reading from left to right) containing the first verse of the *Ballad*, the body is a peripheral presence hanging in space beside the handprinted lines, the slumped head of the bound woman gazes down on the ominous words, 'it'll be tonight'. Continuing the direction of her gaze (a dead look) to the foot of the wall, it rests upon the words 'I rose quiet' and the grainy image of a street with what appears to be male onlookers on the scene of a presumably dead female figure above a text in French, *'Le Cimetière de Versovie se trouvait a l'exterieur du ghetto. Un service special collectait et brûlait les cadavres'*. This image abutts another grainy photo of a Nazi officer arresting a woman. The bound figure and the photo with the dead woman are both over-printed with a luminous yellow-gold.

The viewer's eye constantly shifts between word and image in a triangular movement following the Klepfisz line to the photo-image, then up to the Brecht poem and bound figure, a metonymy

of formal and cultural associations narrating an impossible suffering. The middle section contains Spero's contemporary version of a descent into hell, a fiery chevron broken into sections or stages that chromatically darken towards the base. Across these expressionistic colour-fields, bound together in stark geometrical divisions and edges, the corpses float in a regular and repetitive motion, gradually consumed in an apocalyptic vision of suffering and finality. As with previous works, however, Spero offsets despair with a kind of hope. The concluding line of the fourth verse of the Brecht poem, 'we would start to make sense of our plight', leads the viewer onto images of Jewish women's strength and collaborative resistance.

If the dominant theme of the Jewish Museum installation was the commemoration of the suffering body, with each event as the synecdochical (part for whole) expression of the historical circumstances of oppressive structures and regimes, then the Malmö installation completed the following year returned to the territory of cross-cultural myths and figures of fantasy in 'conversation' with real women. The narrative structure, then, moves from 'abjection' to 'jouissance', although it's never that clear cut, and a darker tone creeps into *Black and the Red III*. Primarily, however, this work is about colour – colour as formally defining pictorial space, as the visual equivalent to musical rhythm, as a symbolically charged sign for psychic states: desire, joy, pleasure and their correlates, anger, sadness and death. Spero juxtaposes colour and mass, transforming surface into volume, with a colour geometry that emphasizes flatness (the wall

plane) and frontality. Aggressively patterned, these conflictual renderings of pictorial space intensify the overall rhythmical and pulsational character of the work, adding recessional qualities – the push/pull effect of certain colour contrasts – to the lateral movement of colour and form. The historical references are to Heraldry and Minimal art, although it has always seemed to me that there is an oblique acknowledgement of the radical mixing of high and mass cultural references in the more subversive examples of Pop art in much of her work. As I have previously suggested, Spero's relationship to art historical and contemporary practice has been in the nature of a 'reaction formation'. Both Heraldry and Minimalism are closely associated with forms of masculine authority and identity, in the case of Heraldry an often excessive but rigidly ordered display of the insignia's of power through lineage and hierarchy. The grids, strict formal colour relations, scale, obsession with finish, order and repetition, characteristic of much Minimal art, have been taken as signifiers of a 'rhetoric of power', an art practice that is deeply invested in an externalization of the self as armoured body, controlled and controlling.[47] Spero adopts these tropes of masculine identity and represents them 'otherwise', as signs within her own narratives that change meanings and consistently undo the stereotype, 'display' finding its correspondence in feminine masquerade.

The performative aspect of *Black and the Red III* (the en-act-ment of the work, and the symbolic function of its narratives), continues the theme of masquerade in *Premiere* and other, previous works. Unlike the Ronacher installation,

**The Ballad of Marie Sanders/
Voices: Jewish Women in Time**
1993
Handprinting on walls
Installation, Jewish Museum,
New York

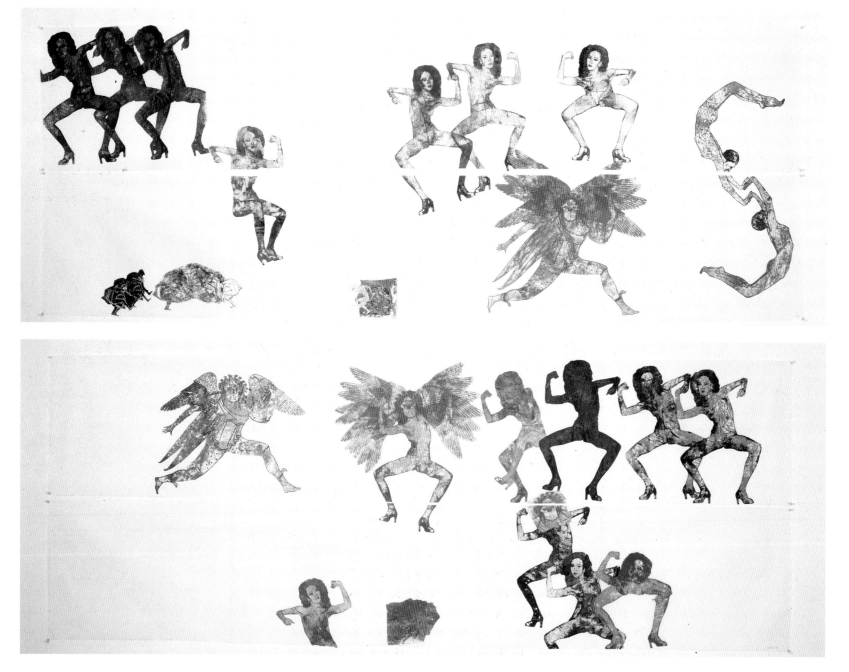

The Cabaret II
1993
Handprinted and printed collage
on paper
4 panels, 107 × 559 cm each

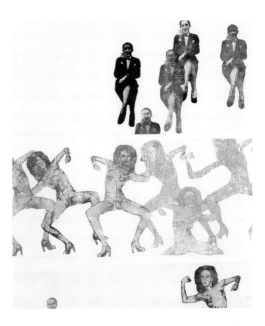

however, the movement is compressed into the extended horizontality of the scroll, over 60 metres in length. Specifically, this work is an amalgam of two previous works, *Black and the Red* of 1983 (remade in a larger and slightly altered version two years later) and *The Cabaret* (1991). The title and dominant colour relations derive from the patterning of Greek vase painting, and the novel by Stendhal *Le Rouge et le noir*. Another reference comes from mythology: in *The White Goddess*, Robert Graves describes the colours of the Mother Goddess as red, gold and black. The original *Black and the Red* interspersed two figures, an adapted dildo dancer and the Inuit fertility figure that reappears as Spero's reconceived Venus/Aphrodite. *The Cabaret* also has just two characters, an adapted Thai 'hospitality' woman refigured as a dancer, naked apart from high heels, legs akimbo and arms in a position mimicking the muscle-flexing of a body-builder (also in *The Cabaret II*), a celebratory and confrontational representation of the female body that confounds the stereotype of submissive 'oriental' femininity. Her companion similarly destabilizes sexual codes: a photo-image from the 1930s of a seated woman, smoking, formally attired in a black suit and with a severe hair style, the connotations of masculinity reinforcing the mobility of gender and the idea of femininity as masquerade. In the Malmö installation, this figure appears alongside that of Marlene Dietrich, a 'star' for whom the masquerade was an overdetermined signifier, an excessive display of femininity as a deliberate deriding of the objectifying male gaze. The photo Spero appropriates is one where Dietrich flaunts the signs of masculine gesture and attire; wearing a suit, cap and gloves she adopts a jaunty walk into the viewing space. Both figures look directly back at the viewer, implicating the viewing subject in a relation of seeing and being seen, a form of embodiment which occurs at other moments across the space.

The real, the imaginary and the symbolic are figured in the scrolls' conjoining of mythology and history. A familiar cast of characters parade across the vividly coloured and subtly modulated surfaces: Egyptian musicians and acrobats, classical figures and contemporary athletes, the Thai dancer and the dildo dancers. Less common or additional images include a classical figure in flowing drapes and graffiti photographed in a men's toilet in Germany that loosely resembles a fertility figure. Given the overall dimensions of the scroll, however, there is a relatively restricted range of images, repeated either singly or in groups across the work. Read conventionally (from left to right), the scene opens with a black and red checkerboard pattern which is then interrupted by an overprinted Indian tomb figure. An area of intense, flat red follows, broken by a band of off-white leading into a group of Egyptian musicians collaged onto a gold ground. A heraldic term, *mise en abyme*, used in literary studies to mean signs that are simultaneously details and signifiers of the work as a whole, appropriately describes the structure of *Black and the Red III*. In any section we perceive both detail and totality, not as an example of an additive logic – the sum of parts – but, rather, as an episodic bricolage of meaning and reference. The directional impulse of the

The Cabaret (detail)
1991
Handprinted collage on paper
51 × 1118 cm

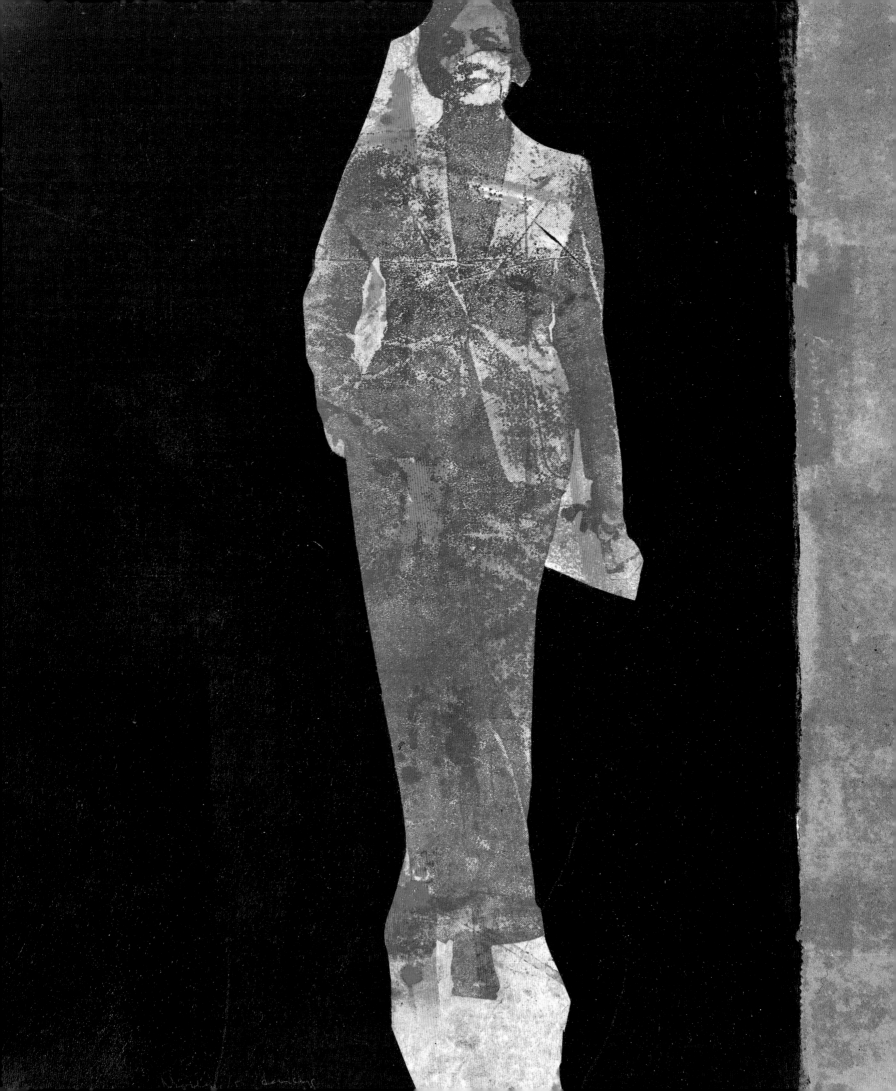

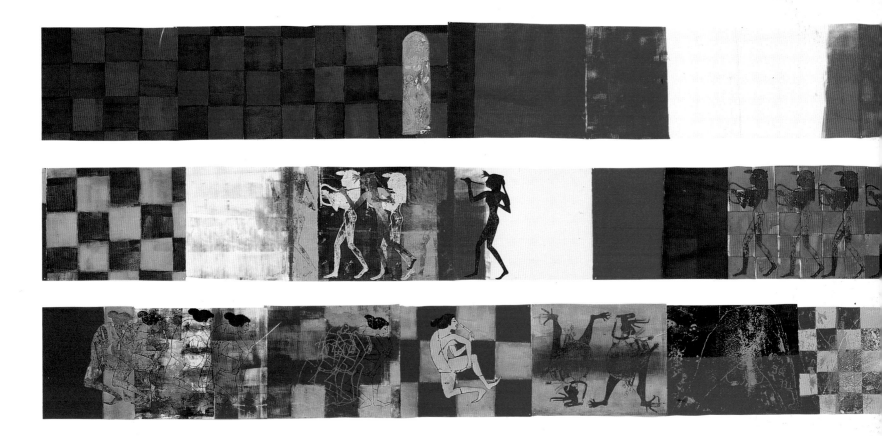

viewer is confounded at various stages by a counter-movement within the scroll and the invitation to retrace our steps, to move up close, to study a detail, or to retreat to consider figure/ ground or colour/field relationships as a whole.

An important aspect of the work's textuality is located in the complex relations between colour and form – image and ground. The areas of pure colour and abstract geometrical patterning abandon representation – the paradigm of Greenbergian Modernism – only to have this immediately contradicted, as colour and form proceed to signify as narrational and representational elements, colour describing form or invested with symbolic value: its iconographical meanings. In the variety of formal and figural relations traversing *Black and the Red III*, and in the interactive tension between viewer and work, there is a metaphorics of the body, of reading the work for the trace of the feminine body's passion

or jouissance. As I noted earlier, Merleau-Ponty's rejection of binary oppositions and centring of the body in the perceptual process suggested a way of interpreting the figure/ground and viewer/work relationships in terms of embodiment. This refers back to the formative stages in the subject's self-definition as occupying space and in relation to the object world. In the theories of some feminist critics, this relation recedes before birth to the interior experience of the amniotic fluid in the womb. Luce Irigaray argues that this period of fusion and fluidity, of closeness without boundaries, is the condition of vision, a tactile experience which structures entry into the world of colour, shape and texture: '(Colour) imposes itself upon me as a recall of what is most archaic in me, the fluid … Colour resuscitates, in me, the whole of anterior life'.[48] Kristeva also links colour to the instinctual drives, although for her it condenses 'narcissistic eroticism and the death drive'.[49]

Black and the Red III (panels I, III, IV)
1994
Handprinted and printed collage on paper
22 panels, 50 × 5395 cm overall
Installation, Malmö Konsthall, Sweden

Marlene and Dancers (detail)
1994
Handprinted and printed collage on paper
50 × 244 cm

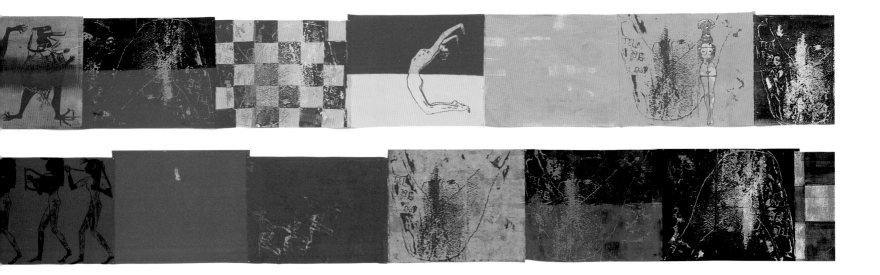

Although she is careful to relate the specific use of colour (in a discussion of Giotto's cycle of frescoes at Padua) as a pictorial device to the historical and formal system in which it operates, she nevertheless argues that colour is less subject to censorship, its 'freedom' is, therefore, potentially subversive. Colour is the means of escape from the Law, evidenced in the constant opposition between line and colour running throughout the history of Western aesthetics, with colour as the secondary or excluded term.[50] Following this line of argument, if we live our sexual bodies through cultural representations, then the historical marginalization of colour, or its strict disciplining within a regime of formal relations and the picture plane, suggests that what is again being repressed is the sexual and maternal body.

The carnivalesque celebration of colour and form, movement and gesture, defines Spero's imaging of the female body's pleasure and desire, just as the same devices, inflected differently, can be made to signify the body's abjection. The sexual and maternal body is brought into representation as the symbolic expression of interior states and fantasies through the reworking of cultural myths and historical memories. For example, a strange crouching figure, half-woman and half-horse

(which originally appeared in *The First Language*), enclosed by contrasting colour areas which bisect the figure and compress the space, suggests mythologies of human/animal hybrids (even Shakespearian analogies – Bottom wearing an ass's head), and signifies 'entrapment', of inhabiting a body that is distorted through language and representation. But 'hybridity' also suggests a way of escaping fixed cultural meanings and identities, of difference positively articulated or, as in other scenes and narratives, transformed into liberatory action accompanied by the music of time. Another section shows an acrobatically arched figure on a red and yellow ground. (Spero extracts considerable signifying potential from each individual image by simply varying the position of the figure on the paper, at times turning them through a 360-degree rotation.) Abutting on one side is a red and silver checkerboard overprinted with a graffitied image depicting a crude female 'beaver shot', which is then repeated, printed onto a red and black ground. On the other side of the acrobat is more of the same, but interrupted by a fetishistic, bound figure wearing an elaborate headdress. Surrounded by these representations of the fragmented, objectified and helpless female form,

opposite and below, **Black and the Red III**
1994
Handprinted and printed collage
on paper
22 panels, 50 × 5395 cm overall
Installation, Malmö Konsthall,
Sweden

opposite, bottom, **Giotto**
Arena Chapel
1306
Fresco
Padua

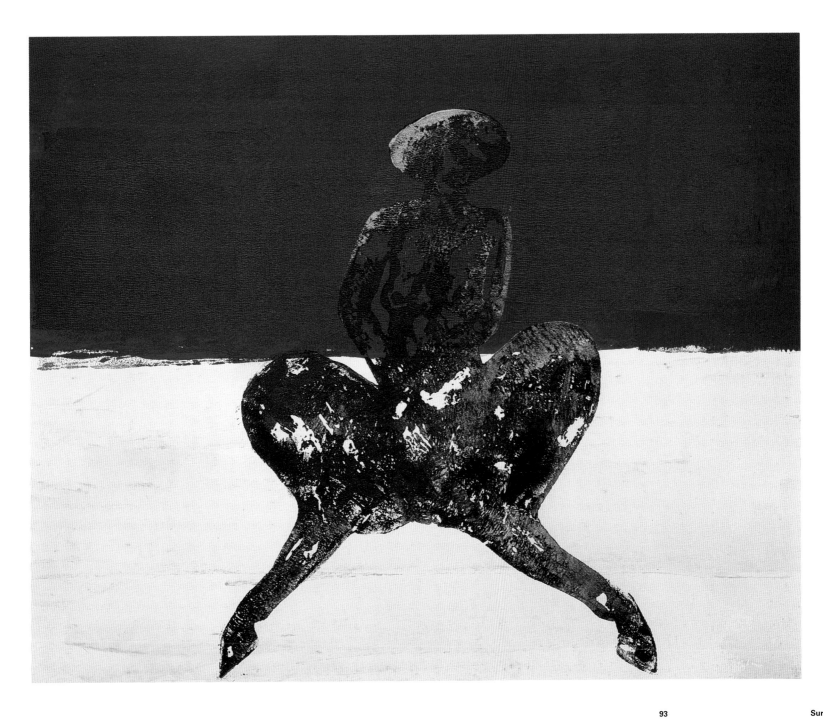

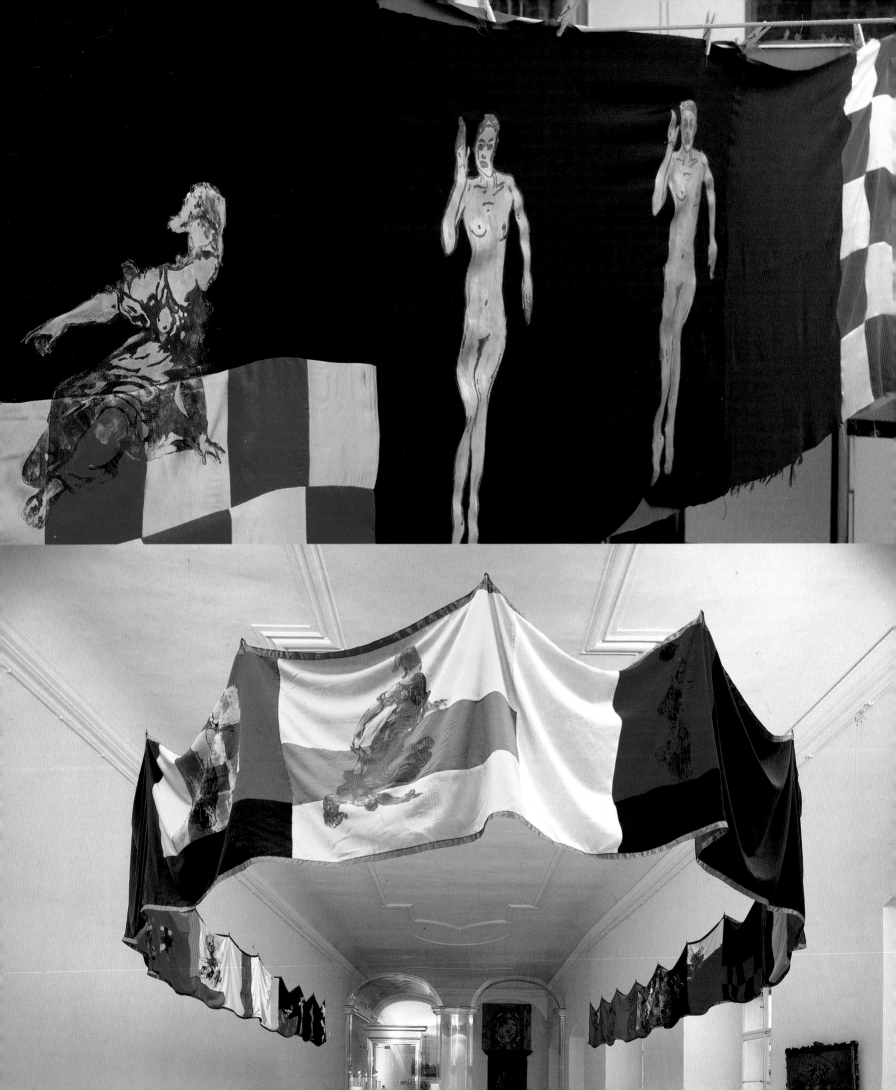

reduced in the graffitied rendering to the most basic anatomical signifiers of sexual difference, the upbeat colour contrasts and gracefully active figures metaphorically break this repressive regime. Against the sexism of male toilet graffiti (the most debased expression of male desire), Spero poses the libidinal female body free from physical restraint, an irreverent 'up yours!' to the representational system that represses fear of the feminine in fetishistic or misogynistic disavowal.

Spero offers the viewer contrasting discourses of the body, on the one hand constricted according to the prevailing exigencies of power, on the other, a vision of empowerment. Both, of course, are cultural constructions marked by historical and social relations, but Spero's imaging of the female body as multiplicity and heterogeneity, pleasure and plenitude, attests to the limits of our conceptualizations and the necessity to imagine otherwise. If this is utopian, then it is projected from the discipline of skills, craft and technique, the acknowledgement of history and historical circumstance, the power of fantasy and the body's capacity for symbolic expression: an extraordinary creative imagination at work and play in the archives, memories and experiences of the culture, remaking in order to be, but differently.

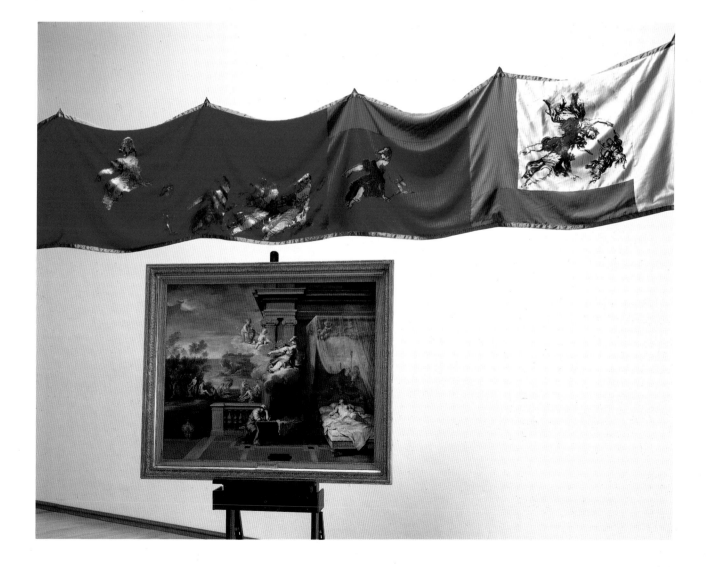

1 Hélène Cixous, 'Akhmatova', Verena Andermatt Conley, *Hélène Cixous: Writing the Feminine*, University of Nebraska Press, Lincoln and London, 1984

2 Julia Kristeva, 'Psychoanalysis and the Polis', trans. Margaret Waller, *Critical Inquiry 9*, September 1982, University of Chicago Press, pp. 77–92

3 Mieke Bal, *Reading Rembrandt: Beyond the Word-Image Opposition*, Cambridge University Press, 1991, p. 19

4 Jacques Lacan, 'Guiding Remarks for a Congress on Feminine Sexuality', *Feminine Sexuality: Jacques Lacan and the école freudienne*, ed. Juliet Mitchell and Jacqueline Rose, Macmillan, London, 1982, p. 89

5 Julia Kristeva, *Desire in Language: A Semiotic Approach to Literature and Art*, ed. Leon S Roudiez, trans. Thomas Gora, Alice Jardine and Leon S Roudiez, Blackwell, Oxford, 1980, p. 286

6 Julia Kristeva, op. cit., p. 142

7 Hélène Cixous, 'The Body in the Text', *The Body and the Text: Hélène Cixous, Reading and Teaching*, ed. Helen Wilcox, Keith McWalters, Ann Thompson and Linda R. Williams, Harvester/Wheatsheaf, UK, 1990, p. 19

8 Jacqueline Rose, *Sexuality in the Field of Vision*, Verso, London, 1986, p. 62

9 Anne Baring and Jules Cashford, *The Myth of the Goddess: Evolution of an Image, Arkana*, Penguin, London, 1993

10 Shorter Oxford English Dictionary

11 Jacques Lacan, 'Les formations de l'inconscient' (Seminars 1956–7), Anika Lemaire, *Jacques Lacan*, trans. David Macey, Routledge & Kegan Paul, London, 1977, p. 83

12 Mieke Bal, 'Sexuality, Sin and Sorrow: The Emergence of Female Character (A Reading of Genesis 1-3)', *The Female Body in Western Culture: Contemporary Perspectives*, ed. Susan Rudin Suleiman, Harvard University Press, Cambridge, Massachusetts, 1986

13 Ibid., pp. 323–24

14 Ibid., p. 324

15 The definition I am using is the one given in the introduction to *Desire in Language*: ' … total joy or ecstasy … also, through the working of the signifier, this implies the presence of meaning … requiring it by going beyond it', Kristeva, op. cit., pp. 15–16

16 Elaine Scarry, *The Body in Pain: The Making and Unmaking of the World*, Oxford University Press, 1985, p. 143

17 Theodor Adorno, *Minima Moralia: Reflections from a Damaged Life*, trans. E.F.N. Jephcott, New Left Books, London, 1974

18 Franz Kafka, 'Lettre a Polack', *Correspondence*, 1904

19 Julia Kristeva, *Black Sun: Depression and Melancholia*, trans. Leon S. Roudiez, Columbia University Press, New York, 1989, p. 138

20 Nancy Spero in conversation with the author, Spring 1994

21 Yve-Alain Bois, *Painting as Model*, MIT Press, Cambridge, Massachusetts, 1990

22 Julia Kristeva, *Desire in Language*, op. cit., p. 78. Carol Duncan also uses the concept of 'liminal space' in her analysis of the museum as the site for a ritual exchange between the citizen/subject and the state. See Carol Duncan, *Civilizing Rituals: Inside Public Art Museums*, Routledge, London, 1995

23 Mikhail Bakhtin, *Rabelais and His World*, trans. Helen Iswolsky, MIT Press, Cambridge, Massachusetts, 1968. Julia Kristeva, 'Word, Dialogue and Novel', op. cit., pp. 64–89

24 Julia Kristeva, ibid.

25 Mieke Bal, op. cit., p. 288

26 'Phallogocentrism' conflates 'phallocentrism' with 'logocentrism': the privileging of the phallus as the symbol of power and the 'logos' (Derrida) – the Western philosophical tradition that privileges the Word as metaphysical presence. For a discussion of Merleau-Ponty and feminist critiques see Elizabeth Grosz, *Volatile Bodies: Towards a Corporeal Feminism*, Indiana University Press, Bloomington and Indianapolis, 1994, pp. 86–111

27 Norman Bryson, *Vision and Painting: The Logic of the Gaze*, Macmillan, London, 1983, p. 94

28 Nancy Spero in conversation with the author, Spring 1994

29 Nancy Spero in conversation with the author, Spring 1994

30 Besides the Carol Duncan book already cited, see Eileen Hooper-

Greenhill, *Museums and the Shaping of Knowledge*, Routledge,
London, 1992; Douglas Crimp, *On the Museum's Ruins*, MIT Press,
Cambridge, Massachusetts, 1993; *Museum Culture: Histories,
Discourses, Spectacles*, ed. Daniel J Sherman and Irit Rogoff,
Routledge, London, 1994

31 The most thorough analysis of the production and consumption of
art has been conducted by Pierre Bourdieu in *Distinction: A Social
Critique of the Judgement of Taste*, Cambridge, Massachusetts, 1984
and Bourdieu, Alain Darbel et al., *The Love of Art: European Art
Museums and Their Public*, Stanford University Press, California, 1990

32 *Power/Knowledge: Selected Interviews and Other Writings
1972–1977*, ed. C. Gordon, Pantheon, New York, 1980, p. 69

33 Erich Neumann, *The Great Mother*, trans. Ralph Mannheim, *Bollington
Series*, XLVII, Princeton University Press, New Jersey, 1955, p. 145

34 Kenneth Clark, *Civilization*, Pelican, London, 1982, p. 86

35 Adrian Rifkin, 'Musical Moments', *Yale French Studies*, no 73,
'Everyday Life', Yale University Press, New Haven, 1987, p. 135

36 Freud discusses 'fetishism' in relation to the work of art in his paper
'Leonardo da Vinci and a Memory of His Childhood', 1910, trans.
Alan Tyson, Standard Edition, vol 11, pp. 59–137, and specifically in
'Fetishism', 1927, Standard Edition vol 21, pp. 147–154. Adrian Rifkin
discusses Yvette Guilbert in his *Street Noises: Parisian Pleasure*,
Manchester University Press, 1993. Lautrec's imagery is discussed
by Griselda Pollock in her forthcoming *Differencing the Canon*,
Routledge, London, 1996

37 Nancy Spero in conversation with the author, Spring 1994

38 Jacqueline Rose, op. cit., p. 160

39 Hélène Cixous, 'The Laugh of the Medusa', trans. K and P Cohen, ed.
Elaine Marks and Isabelle de Courtivron, *New French Feminisms*,
Harvester, Brighton, 1980, pp. 254–64

40 Hélène Cixous's essay 'La dernier tableau ou le portrait de Dieu' is
discussed by Morag Shiach in *Hélène Cixous: A Politics of Writing*,
Routledge, London, 1991, p. 34

41 Nancy Spero in conversation with the author, Spring 1994

42 Hélène Cixous, quoted in ed. Susan Sellers, *Writing Differences:
Readings from the Seminar of Hélène Cixous*, Oxford University Press,
1988, p. 150

43 Nancy Spero in conversation with the author, Spring 1994

44 Nelly Sachs, *O The Chimneys*, Farrar, Strauss and Giroux, New York,
1967

45 Elaine Scarry, op. cit., pp. 179–85

46 Morag Shiach, op. cit., p. 26

47 See, for example, Anna C. Chave, 'Minimalism and the Rhetoric of
Power', *Arts Magazine*, New York, No 5, January 1990, pp. 44–63

48 Elizabeth Grosz, op. cit., p. 105

49 Julia Kristeva, 'Giotto's Joy', *Desire in Language*, op. cit., p. 219

50 Colour as secondary or supplementary in Western aesthetics is
discussed by Yve-Alain Bois, writing on Matisse in *Painting as Model*.
He mentions Jean-Claude Lebenszteyn's compilation of 'all the
expressions of contempt heaped on colour – seen as a mere
cosmetic – since Plato', Yve-Alain Bois, op. cit., p. 61

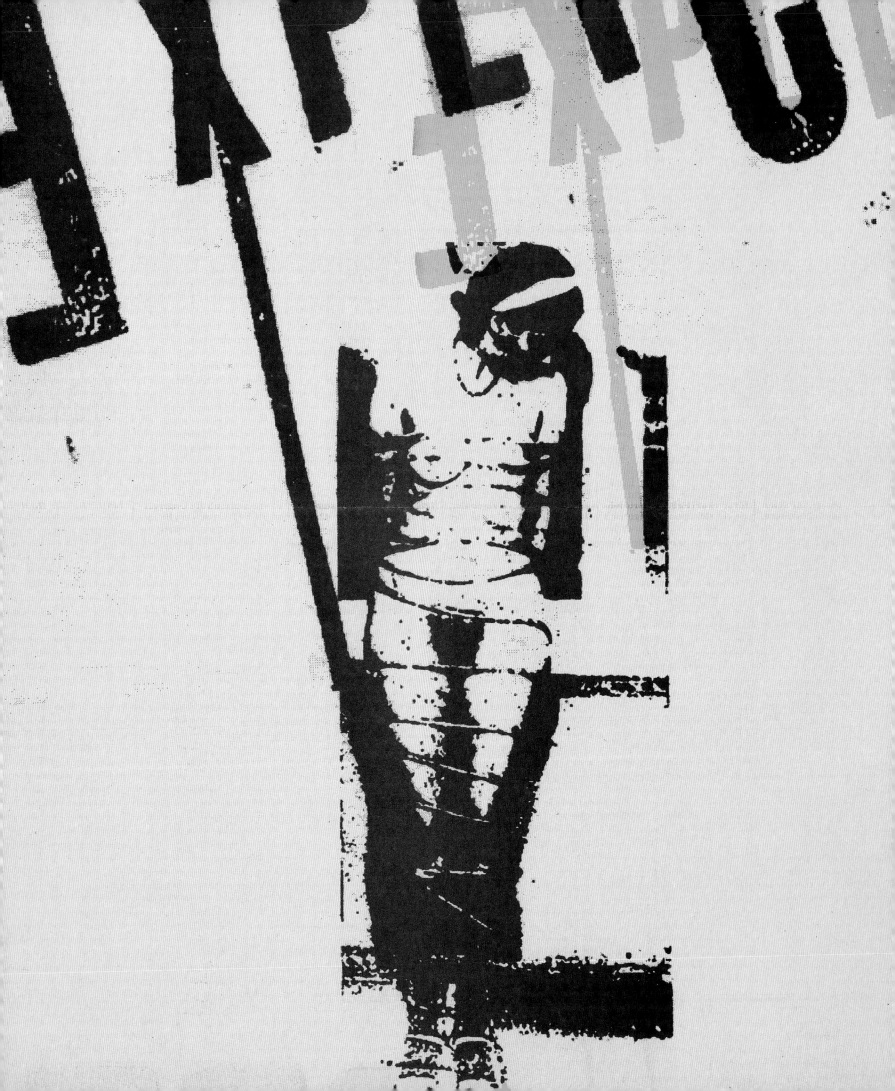

Contents

Interview Jo Anna Isaak in conversation with Nancy Spero, page 6. Survey Jon Bird Dancing to a Different Tune, page 38. Focus Sylvère Lotringer Explicit Material, page 98. Artist's Choice Alice Jardine Gynesis: Configurations of Woman and Modernity (extract), 1985, page 112. Stanley Kubrick, Terry Southern and Peter George Dr. Strangelove or: How I Learned to Stop Worrying and Love the Bomb (extract), 1963, page 114. Artist's Writings Nancy Spero Creation and Pro-creation, 1992, page 118. Statement about Painting, 1965, page 122. The War Series, 1993, page 124. Text for 'Rape' catalogue, 1985, page 126. On Feminism, 1971, page 127. The 'Art World' Has to Join Us, Women Artists, Not We Join It, 1976, page 128. Viewpoint, 1972, page 129. Images of Women, 1985, page 130. The Female Body, 1987, page 134. ICA Statement, 1987, page 135. The Great Goddess Debate, 1987, page 136. Book Reviews, 1989, page 138. Tracing Ana Mendieta, 1992, page 139. Sky Goddess – Egyptian Acrobat, 1988, page 140. Chronology page 144 & Bibliography, page 160.

In a photograph originally published by the *New York Times*, a young woman is shown from the back, dressed in a light grey sweater and a loose, dark skirt. Her hands are tied behind her back, but her body doesn't appear especially tense although the officer is just tightening up the noose around her neck. In the foreground, the impassive profile of another officer uncannily replicates the first, both wearing low caps over their eyes and heavy black SS uniforms. Neither of them look at the girl they're about to hang.

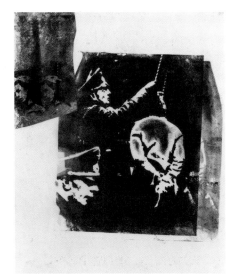

Masha Bruskina, 17, became a legend throughout Russia as the first woman executed during the Nazi occupation of Soviet territory. Yet, unlike all her male companions, she was simply identified as the 'unknown' partisan. It took a painstaking investigation by Soviet journalists, 25 years later, to discover her name, and some 25 years more to have it publicly acknowledged that this quintessential Russian heroine was a Jewish girl from the Minsk ghetto. The reporter from the *New York Times*, quoted in Nancy Spero's installation at the 1993 Whitney Biennial, called Masha Bruskina 'the Ultimate Rejected Jew'. It was also another example of the way women have been treated in a male-dominated society.

Masha Bruskina (details)
1993
Handprinting on wall
Installation, Whitney Museum of
American Art, New York

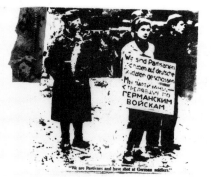

Another picture of Masha Bruskina, which Spero displayed at the Biennial, shows the young woman being marched through the streets with another Russian civilian. (Spero highlighted the woman's role by erasing the second male partisan walking by her side.) A big sign across Bruskina's chest said: 'We are partisans and have shot German soldiers'. It's written in two languages, German, then Russian, but only in the Russian version is the part about SHOOTING GERMAN SOLDIERS written in bigger letters. The warning is clear, yet there is not one Russian in sight. They are surrounded by German soldiers. The real target, obviously, is the Slav population, or possibly the German *volk* back home. This ominous sign is added to all the other signs meant to deter further acts of resistance: the public exposure, the public hanging. This is 'victimage art' of a special kind, pictures celebrating the victors. As Michel Foucault once remarked, the victims end up paying twice, first through their punishment, and then through the signs that are extracted from them.

Ballad of Marie Sanders, the Jew's Whore recounts the brutal story of a young woman who slept with a Jew in Nazi times and was walked down the street to her death, her hair shaved off. As part of an installation, which first appeared at the Von der Heydt-Museum in Wuppertal (1991) and subsequently at the Jewish Museum, New York (1993), Nancy Spero printed Bertold Brecht's well-known ballad on the wall. The English version was interlaced with poems by two Jewish women – Nelly Sachs, 'That the Persecuted May Not Become the Persecutors'; and Irene Klepfisz, 'Death Camp' – together with pictures of Warsaw ghetto victims. In lieu of the (missing) picture of Sanders' ordeal, Spero collaged an unsettling photograph found on a member of the Gestapo, a naked woman about to be hanged, her body tightly roped. An extended version of this picture was subsequently printed on its own in six different installments of the Austrian newspaper *Der Standard*, as part of the Museum in Progress (1995).

In the Whitney Biennial installation, Nancy Spero carefully selected each photograph to suit her purpose. In the first picture Masha Bruskina occupies centre stage, but she's not debased and eroticized for all that. Her face doesn't betray anguish or suffering, anything that could excite among the soldiers (or the viewers) the pleasure of cruelty. She doesn't break down and become an abject sight, nor does she pretend to be a heroine. She seems curiously absent from the spectacle. She simply refuses to register the violence she's been subjected to, even to acknowledge her imminent death. She doesn't quite fit the role of the victim, or any role for that matter. The voyeuristic gaze is left to feed back upon itself.

'Feelings are shit, the real trick is to disappear', says a character in Chris Kraus' film *Gravity and Grace*, quoting Simone Weil. Nancy Spero always makes sure that her victims are never presented as objects of pity or fear (the pathos of power) but shown on their own terms, recast in a mould impervious to the facile display of feelings. How can one make the 'victims' disappear, but not their victimage?

One way is to foreground everything: building a tight case as a journalist does or historicizing the violence, bringing out the specifics of an event instead of the broad (and always revocable) humanistic concerns. Making everything explicit is a strategy Nancy Spero adopted from a medieval *Book of the Apocalypse* where every chapter ended with an 'Explicit Explanation', or an 'Explicit Storia'. Except that it was sinners then who used to find themselves in hell. In our time torture is for the innocents.

following pages, **Woman/War/ Victimage/Resistance** October 1994-March 1995 Curated by Museum in Progress for *Der Standard*, Vienna

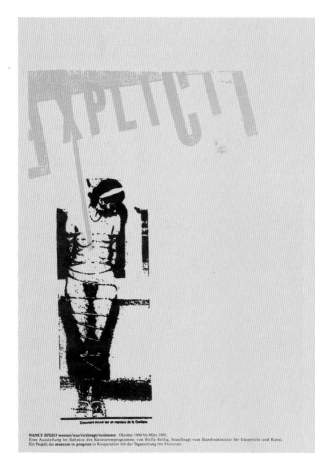

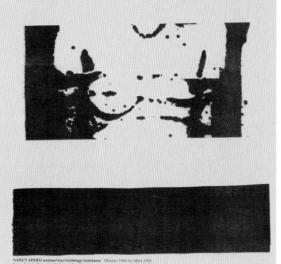

Die Rolle des öffentlich-rechtlichen Rundfunks in einer veränderten Medienwelt

Eine neue Kultur für den Kunden und König

Helmut Kohls liberales Risiko

Umgebaute Viren sollen Pflanzen schützen

Am Rande der Kitzbühler Alpen

Urlaubspräferenzen der Österreicher

DER STANDARD WISSENSCHAFT

Gemeinsam wider den Eindruck der Absurdita

Wo Elektrobastler „alles" finden

Nachtarbeit der Ärzte in NÖ soll nicht gratis se

Baum-Kampf in der Josefstadt — der Radwegbau muß warten

Behindertenintegration stoppt Ausgrenzung und fördert soziale Kompeten

Schulmodell, bei dem alle gewinne

Behinderte auch in AHS-Klassen eingliedern

NANCY SPERO woman/war/victimage/resistance. Oktober 1994 bis März 1995.
Eine Ausstellung im Rahmen des Kuratorenprogramms von Stella Rollig, beauftragt vom Bundesminister für Unterricht und Kunst. Ein Projekt des museum in progress in Kooperation mit der Tageszeitung DER STANDARD.

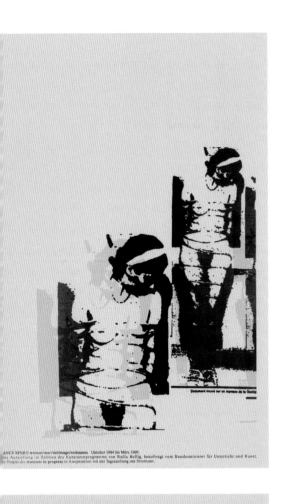

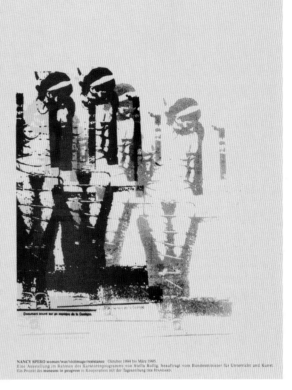

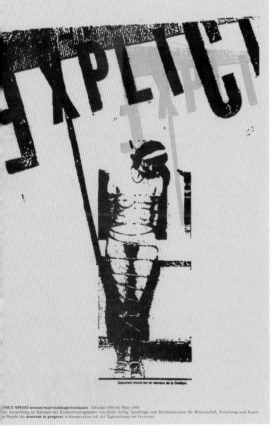

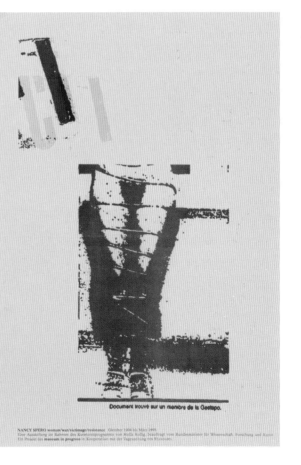

Photojournalists make things explicit too. They do their best to contextualize images of war or violence, using captions, but also carefully positioning elements of information within the picture itself. Yet their concern isn't intrinsically political. They are well aware that no press agency will carry gory images (a heap of dismembered bodies) unless they're surrounded with signs instantly identifying the situation: a veiled woman rushing for cover, a few dishevelled palm trees, dust trailing a tank. All these signs carefully staged around the decomposing bodies in the foreground end up composing a recognizable scene: the Srebrenica massacre, Kurdish rebel casualties in northern Iraq. An unspecified body carries a lot of affects, but no information (at least in terms of the theory of communication). Among a general (Western) audience, this kind of image would most likely provoke a backlash against those who published it. Yet it is no secret that violence greatly enhances the impact of the news. How can violence be made then to serve a more spectacular purpose?

Throwing in a horrific 'human subject' in a photograph has the effect of provoking in the viewer a moment of disarray, an ambiguous mix of revulsion and attraction. The reader's immediate reaction is to move away, looking for something to hang onto, something capable of exorcizing the threat. This is where information comes in, releasing the viewers from the conflicting emotions violence generates. By the same token, it is not the informational content that is activated, but its cathartic function. However 'explicit' it may be, the story is never taken at face value. It becomes a mere 'news item'.

This is the algebra of violence that Nancy Spero is addressing. Surrounding the photographs with text and figures, she keeps recycling her material in a variety of ways, each time changing their meaning and destination. This is one of the devices by which she manages to frustrate the cathartic effect of the news, which turns the dense hieroglyphic body of the women victims into mere ciphers. The same images recur in different sites, like actors in a stock company, collaged with other texts and a vast array of mythological references which act like an eerie historical chorus intensifying the action, modifying the mood of the piece, refracting its meaning emotionally. Ancient pictures of death dance through the text or dart through the huge empty spaces that rhapsodically modulate the impact of the story.

In a recent controversy about 'victim art', a reviewer wondered if indeed it was art, putting newspaper clippings on the wall, as Nancy Spero does. (How is it that people always

wonder if it is art every time an artpiece has any overt political content, or *any* content for that matter?) Using texts has long been a prominent feature of Nancy Spero's work. But her texts aren't just informative. Each letter, handprinted, often rough and botched like the bodies themselves, is also a visual element in their own right, meshing with the figures, slashing them with blocks of type, dancing lightly around them, occasionally bouncing with other texts from one wall to the next.

With this last series, Nancy Spero suddenly found herself dubbed by some a 'Jewish artist', as if being feminist and political, she remarked with a laugh, wasn't enough to discredit her in the market system which only pays attention to 'pure New York art'. Yet 'it just happened', she said. 'It came from my interest in those women victims who happened to be Jewish, and it did strike a very powerful chord'. Nancy Spero's political concerns, obviously, always had a more universal scope, her first victimage series expanding on case histories documented by Amnesty International in South America (*Torture in Chile*, 1974 and *Torture of Women*, 1974–76).

Concern for others, though, doesn't have to exclude one's own history, any more than mourning the Holocaust should separate the Jews from the rest of humanity. Whether deliberate or not, Nancy Spero's itinerary is also exemplary in this respect. Is there a better way of registering the impact of the Jewish martyrologue on one's sensibility than turning it, in Emmanuel Levinas' words, into 'a palpable example, the concrete projection of the calvary of the entire suffering humanity'? Ethical responsibility, after all, is deeply rooted in the Judaic tradition. But infinite suffering can only be vindicated if it leads to infinite responsibility towards all the victims, instantly turning consciousness into action.

Nancy Spero never lets violence dominate her victimage work. For the same reason she avoids staging spectacular scenes that would engulf the viewer. She resorts instead to discrete groupings and collages elements which require an effort of understanding on the part of the audience. Crawling on top of the walls, or scattered on blank surfaces, her latest installations have a jagged quality that keeps discouraging easy identification. In spite of their monumental format, they never strive for a monumental effect. On the contrary: powerful pictures are reduced to vignettes, texts loom large on the walls, mythological figures pop up here and there like afterthoughts. Although they incorporate far more elements than in any of the previous work, these installations remain sparse and austere

following pages, **Masha Bruskina**
1993
Handprinting on wall
Installation, Whitney Biennial,
Whitney Museum of American Art,
New York

Was the Partisan a Jew?

ECHO Of '41

Minsk, U.S.S.R.

The sequence of photograph
s is among the most vivid
and famous from the Nazi
occupation reproduced in
Soviet textbooks, encyc-
lopedias, films and museum
s. _____

Oct. 26, 1941: Impassive SS
men lead a teen-age girl, a boy
nd a man through the streets of
Minsk and hang them side by
side at the gates of a yeast
factory......

..the girl remains officially,
resolutely "nyeizvestnanaya" -
"unknown."

The Ultimate Rejected Jew

But a trove of evidence
compiled by Soviet journalists
backed by the testimony of sur
vivors and endorsed by a prom-
inent criminologist, supports
the claim that the girl is
MASHA BRUSKINA, a Jew from the
Minsk ghetto who was active
in the Partisan resistance.

anaya" -

Rejected Jew

evidence
t journalists
mony of sur
a prom-
upports
is
n the
ve

How ther
book, a
gation, a
aimed at
objection
nition o
her nativ

"It is on
meanness
way," sa
Moscow
swept
years a
ed by
changin
that in
finally
clusion

The girl
is wide
have be
publicly
the Naz
Soviet t
companic
her-Kiri"
Volodya
Partisan
stock
by fam
a few
and pos

...During the occupation, the witnesses recounted, Masha Bruskina worked as a medical assistant in a hospital that the Nazis had converted to a prison camp for wounded Soviet soldiers in league with Partisan groups operating near the city, she smuggled in civilian clothes and false documents used by the escaping officers.

... She lighten hair and used her name which was not tinctively Jewish. reportedly refused form under torture walked to her execu with her head erec was 17 years old.

romises of a
olarly investi
rhaps a lawsuit
ming official
winning recog
Bruskina in

pidity and
stand in the
Dikhtyar, a
alist who became
he story 20
remains haunt
times are
I'm convinced
xt year we'll
this to a con

photograph
eved to
first person
ted during
pation of
ry. The two
ged alongside
and
seyvich
Byelorussian
dentified
bers within
the war,
usly decorated

Twenty years ago Lev Arkadyev, a screen writer working on a film about the war, saw the photographs in the Minsk Museum and resolved to identify the unknown Partisan. He enlisted Mrs. Dikhyar, then a reporter for the Soviet Youth radio station "Yunost, and they began a painstaking investigation.

in outlook. Emotions are not internalized but made explicit: the teardrops that Masha Bruskina didn't shed in her public hanging can be found on the wall, displaced, objectified, marring the text.

I couldn't help wondering what the Nazis would have done to Masha Bruskina (she deliberately took her mother's name, far less conspicuous) had they found out that she was Jewish. She had been lucky in a sense: the SS extracted signs from her, not her teeth or pieces of her skin. Would she even have been exposed naked, like the woman in the Gestapo picture, had they known who she really was?

This question is worth looking into. The two pictures, anyway, have too much in common to be kept separate. Both women wear a noose around their necks, their hands tied behind their back. But one is fully clothed, the other stark naked. Both are victims of the Nazis. Yet while Masha Bruskina's wrists are casually tied, every part of the other woman's body is heavily invested and roped, her feet, thighs, crotch, belly, breasts slashed by the cord imprinted on the flesh.

It is such an obvious overkill. Was there any need to subject the woman to this heavy bondage? Her head bent on the side, she looks subdued enough. There's not a hint of rebellion on her part. Yet somebody did it to her, someone present to the scene, looking at her from the other side of the camera, like a spider ready to pounce on its defenceless victim. Somebody, a man, a Gestapo man, patiently tightened the rope around her naked body, exposing her nakedness, bruising her breasts, savouring every bit of this sadistic ritual.

There was nothing sexual about Bruskina's execution: everything in the other woman, on the contrary, is highly eroticized. She appears to be the very embodiment of victimage. But is she?

The woman's not dead yet: she's looking down, apparently ashamed or still in shock at finding herself subjected to that ultimate indignity. Or maybe she was made to look away from her own body to make it appear all the more exposed, the sadist's staging subtly directing the viewer's eye to the secrets sites of her body, the dark mass of her sex jutting out right at the centre, carefully framed by two rounds of rope. Another three rounds of rope, higher up, do not merely frame her breasts, but cut deep into them, already encouraging aggression.

What the woman was thinking we'll never know. Her face is in the shadow; only her

body is fully exposed to the light. She's just a body, a fetishized object, exhibited for its own sake, like a special treat, a connoisseur's item, independent of its final destination (hanging). The loose noose around her neck is part of the spectacle, before bringing it to its climax.

The woman's nakedness isn't internalized, it is directed outward. It presents a powerful cartography of men's desires, and it is these desires that her body allows us to read. Actually, her body is not entirely naked, which provides an additional erotic charge to the scene. The white headband she's wearing makes her look like a maid. Subservient positions, in any case, fuel aggressive impulses. She's also wearing white shoes. The two white elements further frame her body, making it look more than naked: unclothed, disclosed, stripped bare.

Half a century later, this unsettling document was finally delivered at the front door of Viennese suburban homes in a full page of *Der Standard* with the title EXPLICIT repeated twice over, first foregrounded in huge, black letterheads, then in small grey letters pushed in the background. The picture itself simply bears the caption: *'Document trouvé sur un membre de La Gestapo'* (Document found on a member of the Gestapo). One can assume that it was found on a German officer just after the war. He must have carried it around, probably saw the woman die. The thought of this man from the Gestapo being aroused by the dead woman's picture is deeply disquieting.

This is ultimate porn, sex, bondage and death conflated in a single image, a powerful hieroglyph whose elements had to be carefully 'explicated' (developed). This is what Nancy Spero does through this six-part press project which retains not only the ephemeral quality of her museum installations, but also all the resources of the extended format. In effect, Spero keeps pushing the woman's picture under the readers' eyes, superposing it or replicating it in various shades of grey that suggest continuous motion and presence, travelling cinematically around this puzzling artifact, this highly eroticized body, looking for traces of the men's response, patterns of arousal in the face of torture and oppression. She emphasizes further the brutality of the gaze by bringing the image back and forth, pulling the body back or abruptly closing-up on the torso, on the bare breasts, on the crotch and legs. Alternatively, fragmenting the body and accelerating the flow of images, presenting overlapping versions of the woman like Duchamp's brides descending the staircase, or a futurist diagram, Nancy Spero keeps treating the dynamics of sexual victimization as an objective fact.

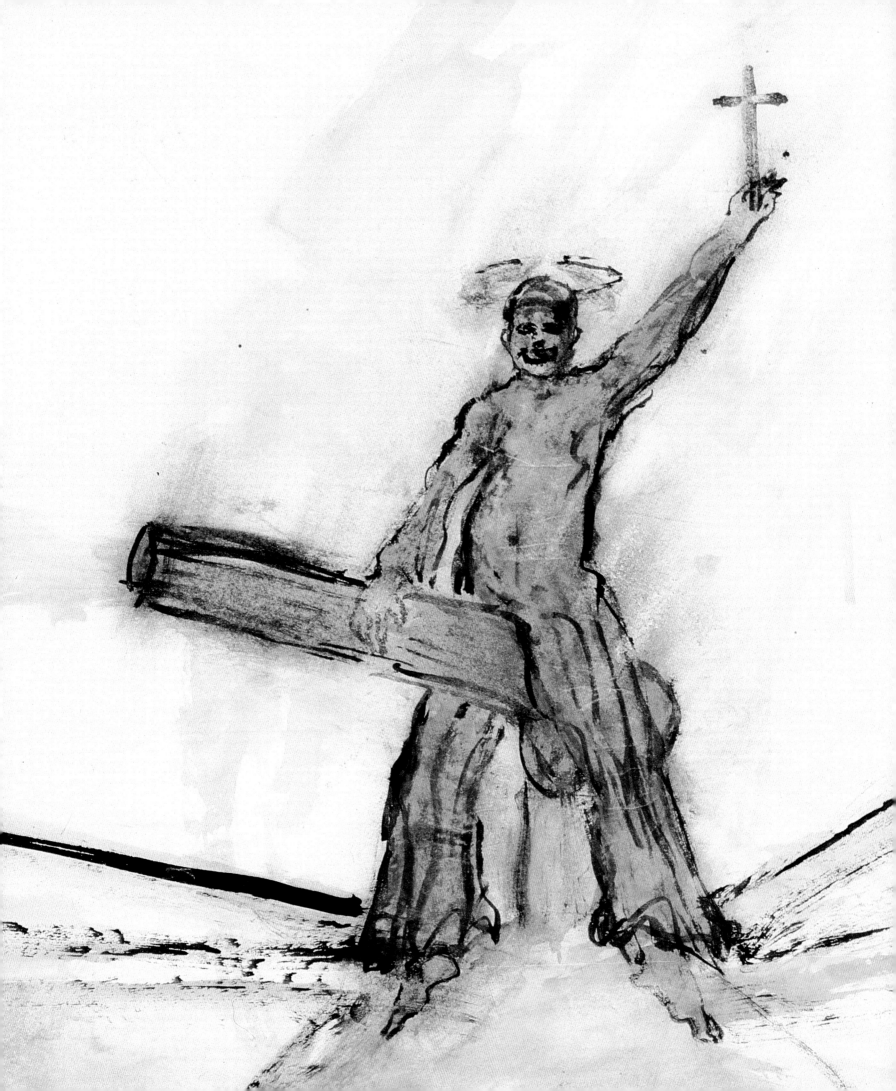

Contents

Interview Jo Anna Isaak in conversation with Nancy Spero, page 6. Survey Jon Bird Dancing to a Different Tune, page 38. Focus Sylvère Lotringer Explicit Material, page 98. Artist's Choice Alice Jardine Gynesis: Configurations of Woman and Modernity (extract), 1985, page 112. Stanley Kubrick, Terry Southern and Peter George Dr. Strangelove or: How I Learned to Stop Worrying and Love the Bomb (extract), 1963, page 114. Artist's Writings Nancy Spero Creation and Pro-creation, 1992, page 118. Statement about Painting, 1965, page 122. The War Series, 1993, page 124. Text for 'Rape' catalogue, 1985, page 126. On Feminism, 1971, page 127. The 'Art World' Has to Join Us, Women Artists, Not We Join It, 1976, page 128. Viewpoint, 1972, page 129. Images of Women, 1985, page 130. The Female Body, 1987, page 134. ICA Statement, 1987, page 135. The Great Goddess Debate, 1987, page 136. Book Reviews, 1989, page 138. Tracing Ana Mendieta, 1992, page 139. Sky Goddess - Egyptian Acrobat, 1988, page 140. Chronology page 144 & Bibliography, page 160.

While proceeding from a 'belief' (in women's oppression), we are nevertheless, necessarily, caught up in a permanent whirlwind of reading practices within a universe of fiction and theory written, but for a few official exceptions, by men. Not believing in 'Truth', we continue to be fascinated by (elaborate) fictions. This is the profound paradox of the feminist speaking in our contemporary culture: she proceeds from a *belief* in a world from which – even the philosophers admit – *Truth* has disappeared. This paradox, it seems to me, can lead to (at least) three possible scenarios: a renewed silence, a form of religion (from mysticism to political orthodoxy), or a continual attention – historical, ideological, and affective – to the place from which we speak [...]

These new ways have not surfaced in a void. Over the past century, those master (European) narratives – history, philosophy, religion – which have determined our sense of legitimacy in the West have undergone a series of crises in legitimation. It is widely recognized that legitimacy is part of that judicial domain which, historically, has determined the right to govern, the succession of kings, the link between father and son, the necessary paternal fiction, the ability to decide who is the father – in patriarchal culture. The crises experienced by the major Western narratives have not, therefore, been gender-neutral. They are crises in the narratives invented by men [...]

The key master discourses in the West – philosophy, religion, history – have thus had to confront, since the nineteenth century, a new space which refuses to stay silent within its frame of representation. This nature – this space, object, and Other – is, in a sense, no longer natural. It is described as the motor of a world without a God. What is henceforth necessary for any human subject who desires to describe the modern world will be to walk through the mirror, dismantle the frame held together by the Big Dichotomies and operate a trans-position of the boundaries and spaces now tangled in a figurative confusion. The inside and outside seem to turn inside-out like a glove. Even history cannot name the resultant relining, for this Master of the Masters has itself turned capricious [...]

Sacred and Profane Love
1993
Handprinted collage on paper
8 panels, 50 × 2235 cm overall

The ancient problem of the relationship between what in every-day language we call 'experience' of 'reality' and what we then decide to call 'knowledge' about it (let alone knowing the 'truth' about it) has resurfaced with a vengeance in the twentieth century. Radical critics of dominant Western culture have been urgently concerned, since at least the turn of the century, with the problem of how to continue criticism in a modern world where it is understood not only that what is being criticized is already an ideological, symbolic construction, but also that it is therefore already a lie. So then, where might be found the truth? From the arts, especially modernist and postmodernist fiction, to the philosophies, a deep dissatisfaction with science has led to a radical re-evaluation of the relationships between what Walter Benjamin called 'direct, lived experience' (*Erlebnis*, 'shock') as opposed to retrospective, 'privileged, inward experience' (*Erfahrung*, 'aura'). That the relationship between the two is no longer obvious; that, in any case, it can no longer be seen as reflective, natural, or unmediated, is now certain. As Gilles Deleuze has explained, we are talking about an era of generalized anti-Platonism, where it is no longer only models and their copies that are put into play, privileged; but also the *simulacrum*, traditionally seen as false, bad and ugly because it does not resemble enough the Original *or* its copies.

In fact, 'One defines modernity by the potency of the *simulacrum*'. The power and full implications of this statement are only slowly becoming more tangible to those still thinking in a psychologized and representational mode (and almost everyone is), especially with regard to their own experience. For example, media and computer technology are no longer so limited in scope: most of us can at least begin to glimpse the ways in which the components of 'our lives' have already been imagined, repeated, erased, spliced to other 'lives'; ways which are not only out of our own control, but under no-One's control at all, except perhaps that of technology itself […]

Dr Strangelove or: How I Learned to Stop Worrying and Love the Bomb (extract), 1963
Stanley Kubrick, Terry Southern and Peter George

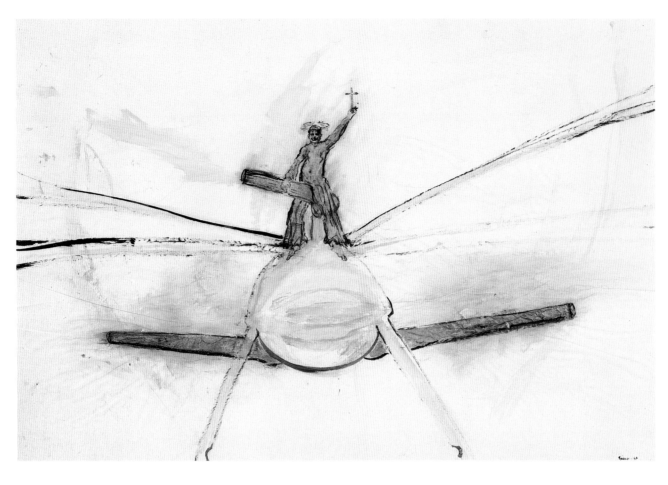

Soundtrack: 'When Johnny Comes Marching Home'

Lt. Lothar Zogg, Bombardier Bombardier ready, sir […]

Major T.J. 'King' Kong Bomb arming test lights on one through four.

Zogg Bomb arming test lights on one through four.

Major Kong Engage primary trigger switch override.

Zogg Primary trigger switch override engaged.

Major Kong Track indicators to maximum deflection.

Zogg Track indicators to maximum deflection.

Major Kong Detonator set to zero altitude.

Zogg Detonator set to zero altitude.

Major Kong Release first safety.

Lt. HR. Dietrich, D.S.O. First safety released.

Zogg First safety.

Major Kong Release second safety.

Dietrich Second safety released.

Zogg Second safety.

Major Kong Check bomb door circuits one through four.

Zogg Uh … bomb door circuits negative function. Lights red.

Major Kong Switch in back-up circuits.

Zogg Roger. Backup circuit switched in. Still negative function.

Major Kong Engage emergency power.

Zogg Roger. Emergency power on. Still negative function.

Major Kong Operate manual override.

Zogg Roger. Uh … still negative function. The teleflex drive cable must be sheared away.

Major Kong Fire the explosive bolts.

Zogg Roger. Uh … still negative, sir. The operating circuits are dead, sir.

Major Kong Stay on the bomb-run Ace. I'm going down below and see what I can do.

Ace Roger.

Major Kong Stay on the bomb-run boys. I'm going to get them doors open if it hare-lips everybody on Bear Creek.

Kivel Target range grid reference, checks. Target distance eight miles.

The Male Bomb
1966
Gouache, ink on paper
91 × 61 cm

Eagle Choked on Victims
1970
Gouache, ink, collage on paper
61 × 99 cm

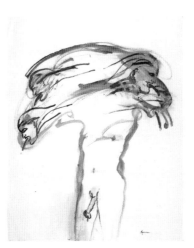

Stanley Kubrick
Dr Strangelove or: How I Learned
to Stop Worrying and Love the
Bomb
1963
91 mins., black and white
Film still
Major Kong (Slim Pickins) riding
the bomb 'rodeo style'

Ace Roger. Eight miles.

Kivel Telemetric guidance computer to orange grid.

Zogg Telemetric guidance computer to orange grid.

Kivel Target distance seven miles. Correct tract indicator minus seven.

Ace Roger. Seven miles. Check G.P.I. acceleration factors.

Zogg G.P.I. acceleration factor set.

Kivel Target distance six miles.

Ace Roger. Six miles. Pulse identransponder active.

Zogg Pulse identransponder active.

Kivel Target distance five miles.

Ace Five miles. Homing alignment factor to zero mode.

Zogg Five miles. Homing alignment factor to zero mode.

Kivel Target distance four miles.

Ace Roger. Four miles. Auto C.D.C. into manual teleflex link.

Zogg Auto C.D.C into manual teleflex link.

Kivel Target distance three miles.

Ace Roger. Three miles.

Kivel Target in sight!

Ace Where in hell is Major Kong?

Major Kong Ya-hooo! Ya-hooo! Ya-hooo! Ya-hooo!

Zogg Hey, what about Major Kong?

Major Kong Ya-hooo! Ya-hooo! Ya-hooo! Ya-hooo!

Based on the book **Red Alert** by Peter George.

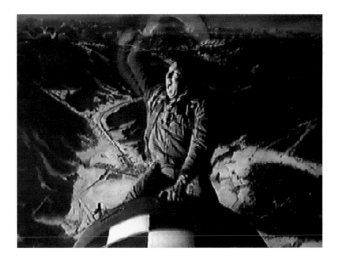

Contents

Interview Jo Anna Isaak in conversation with Nancy Spero, page 6. Survey Jon Bird

Dancing to a Different Tune, page 38. Focus Sylvère Lotringer Explicit Material, page 98. Artist's

Choice Alice Jardine 'Gynesis' Configurations of Woman and Modernity [extract], 1985, page 112. Stanley

Kubrick, Terry Southern and Peter George Dr. Strangelove or: How I Learned to Stop Worrying and Love the Bomb [extract],

1963, page 114.

Artist's Writings

Nancy Spero Creation and Pro-creation, 1992, **page 118**.

Statement about Painting, 1965, **page 122**. The War Series, 1993, **page 124**. Text for 'Rape' catalogue, 1985, **page 126**. On

Feminism, 1971, **page 127**. The 'Art World' Has to Join Us, Women Artists, Not We Join It, 1976, **page 128**. Viewpoint, 1972, **page**

129. Images of Women, 1985, **page 130**. The Female Body, 1987, **page 134**. ICA Statement, 1987, **page 135**. The Great Goddess

Debate, 1987, **page 136**. Book Reviews, 1989, **page 138**. Tracing Ana Mendieta, 1992, **page 139**. Sky Goddess - Egyptian Acrobat,

1988, **page 140**. Chronology page 144 & Bibliography, page 160.

Creation and Pro-creation 1992

The First Language (*right,* panels
II,VI; *opposite,* panels VII,IX)
1981
Handprinting, printing, painted
collage on paper
22 panels, 51 × 5791 cm overall

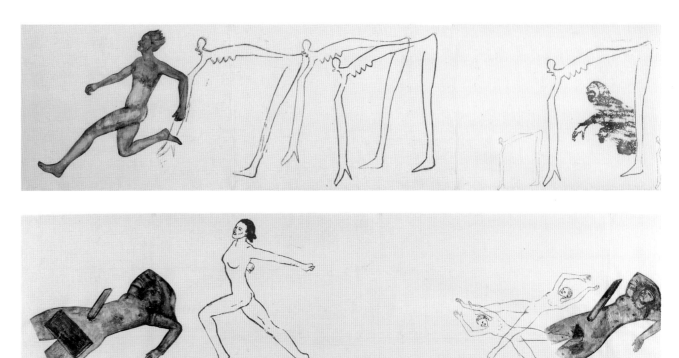

We (Leon Golub and myself) have three adult sons, Stephen, Philip and Paul. The first two were born in Chicago in the early 1950s. My consciousness was not 'raised' at the time, but I was acutely aware that after having an autonomous role at the School of the Art Institute of Chicago and after functioning as a young artist in Chicago, I was treated differently as a wife and mother.

The stigma of motherhood had struck. It seemed even artist friends regarded me differently, as if there couldn't be two artists in one household. My work was virtually and sometimes conspicuously ignored in the 1950s (see CV!) – particularly when the male half was honing his skills in theoretical explanations of a powerful oeuvre, recognized as a 'young turk'. My art was more lyrical and layered, less accessible – coming from a female sensibility? Less accessible meaning that the Chicago art world I knew was unwilling to grant it access. The 1950s, like the 1980s, was an era of macho roles. I was hidden behind the nuclear family, and the general denial of validity to women artists, particularly mothers.

Having a primary responsibility towards the children – Leon's consciousness needed a lot of raising in that era – I never stopped working and always late at night, proving if only to myself that I was an artist.

Nancy Spero and Leon Golub,
Paris, 1962

In 1959 we went to Paris where we lived and worked for five years. Our third son, Paul, was born there. The art world in Paris opened for me as it hadn't in Chicago. Perhaps because I wasn't categorized as 'wife' or 'mother'. I had three solo shows at Galerie Breteau, and exhibited in various group exhibitions in France and Switzerland.

In 1964 we returned to the United States – to New York. The Vietnam War was raging, and I was upset at the US involvement and actions in the conflict. Also I was intensely rethinking my position as an artist. Did I want to reiterate timeless subjects, employing an extended, lengthy process, or did I want to address the excesses of violence in war – its potential for total destruction? Perhaps motherhood was part of a political, personal choice in my changing mediums and content. I started working rapidly on paper, angry works, often scatological – manifestoes

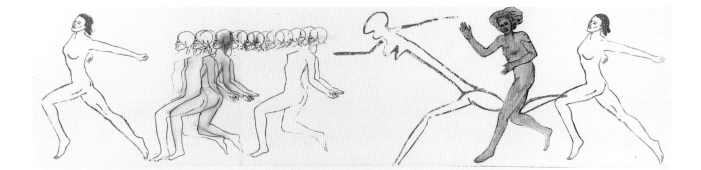

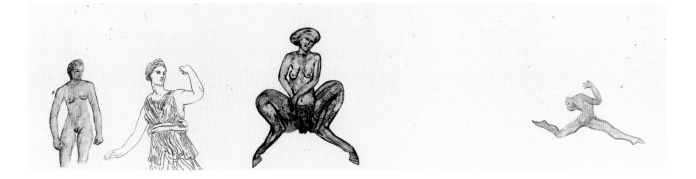

against a senseless obscene war, a war that my sons (too young then) could have been called up for. Those works were exorcisms to keep the war away.

I felt silenced as an artist, with no dialogue, as there were no venues – other than a few anti-war shows and benefits. The silencing of women's voices in society is pervasive. In the *War Series*, angry screaming heads in clouds of bombs spew and vomit poison onto the victims below. Phallic tongues emerge from human heads at the tips of the penile extensions of the bomb or helicopter blades. Making these extreme images, I worried that the children might be embarrassed with the content of my art, what 'their mother' might be doing as an artist.

They must have realized what I was painting (the *War Series* and the *Codex Artaud*). But they were at ease about the art, largely ignoring what both of us were doing, taking us for granted, occasionally as they got older displaying a relaxed acceptance. But I learned years later that they were much more concerned that I didn't appear or dress in more conventional or conservative feminine attire.

In the Artaud Paintings (1969–70) and *Codex Artaud* (1969–72), I used fragmented quotes from Antonin Artaud – of his desperation, humour, misogyny and violent language. He speaks of his tongue being cut! – silenced. I fragmented these quotes with images I had painted – disembodied heads, defiant phallic tongues on tense male, female and androgynous figures, victims in strait-jackets, mythological or alchemical references, etc. I was literally sticking my tongue out at the world – woman silenced, victimized and brutalized, hysterical, talking 'in tongues'. These descriptions of women fit Artaud's writings and behaviour. But as a male character, he is canonized because of his 'otherness' – his disruption of language.

I became an active participant in the art world in the late 1960s and early 1970s, joining women artists' action and discussion groups, such as WAR (Women Artists in Revolution), the Ad Hoc committee of women artists, and AIR Gallery, an all-woman's co-operative gallery founded in 1972. We analyzed women's status in the art world, the collusion of power (galleries, museums, critics, collectors, auctions, etc.) how the 'heroes' are kept on top. (I joke that I joined the women artists groups as I was the only woman in an all-male household – even the dog was male!)

The First Language
1981
Handprinting, printing, painted
collage on paper
22 panels, 51 × 5791 cm overall
Installation, Anthony Reynolds
Gallery, London, 1990

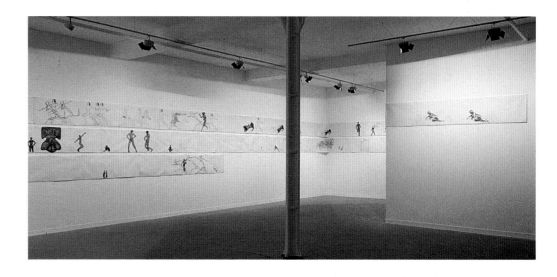

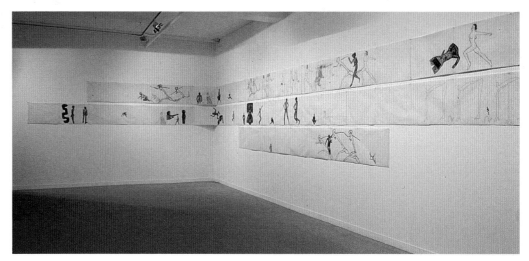

Picketing outside the Museum of
Modern Art, New York, 1976

We took action picketing the Whitney Museum (in 1970, women artists represented only 4% of those exhibited at the Whitney Biennial); we wrote manifestoes for parity and more exhibition opportunities, joined pro-choice marches, etc.

By different roads, Golub's career and mine have become equal. My art now for the most part has crossed the boundaries from the private into the public domain (from the feminine ghetto into a man's world?). The work that was ignored in the 1950s and 1960s became 'relevant' in the 1980s. Leon was consistently critically supportive of my work, and we continued to have an ongoing dialogue.

In the early 1980s, I had (gave myself) a three-gallery show (AIR, 345 Gallery and Art Galaxy) – a mini-retrospective so that my art was then seen to have a history. And too, there was the continuance of the dialogues with women artists, historians, theorists, etc. (even if women artists were again more dispersed and isolated in the 1980s, the Reagan/Bush years, *Kinder, Kücke & Kirche* – conservative times without much group political action, with the exception of the Guerilla Girls). Now in the 1990s, with women's political action groups such as WAC (Women's Action Coalition), many women artists are joining together as there is an almost universal anger and frustration with the system.

'Forum: On Motherhood, Art and Apple Pie', *M/E/A/N/I/N/G* No 12, New York, 1992, pp. 38-40

The First Language
(panel IXX, detail)
1981
Handprinting, printing, painted
collage on paper
22 panels, 51 × 5791 cm overall

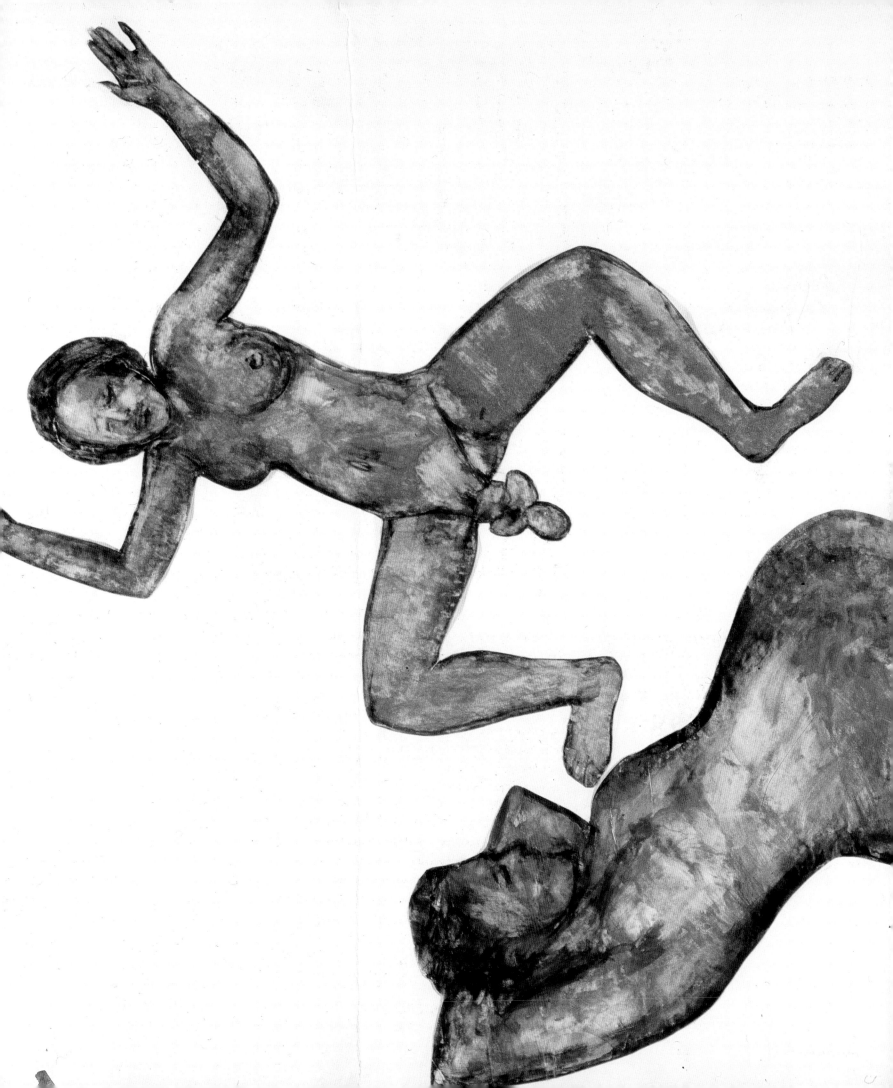

Statement about Painting 1965

As I work, and re-work my canvases, eventually the image appears (sometimes only to elude me, then to re-assert itself much later). The composition and figures are never preconceived yet my themes are recurrent.

For many years I have returned to a double image which has assumed diverse forms – in a series of *'le couple'* or 'the lovers' – existentially expressed through the inspiration of Tarot cards. This theme embodies a rapport, a contact of two beings in a ritual or sensual sense. Earlier, except for a mother and children series, the figures in my work were alone, isolated, elegiac. The Black Paintings tend to be dark and sombre.

I would like to believe I am creating images of poetic ritual.

Nancy Spero in her studio,
Paris, 1962

Lovers V
1962–65
Oil on canvas
128 × 161 cm

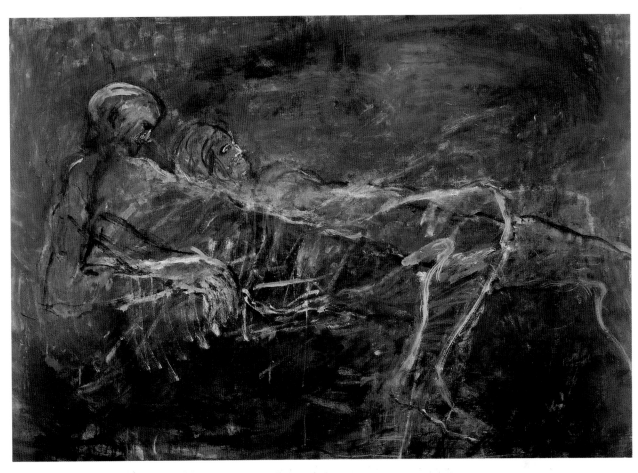

Lovers III
1964
Oil on canvas
137 × 203 cm

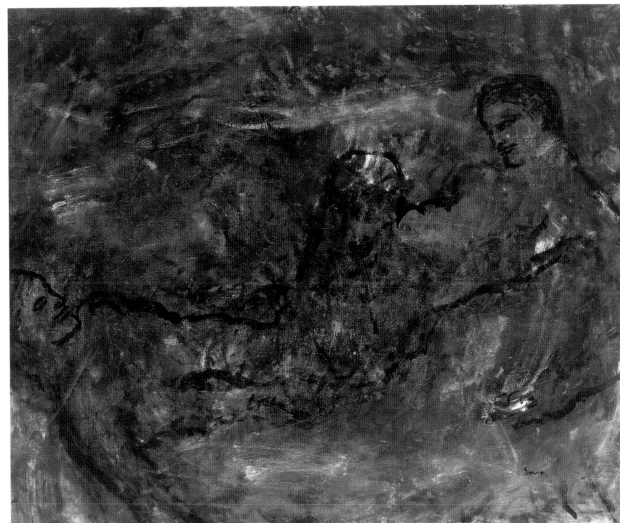

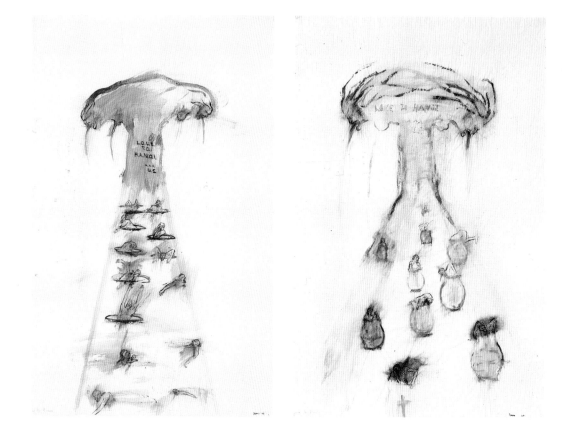

right, **Love to Hanoi**
1967
Gouache, ink on paper
91 × 61 cm

far right, **Bomb and Victims in Individual Bomb Shelters**
1967
Gouache, ink on paper
91 × 61 cm

bottom left, **Rifle/Female Victim**
1966
Gouache, ink on paper
61 × 48 cm

bottom middle, **The Great Mother Victim**
1968
Handpainted collage on paper
99 × 62 cm

bottom right, **Mars, Victims, Airplane Wing, Eagle Claw, Mercury**
1970
Gouache collage on paper
99 × 61 cm

For five years, from 1966-70, I painted (gouache and ink on paper) *The War Series: Bombs and Helicopters*. These works were intended as manifestoes against our (the US) incursion into Vietnam, a personal attempt at exorcism. The Bombs are phallic and nasty, exaggerated sexual representations of the penis: heads with tongues sticking out, violent depictions of the human (mostly male) body. The clouds of the Bomb are filled with screaming heads vomiting poison onto the victims below, etc.

The helicopter becomes anthropomorphic – a primeval (prime-evil) bird or bug wreaking destruction. I imagined that Vietnamese peasants saw it as a giant monster. I viewed the helicopter as *the* symbol of this war – the omnipresent image of the chopper hovering, transporting soldiers, napalming villages, gunning fleeing peasants or picking up wounded and dead US soldiers.

In the 1980s the image of the Vietnam War recurs in my work in a more realistic mode. Figures of young women, mothers with infants, an old woman with a cigarette in her mouth (to me a symbol of survival) all stride or flee from the corpses on the ground.

clockwise from top left, **Bomb and Victims**
1965
Gouache, ink on paper
71 × 91 cm

Search and Destroy
1967
Gouache, ink on paper
61 × 91 cm

Gunship, Eagle, Pilot, Victims
1969
Gouache, ink, collage on paper
64 × 99 cm

Victims
1967
Gouache, ink on paper
61 × 90 cm

Eagles, Swastikas and Victims
1968
Gouache, ink on paper
61 × 91 cm

Holocaust
1968
Gouache, ink, collage on paper
64 × 99 cm

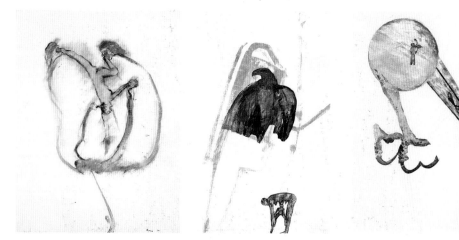

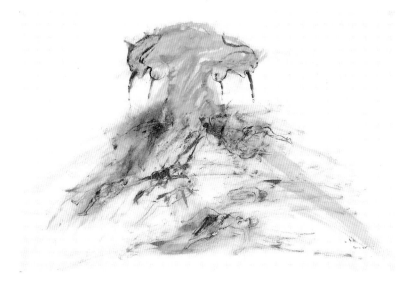

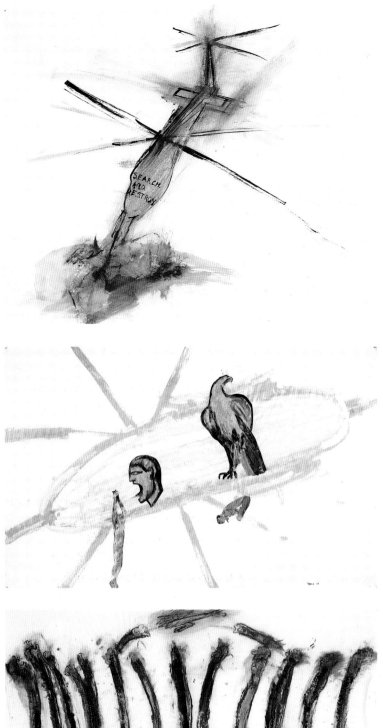

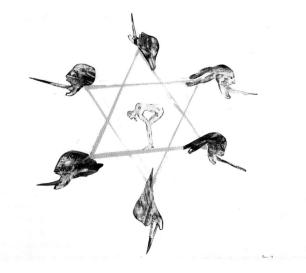

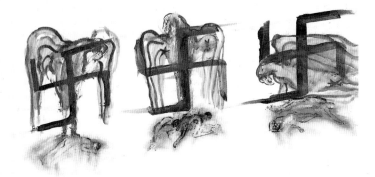

Text for 'Rape' catalogue 1985

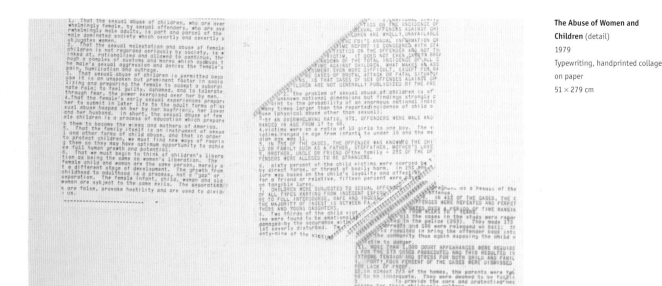

The Abuse of Women and
Children (detail)
1979
Typewriting, handprinted collage
on paper
51 × 279 cm

In *Sexual Abuse of Women and Children* (1979) I document how men (mostly) regard these crimes of rape and violation, how the victim herself is considered guilty, not the perpetrator. Unhappily in many cases this is considered normal male behaviour. The piece is informational, bulletin-typed quotes collaged on paper 20 inches high by 9 feet long (51 x 274 cm). I have handprinted a few purple triangles as a universal female symbol and subsequently learned that in Nazi Germany homosexuals were obliged to wear a pink triangle. This work has been likened to the (now censored) Chinese information walls on which all types of political slogans and information compete for space.

 Torture of Women IV (1981) documents case histories of brutality to women political prisoners – how they are sexually abused and degraded. Many young women on leaving these prisons are pregnant as they have been raped by the guards and/or suffer the effects of the torture for most of their lives. This piece is a diptych 20 x 80 inches (51 x 203 cm), collaged bulletin type and handprinting.

 I combine language and figurative images on long stretches of blank paper to alleviate and isolate the density of both language (messages, quotes, slogans, or cryptic references) and image (classical, primitive, sexual monsters, etc). The images are collaged in tension/or in relation to the language. In the *Codex Artaud* it is a scream of the artist in a bourgeois society. The figures distanced and isolated, the language fractured, the open field renders the 'sound space' intense with pain, both mental and physical.

'Rape' (cat.), Ohio State University, Columbus, 1985

Torture of Women III
1981
Handprinted collage on paper
86 × 218 cm

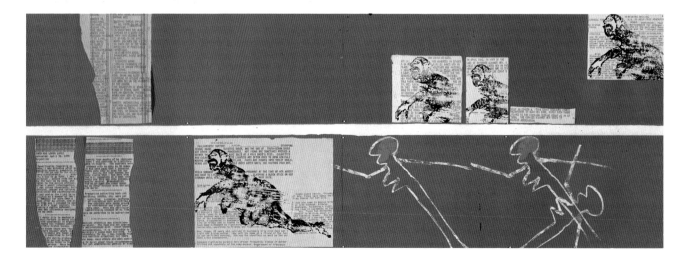

On Feminism 1971

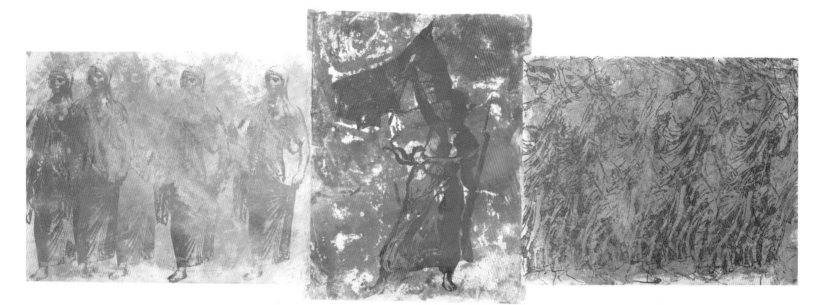

Phalanx
1995
Handprinting on paper
61 × 171 cm

The arts are a territory governed by the laws of male supremacy. In a bourgeois society everything becomes a possession – an object: art is an object, woman is an object, etc. These objects are the pride and extension of the male ego, proof of his power and taste to be manipulated and used for his pleasure and gain. The word 'possessed', with its objectual and sexual connotation; similarly, the word 'ravish', to ravish a woman, to ravish a civilization. These are male attributes and prerogatives. The male ego in possession.

The work of successful male artists is coveted, esteemed – prestigious property. The work of a successful woman artist is usually less esteemed. Her achievements do not inspire the same confidence as a man's would – she is viewed with suspicion and the utmost caution. The woman artist's work would be judged of lower value, as the art world upholds its traditionally masculine control of aesthetics and market values. Women tend to become isolated – solitary, away from the arena of action, non-challenging. This is the compliance of female history, the woman forced into supplicating roles.

In the future there will be arts that will evolve under some more ultimate liberation. The ultimate liberation of women is the hardest and most ultimate task of revolution because her biological subordination has been so historical and determined. Her subordination is so deep-rooted that to break with it is to create a virtually new order of creature co-equal to man.

Today, a woman who dares to struggle in masculine territory becomes in Simone de Beauvoir's terms the subject, rather than remaining the object of the male power structure that oppresses and keeps her powerless. Yet the standards of success in our bourgeois society – power, wealth, acquisition – force an assertive woman into emulation of the male role. In order to succeed, the woman is forced to imitate male chauvinist aggressions.

Paper given at a panel-discussion on feminism at the Art Student's League, 1971

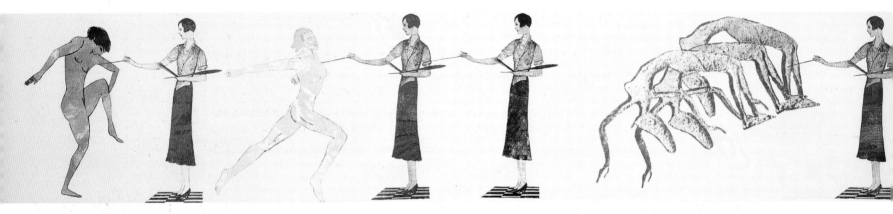

The Artist
1988
Handprinted collage on paper
51 × 279 cm

I have come to the conclusion that the 'art world' has to join us, women artists, not we join it. When women take leadership and gain just rewards and recognition, then perhaps 'we' (women and men) can all work together in art world actions. Until the radical rights of women to determine such actions is won, all we can expect is tokenism.

When men follow feminist leadership to the extent that women have followed male leadership then sexism is on its way out. Also, until we see women getting 40-60% of the financial rewards, museum and gallery exhibitions, college jobs, etc., etc., etc., it is still tokenism. When women artists attain this, then we'll know the sexist system is over.

Hopefully women artists will not be satisfied with parity, but will continue to search for alternatives. Women's goals must be more than parity. The established patterns in the art world have proven frustrating and mostly non-rewarding to women artists since the ideal feminist stance of alternate structures is contradicted by the status quo. But such an ideal of non-elitist milieus will only prove itself over a long period. While we claim the right to search for alternatives, we don't intend to let the rewards of the system remain largely in male hands.

Women artists have only recently emerged from the underground (the real underground, not the slick-storied underground of the 1960s) waging concerted political actions. Our future is to maintain this political action and energy.

Viewpoint 1972

Protective
1995
Handprinted and printed collage
on paper
50 × 253 cm

Rite of Spring
1994
Handprinted and printed collage
on paper
50 × 185 cm

It has been suggested that my most recent work has a cinematic quality – partially due to lay-out (2 feet high by 8 -15 feet length, 61 by 244-457 cm), and to the fragmented positioning of the images and quotations. In order to view it one has to change position, to move close or further away according to the size of the images (some are extremely small), to move along as in reading a manuscript, or to move further away to view it in its entirety. My ideas on using collage technique are related to the fleeting gesture, moments (indelible impression) caught in motion. The rhythm of the whole, seemingly discordant and incomplete, relates to fractured time – as well as the immediate external realities that impose themselves on my consciousness […]

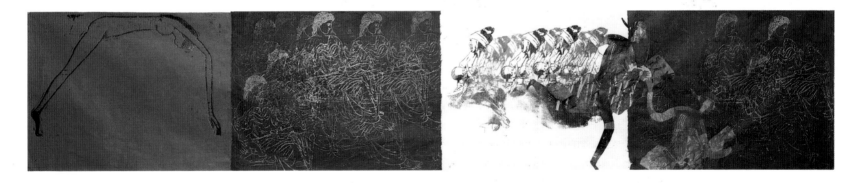

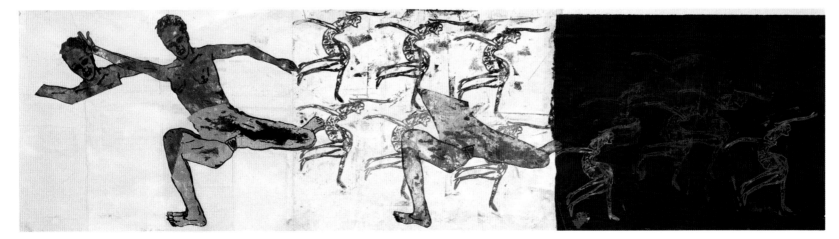

Images of Women 1985

right, **Sky Goddess, Bound Figure and Snake**
1990
Handprinted and printed collage,
vellum on paper
53 × 185 cm

bottom, **Offering: Hera and Kneeling Figure**
1987–94
Handprinted and printed collage
on paper
51 × 123 cm

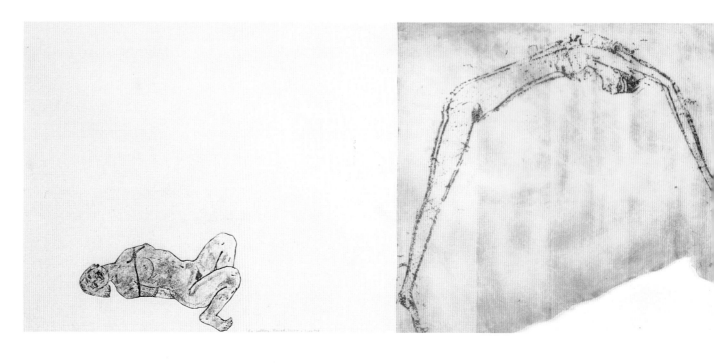

I use only images of women, to represent woman as protagonist and hero. This is a reversal of the typical art practice of portraying men as heroes and protagonists. I articulate women's situation and actions from that of repressed, victimized states to buoyant, self-confident stances.

These works are distanced from the Westernized notions of the personal subjective portrayal of individuality. The work deals with rhythm, stylization, contrast of body types, the juxtaposition of images past and present, varied historical references from disparate cultures, political information, etc.

I am not interested in individual physiognomies or personifications. The figures become generic in a somewhat similar way to, for example, the stylizations of Australian aboriginal art, early Greek vase painting, prehistoric art, etc. I combine in one work figures derived from various cultures whose extremely diverse and often disproportionate body sizes and types co-exist in simultaneous time.

I use photographs informationally to derive images of contemporary women, for example, older Vietnamese women, a range of war and rape victims, youthful celebratory figures, who are depicted in stressed actions and symbolic representations. This is often emphasized by repeating the same figures but printed differently so that change between images are based on characteristics of tempo and time spans creating movement across the page. The repetition de-individualizes Western 'subjectivity' in a non-hierarchical continuous presence.

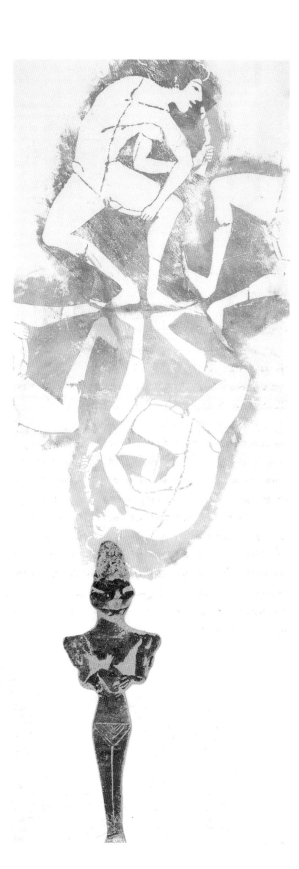

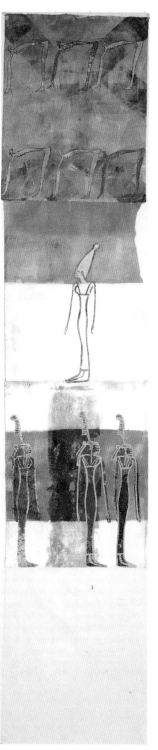

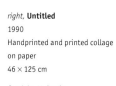

right, **Untitled**
1990
Handprinted and printed collage
on paper
46 × 125 cm

far right, **Heiratic**
1995
Handprinted and printed collage
on paper
244 × 50 cm
Collection, Brooklyn Museum,
New York

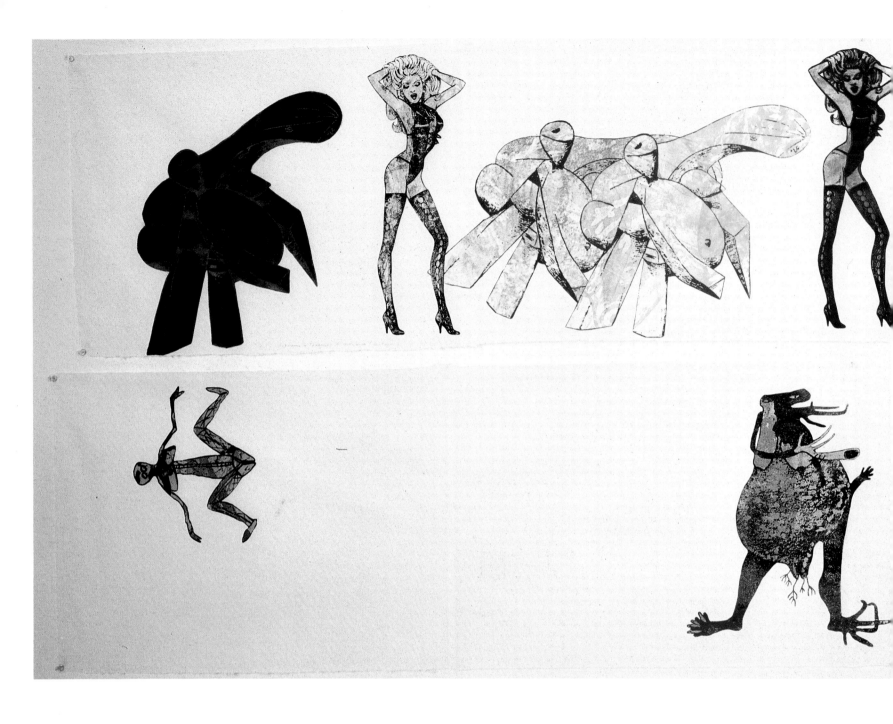

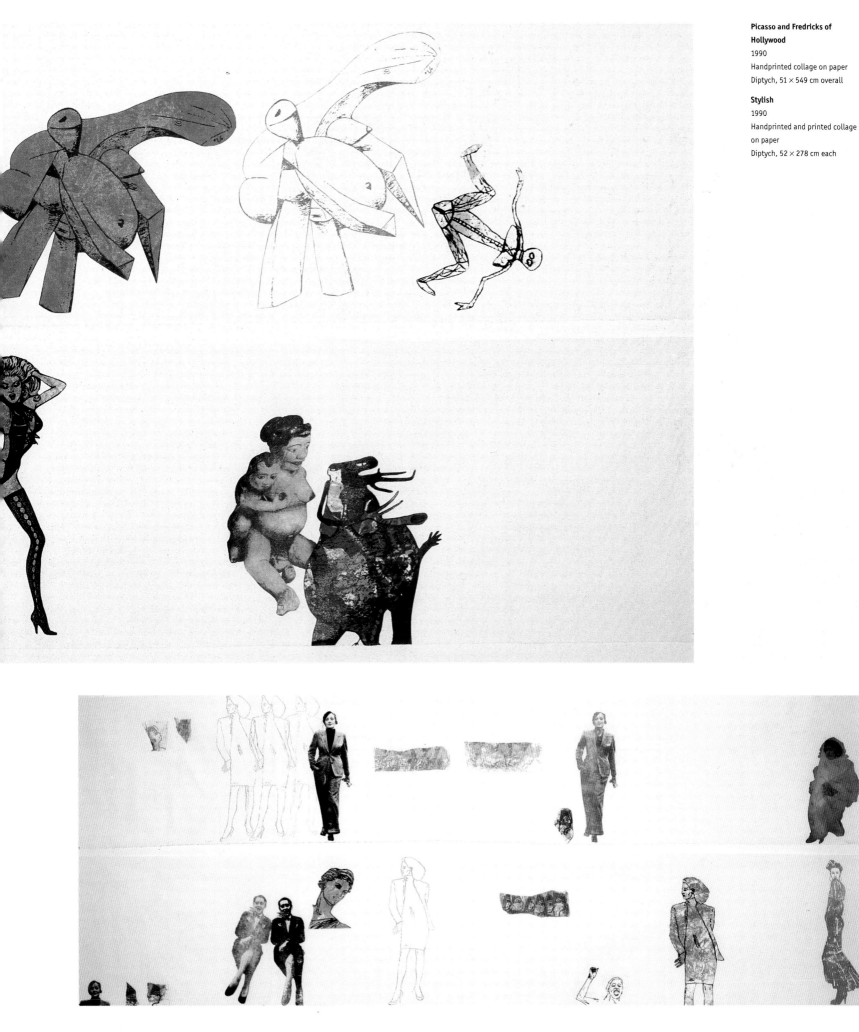

Picasso and Fredricks of Hollywood
1990
Handprinted collage on paper
Diptych, 51 × 549 cm overall

Stylish
1990
Handprinted and printed collage on paper
Diptych, 52 × 278 cm each

The Female Body 1987

I think that if you don't use the body there is an absence. And to use the body embodies an idea and, in a sense, it's the most complex and challenging kind of conceptual reference. And also for me, the body is a symbol or a hieroglyph, in a sense, an extension of language. And so, in making a statement about women's bodies I want the idea of a woman's body to transcend a male ideal of woman in a male-controlled world. The realities of war, primary power, the bomb, etc. are depicted in my work through the images of woman as victim of these catastrophic events. But what I suppose might be most subversive about the work is what I am trying to say in depicting the female body: that woman is not the 'other', that the female image is universal. And when I show difference, I want to show differences in women, women's rites of passage, rather than men's rites of passage. Woman as protagonist: the woman on stage.

Jeanne Siegel, 'Nancy Spero: Woman as Protagonist', interview, *Arts Magazine*, New York, September 1987

I've described my work as far-out – over the edge, but that can easily reinforce the social exclusion of women, the hysterical woman, the man-woman – a dangerous categorization. I think that my work allows for the ecstatic ritual, the utopian moment, but I have to be very careful that it doesn't get to the point of unreality. There is, of course, an imagining; a putting-together of disparate cultures in time, but there has to be a certain amount of control amidst the ecstasy of the carnival.

'Nancy Spero' (cat.), in conversation with Jon Bird, Institute of Contemporary Arts, London, 1987

The Great Goddess Debate 1987

'The Great Goddess Debate: Spirituality and Social Practice in Recent Feminist Art' at the New Museum of Contemporary Art, New York, was held on the occasion of a posthumous retrospective of the work of Ana Mendieta. The panel of women ranged from those critics and artists who invalidate artworks that incorporate images of women, to the other end of the spectrum – those artists and critics who believe and make central goddess imagery.

Women have been historically depicted as the object, but the reaction of a censorious theoretical stance by several panelists limits options, narrows and sets too stringent limits on what one can express, resulting in more academic and neatly charted visual aids.

I try to indicate the range of differences as coded in a variety of female images, how we envision the body, how it is or can be represented. The representations of images of women have varied enormously in different historical and cultural situations. I try to emphasize this diversity, sometimes with shocking contrast and disjunctions. I use them to speculate on a sense of possibility and to comment upon immediate events, political, sexual and otherwise.

What extent does an old Vietnamese woman walking beside corpses have in common with a Hittite goddess? Or male graffitied insults to women and pornographic gestures to a woman on her knees scrubbing the floor?

These are not universals but they point up how women are used and function and whenever possible, resist such usage.

Women under any possible viewing are at least as diverse as men in respect to sexual orientation and sexual practice, location, social role, etc. yet are continuously being simplified or ignored or disembodied. The fact that so many artists have painted women as delectation is not sufficient grounds for the current theoretical assaults on women artists who represent women visually.

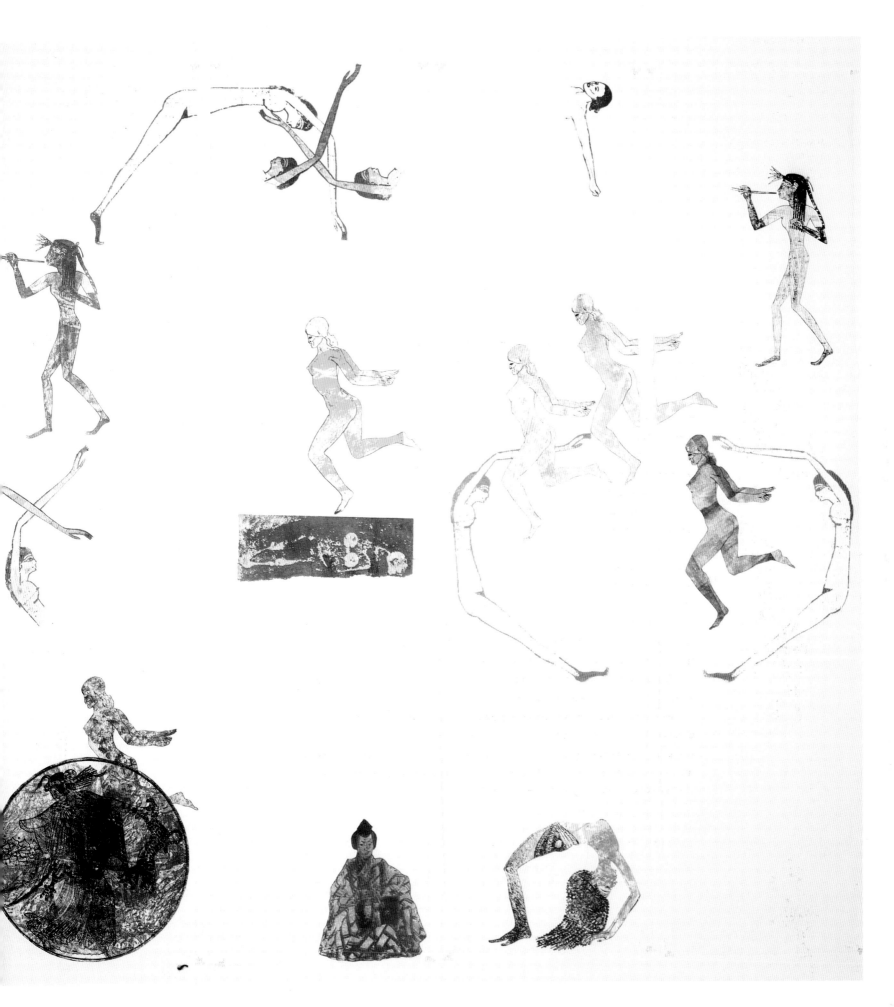

Sheela and Wilma (detail)
1985
Handprinted and printed collage
on paper
51 × 279 cm

Where Are the Men: The Curious Disappearance of the Male Artist
By the Fury Sisters Collective, New York: Vagi Nine Press, 1989, 450 pp., 2 colour plates,
$12.95 paper
An overwhelming change in the art production of the 1980s – the raging of linguistics,
feminism, etc., and the disruption of the canon – has so discombobulated male artists
that the object of desire, a subverted notion of reality, is decentred in its reaction to sign
without signifying. This valuable volume proairetically argues that the gazer becomes
the gazee. But who's looking, anyway?

The Jesse Helms Colouring Book
By Roar Barker, Washington, D.C.: Congressional Back Lash Press, 1989, 69 pp., 69 hot
images, $1.95
This book, a simulacrum of the feigning of the senator, outlines a succession of alienating
and obscene images. A colouration of these most fundamentalist godforsaken images
cannot resurrect the hyperreal – so PAINT IT BLACK.

Why Is Art Not Dead Yet?
By Dada and Mama, New Hope: Dead Ringers Press, deluxe limited edition, 1989, 7 pp.,
signed photograph of authors, $250.00
It's not just the new right that threatens the art world, it is a territory engendering
decay, the demise of the real. Despite the enormous conflicts and repressions of the
real/hyperreal, spiritual/debased, heartfelt/cynical, etc., etc., art *will* pollinate culture,
as the wind blows and seeds, implants it under a cement walk, then the blade of grass
cracks the cement. Truly a moving argument in our desperate era.

November – A Quarterly
Guest edited by Jouie Sance, the Nitpickers Press, vol. 1, Fall 1989, $10
The newest in pre-modernist film theory, retro-revolutionary, post-colonial liberation.
Scandalous imagery of paradoxical systems.

'Twelve Artists on the Year's Books', *Artforum*, New York, December 1989, p. 131

Tracing Ana Mendieta 1992

Ana Mendieta
Untitled
1983
Sand and binder on wood
160 × 99 × 5 cm

Ana Mendieta
Untitled, from the 'Las Tumbas'
series
1977
Earthwork in sand and clay
Iowa

Ana Mendieta
Untitled, from the 'Volcano' series
1979
Earthwork with gunpowder
Sharon Center, Iowa

Ana Mendieta
Untitled, from the 'Silhueta'
series
1978
Earth/bodywork in grass with
gravel
Iowa

Ana Mendieta carved and incised in the earth and stone, and, in July 1981, on the almost inaccessible walls of caves in Jasuco Park in Cuba: always the symbol of the female body, the breathing woman's body melding with the earth or stone or trees or grass, in a transformative representation of the living body mutating into another substance. This repetitive ritual, never the same, always the same, was in sum a constellation of tiny planets – the female mark, the vulva, featureless, sexual, dug into the ground.

Alone with her special tools and gear, she would hike to a chosen site, lie down and mark her body on the ground, dig trenches, filling them with gunpowder and setting them alight to blaze madly. Celebrating the small earthen shape of an abstracted female form. A violent ritual, yet contained. The land eventually covered up the traces of the performance as her art eroded and the earth returned to its previous state. The only records are photographs and videos made by the artist.

Ana did not rampage the earth to control or dominate or to create grandiose monuments of power and authority. She sought intimate, recessed spaces, protective habitats, signalling a temporary respite of comfort and meditation. The imprint of a woman's passage eroding and disappearing, the regrowth of grass or the shifting of sands or a carved fragmentary relief, a timeless cycle momentarily interrupted, receiving the shape of a woman – a trace, such as the smudged body-print a victim of fire might leave, or a shadow, the recessive mark left by a victim of the bomb in Hiroshima or Nagasaki …

Ana's anger fed her desire to create works of endurance, works made to exorcise – with blood, with fire, with rock, with earth, with stress – her profound sense of displacement. Her art is an elemental force, divorced from accidents of individuality, speaking of life and death, growth and decay, of fragility yet indomitable will. It is an intense, unified oeuvre, encompassing the violent fire pieces and the quietly lyrical works in which she lay on the ground covered with leaves or flowers, observing the transmutation of matter and spirit that marks the rites of nature and of nature's reclamation. If one of her sculptures were sent to a distant planet or were kept sealed for thousands of years on earth, it would still convey the imagery, strength, mystery and sexuality of the female human form – woman's body and spirit inscribed.

Walking around Washington Square Park, I sometimes think I see Ana running, circling the park as she used to. We would wave to one another and continue on our individual routines.

Artforum, New York, April 1992, pp. 75-77

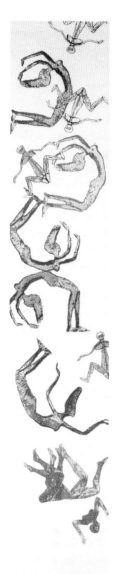

Simone de Beauvoir looked at the world around her with an unflinching gaze. A look into old age, love, ethics, women's status – the list goes on. De Beauvoir revealed the embarrassing, the unspeakable, in her observations of the human condition. Did she speak so frankly without the mediation of her art?

How am I to speak frankly, to state what I consider of moment, to observe and document what is occurring now? I can speak most directly (though often, by necessity, obliquely) through painting or printing, articulating by hand, by brush – rather than by word, by mouth. The transformations of thought become visual notes, the figures hieroglyphs and the language (when used) borrowed.

The performer's body is her actual vehicle. The artifact (artist's product) is a symbolic embodiment of the visual artist. Expression may be abstracted, but the body is present even if in disguise.

Painted and printed images of many types are substitutes for my body. So if these works are ignored, I lose identity; since my persona is identified by my art, I am silenced. Whether the art is praised or reviled, once received it enters a public or external discourse. My body, my presence mediated by the mark on the paper, is no longer absent. I speak.

Artist's project for *Artforum*, New York, March 1988, pp. 103-105

left, **Acrobat Totem**
1988
Handprinted and printed collage
on paper
304 × 50 cm
Collection, FRAC Nord-Pas de
Calais, France

opposite, **Mourning Women**
1992
Handprinting and printed collage
on paper
128 × 65 cm

following pages, **Sky
Goddess/Egyptian Acrobat**
1987-88
Handprinted and printed collage
on paper
11 panels, 274 × 671 overall

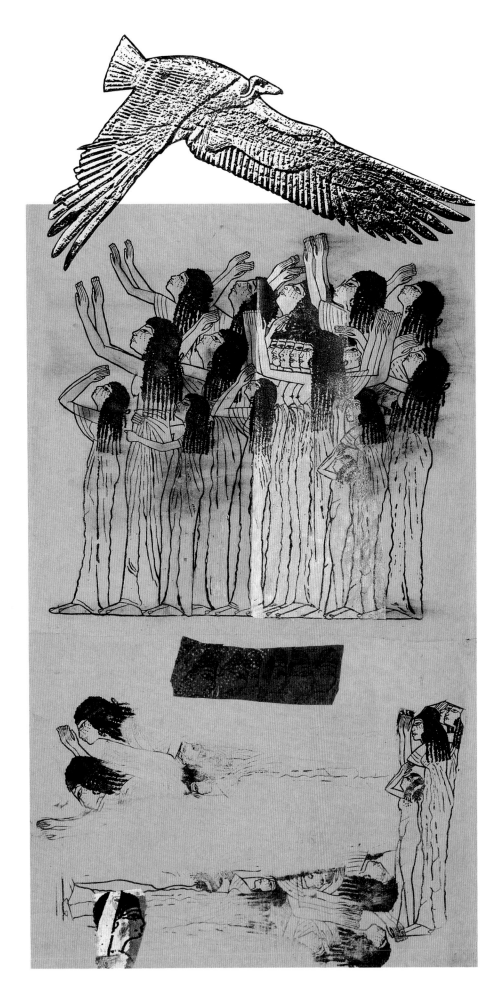

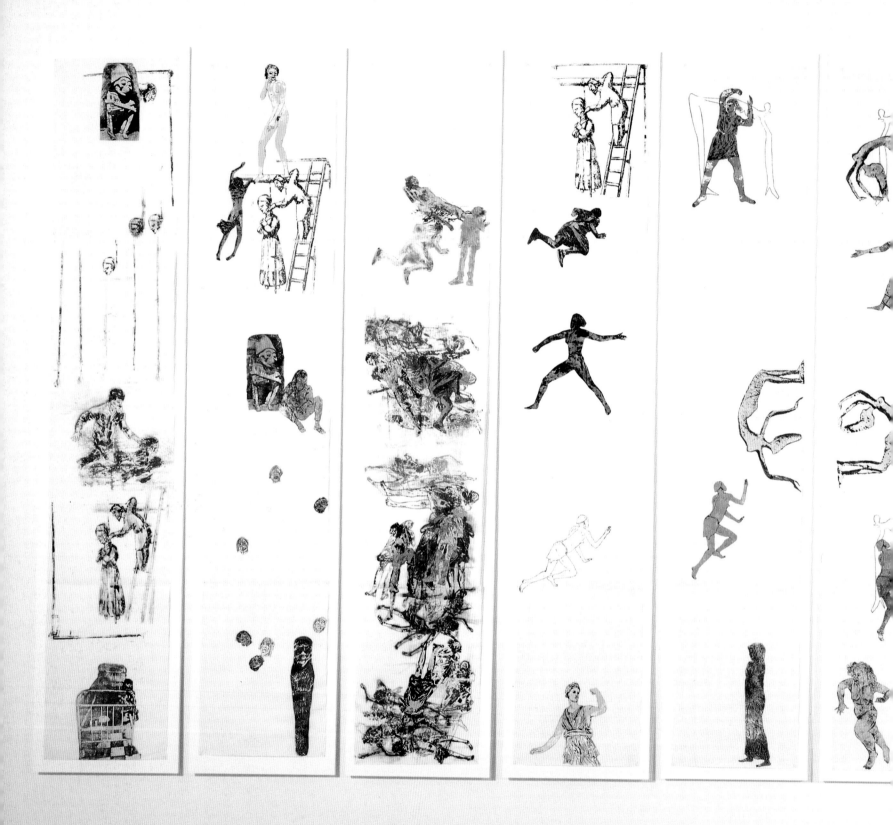

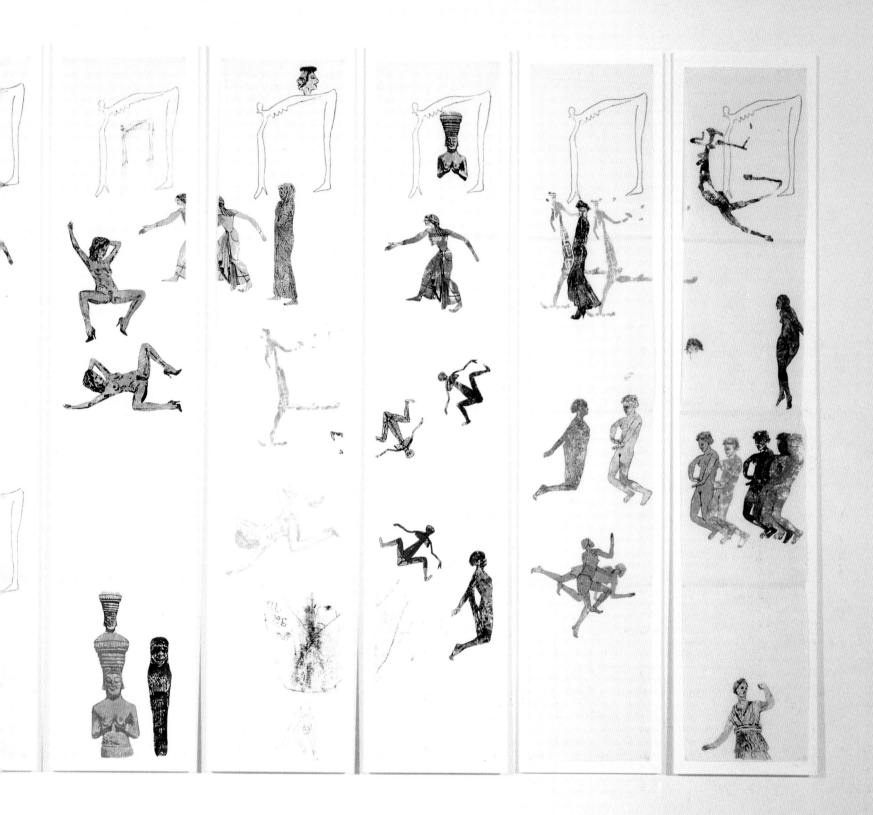

Contents

Interview Jo Anna Isaak in conversation with Nancy Spero, page 6. **Survey** Jon Bird Dancing to a Different Tune, page 38. **Focus** Sylvère Lotringer Explicit Material, page 98. **Artist's Choice** Alice Jardine Gynesis: Configurations of Woman and Modernity (extract), 1985, page 112. Stanley Kubrick, Terry Southern and Peter George Dr. Strangelove or. How I Learned to Stop Worrying and Love the Bomb (extract), 1963, page 114. **Artist's Writings** Nancy Spero Creation and Pro-creation, 1992, page 118. Statement about Painting, 1965, page 122. The War Series, 1993, page 124. Text for 'Rape' catalogue, 1985, page 126. On Feminism, 1971, page 127. The 'Art World' Has to Join Us, Women Artists, Not We Join It, 1976, page 128. Viewpoint, 1972, page 129. Images of Women, 1985, page 130. The Female Body, 1987, page 134. ICA Statement, 1987, page 135. The Great Goddess Debate, 1987, page 136. Book Reviews, 1989, page 138. Tracing Ana Mendieta, 1992, page 139. Sky Goddess - Egyptian Acrobat, 1988, page 140. **Chronology** page 144 & Bibliography, page 160.

Selected exhibitions and projects
1944-1962

1944-45
University of Colorado, Boulder, Colorado

1948
Bordelon Gallery, Chicago (group)

1949
BFA, **School of the Art Institute of Chicago**

Evanston Arts Center, Illinois (group)

1949-50
Ecole des Beaux-Arts and **Atelier Andre l'Hote**, Paris

1950
Apprenticeship in scene design, **Ivoryton Summer Theatre**, Connecticut

'61e Exposition',
Salon des Independents, Grand Palais, Paris (group)
Cat. *61e Exposition Societe des Artistes Independents Catalogue 1950*, Grand Palais, Paris, text exhibition organisers

Lives and works in New York

1951
Marries Leon Golub, they move to Chicago

Leonard Linn Gallery, Winnetka, Illinois (solo)

1952
Stuart Brent Bookstore Gallery, Chicago (solo)

1953
Son Stephen born

1954
M Singer and Sons Gallery, Chicago (solo)

Son Philip born

1956-57
Lives in Ischia and Florence, Italy

1959
Rockford College, Illinois (solo)

1958
'Nancy Spero/Leon Golub',
Indiana University, Bloomington (solo)

'Chicago Area Exhibit', The North Shire Art League,
Cat. *Chicago Area Exhibit*, texts, Members of the North Shore Art League

1957-59
Lives in Bloomington, Indiana

1959-64
Lives in Paris

1961
Son Paul born

1962
Galerie Breteau, Paris (solo)

Nancy Spero, School of the Art Institute, Chicago, 1948

l. to r., Stephen, Paul and Philip Golub, Leon Golub, Nancy Spero, Paris, 1964

Selected articles and interviews
1944-1962

Nancy Spero, second from the right, School of the Art Institute, Chicago, c. 1948

Hirschman, Jack, 'Classics in Modern Art Theme of Two-Man Show', *Indiana University Newspaper*, March

Exhibitions and projects
1963-73

1963
SALON Internationale, '1er de Galeries Pilotes',
Palais de Rumine Lausanne, Switzerland
Cat. *1er SALON International de Galeries Pilotes*,
Palais de Rumine Lausanne, texts Rene Berger and
Raymonde Moulin

1964
Returns to New York

'Huit Americains de Paris',
American Cultural Center, Paris (group)
Cat. *Huit Americains de Paris*, American Cultural Center,
Paris, text Darthea Speyer

1965
Galerie Breteau, Paris (solo)

Los Angeles Peace Tower (group)

1967
'Collage of Indignation I: Angry Arts',
New York University (group)

1968
Galerie Breteau, Paris (solo)

1969
'Viewpoints II',
Colgate University, New York (group)

1970
'Flag Show',
Judson Memorial Church, New York (group)

'Mod Donn Art',
New York Public Theater (group)
Cat. *Mod Donn Art*, New York Public Theater, texts by
participating artists

1971
'The Artaud Paintings',
University of California at San Diego (solo)

'Collage of Indignation II',
New York Cultural Center (group)

'Nancy Spero: Codex Artaud',
Mombaccus Art Center Gallery, Accord, New York (solo)

Text, 'The Whitney Museum and Women,' *Art Gallery
Magazine*, New York, January

1972
'American Woman Artist Show',
Gedok-Kunsthaus, Hamburg (group)

Text, 'Women's Speakout', *New York Element*,
February/March

1973
'Codex Artaud',
AIR Gallery, New York (solo)

'Women Choose Women',

Selected articles and interviews
1963-73

Nancy Spero with son Paul Golub, Paris, 1963

1967

Golub, Leon, 'Bombs and Helicopters: The Art of Nancy
Spero', *Caterpillar I*, USA

1973

Kingsley, April, 'Women Choose Women', *Art*

Exhibitions and projects

1974-77

New York Cultural Center (group)
Cat. *Women Choose Women*, New York Cultural Center,
texts Mario Amaya, Lucy Lippard and Women in the
Arts Collective

1974
'Codex Artaud',
Douglas College, Rutgers University, New Jersey (solo)

Williams College Women's Center, Williamstown,
Massachusetts (solo)

'Conceptual Art',
Women's Interart Center, New York (group)

'The Hours of the Night' and 'Torture in Chile',
AIR Gallery, New York (solo)
Cat. *Licit Exp*, AIR Gallery, New York, text Corinne
Robins

1976
'Torture of Women',
AIR Gallery, New York (solo)
Cat. *Torture of Women*, AIR Gallery, New York, text Lucy
Lippard

Text, 'Ongoing Dialogue Goes On', *Women Artists
Newsletter*, February

1977
Marianne Deson Gallery, Chicago (solo)

'What is Feminist Art?',
The Woman's Building, Los Angeles (group)

```
Lic|t   |xp
normal love
torture in chile
ars et scientia
smoke lick
the hours
        of the night
body count
```

Selected articles and interviews

1974-77

International, Lugano, Summer
Alloway, Lawrence, 'Art', *The Nation*, USA, 2 April

1974

Kuspit, Donald, 'Nancy Spero', *Art in America*, New
York, July/August, 1975
Lubell, Ellen, 'Nancy Spero', *Arts Magazine*, New York,
January, 1975
Robins, Corinne, 'Nancy Spero: Political Artist of
Poetry and Nightmare', *Feminist Art Journal*, USA,
Spring, 1975

Nemser, Cindy, 'In Her Own Image', *Feminist Art
Journal*, USA, Spring

1976
Bourdon, David, 'Art', *The Village Voice*, New York, 27
September
Perreault, John, 'Women Ain't Losers', *The Soho Weekly
News*, New York, 23 September
Trachtenberg, Nancy, 'Moma Guga', *World Trade
Community News*, New York, April, 1977
de Pasquale, Carol, 'Dialogues with Nancy Spero',
Womanart, USA, Winter/Spring, 1977
Alloway, Lawrence, 'Nancy Spero', *Artforum*, New York,
May

Alloway, Lawrence, 'Art', *The Nation*, USA, February 19,
1977
Dallier, Anne, 'L'Image de la violence l'art des femmes',
Les Cahiers du Grif, No 14/15, Paris, December
Lippard, Lucy, *From the Center*, E.P. Dutton & Co., New
York
Lubell, Ellen, 'Nancy Spero', *Arts Magazine*, New York,
November
Robins, Corinne, 'Nancy Spero', *Arts Magazine*, New
York, November
Stubbs, Ann, 'N. Spero Selected Works', *Fire in the
Lake*, USA, February/March

1977

Lippard, Lucy, 'Caring: Five Political Artists', *Studio
International*, No 987, London
Lubell, Ellen, 'The Women Artists' Movement',
Womanart, USA, Spring
Robins, Corinne, 'Artists in Residence: The First Five
Years', *Womanart*, USA, Winter

Exhibitions and projects
1978-82

1978
The Woman's Building, Los Angeles (solo)

Text, 'Ende', *Women's Studies*, Gordon & Breach
Science Publishers, Ltd., United Kingdom

1979
'Notes in Time on Women',
Peachtree Center Gallery, sponsored by Atlanta
Women's Art Collective (solo)

'Notes in Time on Women, Part II/Women: Appraisals,
Dance and Active Histories',
AIR Gallery, New York (solo)

'Torture of Women: A Major Collage/Paintings Cycle',
Real Art Ways, Hartford, Connecticut (solo)

'Torture of Women',
Hampshire College Art Gallery, Amherst,
Massachusetts (solo)

'Feministische Kunst Internationaal',
Haags Gemeentemuseum, The Hague, toured
throughout Holland (group)
Cat. *Feministische Kunst Internationaal*, Haags
Gemeentemuseum, The Hague, texts Marlite
Halbertsma, Liesbeth Brandt Corstius et al.

1980
'Notes in Time on Women',
Picker Art Gallery, Colgate University, New York (solo)
Cat. *Notes in Time on Women Part II*, Picker Art Gallery,
Colgate University, text Donald Kuspit

'Issue: Social Strategies by Women Artists',
Institute for Contemporary Arts, London (group)
Cat. *Issue: Social Strategies by Women Artists*, Institute
of Contemporary Arts, London, text Lucy Lippard

1981
'The First Language',
AIR Gallery, New York (solo)

'Women: Appraisals, Dance and Active Histories' and
'Notes in Time on Women, Part II',
Herter Gallery, University of Massachusetts, Amherst
(solo)

'Nancy Spero/Leon Golub: Collages and Paintings',
Florence Wilcox Gallery in Commons, Swarthmore
College, Pennsylvania (solo)

'Crimes of Compassion',
Chrysler Museum, Norfolk, Virginia (group)
Cat. *Crimes of Compassion*, Chrysler Museum, Norfolk,
Virginia, text Thomas Styron

1982
'Vietnam War: Nancy Spero/Leon Golub',

Selected articles and interviews
1978-82

1979

Heit, Janet, 'Spero's Appraisals of Women: A Lot to
See, A Lot to Read', *The Villager*, USA, 29 January, 1980
Lubell, Ellen, 'Notes on Women', *The Soho Weekly News*,
New York, 25 January, 1980
Robins, Corinne, 'Words and Images Through Time: The
Art of Nancy Spero', *Arts Magazine*, New York, December

Hirsh, Linda Blaker, 'A Chanting of Terrible Events',
Hartford Advocate, Connecticut, 19 November

Nancy Spero with son Paul Golub (right), 1979

Alloway, Lawrence, 'Feminist Collage', *Women's Art in
the 70s*, Teacher's College Press, Columbia University,
New York, ed. Judy Loeb

1980
Kuspit, Donald, 'Spero's Apocalypse', *Artforum*, New
York, April

1981
Schjeldahl, Peter, 'Opposites Attract', *The Village Voice*,
New York, 15 April

Exhibitions and projects
1982-84

Tweed Arts Group, Plainfield, New Jersey (group)

'Expositions en Deux Volets',
Galerie France Morin, Montreal (solo)

'Words & Images',
Francis Colburn Gallery, University of Vermont,
Burlington (solo)

'Luchar/ An Exhibition for the People of Central
America',
sponsored by Group Material, Taller Latino Americano,
New York (group)

1983
'Paintings From the Sixties and Recent Drawings',
Willard Gallery, New York (solo)

Matrix Gallery, Wadsworth Atheneum, Hartford,
Connecticut (solo)
Cat. *Nancy Spero*, Matrix Gallery, Wadsworth
Atheneum, Hartford, Connecticut, text Judith Rohrer

'War Series 1966-70' and 'Artemis 1983',
Gallery 345/Art for Social Change Inc., New York (solo)

'Black Paintings, Paris, 1959-64' and 'Codex Artaud,
1971-72',
AIR Gallery, New York (solo)

'New Paintings 1979-83',
Art Galaxy, New York (solo)

'Terminal New York',
Harborside Industrial Center, Brooklyn, New York
(group)

'Nancy Spero 1974-1983',
Rhona Hoffman Gallery, Chicago (solo)

'The Revolutionary Power of Women's Laughter',
Protetch-McNeil Gallery, New York (group)
Cat. *The Revolutionary Power of Women's Laughter*,
Protetch McNeil Gallery, New York, text Jo Anna Isaak

1984
'Art and Ideology',
The New Museum of Contemporary Art, New York
(group)
Cat. *Art and Ideology*, The New Museum of
Contemporary Art, New York, text Donald Kuspit

'The First Language',
Matrix Gallery, University Art Museum, University of
California, Berkeley (solo)

Riverside Studios, London (solo)

Selected articles and interviews
1982-84

Landry, Pierre, 'Nancy Spero', *Parachute*, Montreal,
September/October/November

1983

Lippard, Lucy, 'Nancy Spero's 30 Years War', *The Village
Voice*, New York, 19 April

Lyon, Christopher, 'Art According to Gender Gives
Fragmented View of Women', *Chicago SunTimes*, 16
October

Weinstock, Jane, 'Issues and Commentary: A Lass, A
Laugh, A Lad', *Art in America*, New York, Summer
Weinstock, Jane, Reply 'Letters', *Art in America*, New
York, November

Blumenthal, Lyn and Horsfield, Kate, 'Interview with
Nancy Spero', *Profile*, Vol 3, No 1, USA, January
Heit, Janet, 'Nancy Spero', *Arts Magazine*, New York,
November

1984
Bird, Jon, 'Culture and Control: Art and Politics in New
York', *Art Monthly*, London, July/August
Brenson, Michael, 'Can Political Passion Inspire Great
Art?', *The New York Times*, 28 April
Kuspit, Donald, 'From Existence to Essence', *Art in
America*, New York, January

Cebulski, Frank, 'Images of the First Language',
Artweek, Berkeley, 7 April

Gooding, Mel, 'Nancy Spero at Riverside...' *Artscribe*,
London, September/October
Newman, Michael, 'Nancy Spero', *Art Monthly*, London,
September

Exhibitions and projects
1984-86

'El Arte Narrativo and Pintura Narrativa Mexicana',
Museo Rufino Tamayo, Mexico City; **The Institute for
Art & Urban Resources Inc**, **PS1**, Long Island City, New
York (group)

'The Black Paintings',
The Renaissance Society at the University of Chicago
(solo)

1985
'Nancy Spero: The Paris Black Paintings 1959-1966',
Hewlett Gallery, Carnegie-Mellon University, College
of Fine Arts, Pittsburgh, Pennsylvania (solo)
Cat. *Nancy Spero: The Paris Black Paintings*, Hewlett
Gallery, Carnegie Mellon University, Pittsburgh,
Pennsylvania, text Elaine King

Galerie Powerhouse, Montreal (solo)

'She Writes in White Ink: 3 Women Painters',
The Walter Phillips Gallery, The Banff Centre, Alberta
(group)
Cat. *She Writes in White Ink*, The Walter Phillips Gallery,
The Banff Centre, Alberta, text Barbara Fischer

Burnett Miller Gallery, Los Angeles (solo)

'Kunst Mit Eigen-Sinn: Internationale Ausstellung
aktueller Kunst von Frauen',
Museum des 20 Jahrhunderts, Vienna, Austria
(group)

'Nancy Spero: Re-Birth of Venus 1985',
Atrium Gallery, School of Fine Arts, Department of
Art, The University of Connecticut (solo)

'Memento Mori',
Moore College of Art, Philadelphia; **Centro Cultural
del Arte Contemporaneo**, Mexico City (group)
Cat. *Memento Mori*, Moore College of Art, Philadelphia,
Centro Cultural del Arte Contemporaneo, Mexico City,
text Richard Flood

'Rape',
University Gallery, Ohio State University, Columbus
(group)
Cat. *Rape*, University Gallery, Ohio State University,
text Arlene Raven

1986
Rhona Hoffman Gallery, Chicago (solo)

Selected articles and interviews
1984-86

Liebmann, Lisa, 'Nancy Spero', *Artforum*, New York,
March

1985
Kirshner, Judith, 'Chicago: Nancy Spero, The
Renaissance Society', *Artforum*, New York, April

Greenberg, Reesa, 'Critical Couplings', *Vanguard*,
Vancouver, September
McGreevy, Linda F, 'Chilliastic Reflections on the Old
Adage 'Three's the Charm'', *Arts Magazine*, New York,
January

Salisbury, Stephan, 'At Long Last, Success Comes to
Two Artists', *The Philadelphia Inquirer*, 11 February

Levin, Kim, 'Art in the Anchorage', *The Village Voice*,
New York, 18 June
Carr, C, 'What is Political Art … Now?', interview, *The
Village Voice*, New York, 15 October
Décary, Marie, 'Quand Artemis Harnache le Centaure',
Le Devoir, Paris, 27 April
Falcon, Sylvia, 'Nancy Spero sees the Light', *East
Village Eye*, New York, August
Jolicoeur, Nicole and Nell Tenhaaf, 'Defying the Death
Machine', *Parachute*, No 39, Montreal,
June/July/August

1986
Palmer, Laurie, 'Nancy Spero at the Rhona Hoffman
Gallery', *New Art Examiner*, Chicago, April
Taylor, Sue, 'Artist Gives Upstanding View of Women',
Chicago SunTimes, 27 February

She writes in white ink

NANCY SPERO

THE BLACK PARIS PAINTINGS
1959–1966

March 30 through April 20, 1985

HEWLETT GALLERY
CARNEGIE-MELLON UNIVERSITY
COLLEGE OF FINE ARTS
PITTSBURGH, PENNSYLVANIA

Exhibitions and projects
1986-87

Josh Baer Gallery, New York (solo)

'Nancy Spero/Leon Golub',
Greenville County Museum of Art, Greenville, South
Carolina (group)

'Continuum',
Museum Villa Stuck, Munich, Germany (solo)

'The Biennial of Sydney',
Australia (group)

'Segunda Bienal de la Habana', Havana, Cuba (group)
Cat. *Segunda Bienal de la Habana*, Havana, Cuba, text,
Lucy Lippard

Catalogue, *Forty-Three Works on Paper: Excerpts from
the Writings of Antonin Artaud*, Galerie Rudolf Zwirner,
Cologne, Germany, interview with Barbara Flynn

1987
'Nancy Spero',
Institute of Contemporary Arts, London ;
The Fruitmarket Gallery, Edinburgh, **The Orchard
Gallery**, Derry (solo)
Cat. *Nancy Spero: Inscribing woman between the lines*,
Institute of Contemporary Arts, London, texts Jon Bird
and Lisa Tickner

'Sheela and the Dildo Dancer',
Josh Baer Gallery, New York (solo)

'Resistance (Anti-Baudrillard)',
curated by Group Material
White Columns, New York (group)

S.L. Simpson Gallery, Toronto (solo)

The Arts Gallery, Barnard Annex, Columbia University,
New York (solo)

Lawrence Oliver Gallery, Philadelphia, Pennsylvania
(solo)
Cat. *Nancy Spero*, Lawrence Oliver Gallery,
Philadelphia, Pennsylvania, text Rosetta Brooks

'Nancy Spero, Works Since 1950',
Everson Museum of Art, Syracuse, New York; **Museum
of Contemporary Art**, Chicago; **Mendel Gallery**,
Saskatoon, Saskatchewan, Canada; **M I T, List Visual
Arts Center**, Cambridge, Massachusetts; **The Power
Plant**, Toronto; **The New Museum of Contemporary
Art**, New York (solo)
Cat. *Nancy Spero: Works Since 1950,* Everson Museum of
Art, Syracuse, New York, et al., texts Leon Golub, Jo
Anna Isaak, Dominique Nahas, Robert Storr

Text, 'The Discovered Uncovered', *M/E/A/N/I/N/G*, No
2, New York, November

Selected articles and interviews
1986-87

Brenson, Michael, 'Nancy Spero', *The New York Times*,
28 March
McEvilley, Thomas, 'Nancy Spero, Josh Baer Gallery',
Artforum, New York, Summer
Raven, Arlene, 'Not a Pretty Picture: Can Violent Art
Heal?', *The Village Voice*, New York, 17 June

1987
Kent, Sarah, 'Frieze Frame', *Time Out*, London, April
Miles, Malcolm, 'Nancy Spero', *Alba*, Edinburgh,
Summer
Warner, Marina, 'Ravishing the Image', *The
Independent*, London, 16 March

Installation, Institute of Contemporary Arts, London

Miller, Earl, 'Nancy Spero', *C Magazine*, No 15, Toronto,
Autumn

Chayat, Sherry, 'Beyond Symbolism: Spero's Work
Defies Assumptions', *Syracuse Herald American Stars
Magazine*, 3 January, 1988
Haggart, Robert R., 'The Everson Paints A Portrait of
Courage Over Censorship.' *The Post Standard*, Syracuse,
20 January, 1988
McEvilley, Thomas, 'Nancy Spero: Everson Museum of
Art', *Artforum*, New York, May 1988
Miller, Tyrus, 'Nancy Spero: Works Since 1950 Museum
of Contemporary Art, Chicago', *SULFUR 24*, Spring,
1989
Schor, Mira, 'Nancy Spero: New Museum of
Contemporary Art', *Tema Celeste*, Siracusa,
October/November, 1989

Exhibitions and projects
1987-88

1988
'The Artaud Series: 1969-1970',
Barbara Gladstone Gallery, New York (solo)

'The First Language',
The Museum of Contemporary Art, Los Angeles (with
wall printing installation, *To Soar*) (solo)
Cat. *The First Language*, The Museum of Contemporary
Art, Los Angeles, text Susan L. Jenkins

Barbara Gross Galerie, Munich (solo)

'Nancy Spero: Works',
Terrain Gallery, San Francisco (solo)

'Nancy Spero: War Series 1966-1969, Artaud Paintings:
1969-1970',
Rhona Hoffman Gallery, Chicago (solo)

'The War Series',
Josh Baer Gallery, New York (solo)

'Nancy Spero' (in conjunction with Leon Golub),
Douglas Hyde Gallery, Dublin (solo)

Wall painting installation, *Waterworks*,
Visual Arts Ontario, The Filter Gallery, RC Harris
Water Filtration Plant, Toronto (solo)

'Representing Vietnam 1965-1973, The Antiwar
Movement in America',

Selected articles and interviews
1987-88

Shottenkirk, Dena, 'Dialogue: An Exchange of Ideas
between Dena Shottenkirk and Nancy Spero', *Arts
Magazine*, New York, USA, May
Engler, Brigitte, 'Woman of Motion', *PAPER*, New York,
March
Garb, Tamar, 'Nancy Spero', *Artscribe*, London, Summer
Isaak, Jo Anna, 'Seduction Without Desire', *Vanguard*,
Vancouver, Summer
Laing, Carol, 'Nancy Spero', *Parachute*, Montreal,
September/October/November
Lee, Jonathan Scott, 'Bodily Transcendence',
PsychCritique, 2:3, USA
Lubell, Ellen, 'Spectacolor Short Circuits', *The Village
Voice*, New York, 10 February
Philippi, Desa, 'The Conjunction of Race and Gender in
Anthropology and Art History: A Critical Study of
Nancy Spero's Work', *Third Text*, No 1, London, Autumn
Siegel, Jeanne, 'Nancy Spero: Woman as Protagonist',
Arts Magazine, New York, September
Storr, Robert, 'Peripheral Visions', *Parkett*, No 14,
Zurich
Hutchinson, John, 'Nancy Spero/Leon Golub in
Conversation with John Hutchinson', *CIRCA*, No 36,
Dublin, September/October

1988
Lyon, Christopher, 'Nancy Spero: Barbara Gladstone,
Josh Baer', *ARTnews*, New York, May
Indiana, Gary, 'Nerve Meter Revisited', *The Village
Voice*, New York, 8 March
Smith, Roberta, 'Greene Street', *The New York Times*,
26 February
Weskott, Hanne, 'Nancy Spero', *Kunstforum*, No 97,
Cologne

Dennis, Kelly, 'Dirty War: Nancy Spero Connects Sexual
and Public Politics', *L.A. Weekly*, 14 October

Cöppan, Gabi, 'Nancy Spero: Galerie Barbara Gross,
München', *NIKE*, No 25, Munich, October/November
Müller, Elisabeth, 'Notizen aus Münchner Galerien: Ein
Aufschrei gegen Diskriminierung', *Abendzeitung*,
Munich, 21 October

Dempsey, Terrence, 'Myths as Celebration and
Healing', *Shift 5*, Vol 3, No 1, San Francisco, 1989

Fisher, Jennifer and Seaton, Beth, 'Waterworks',
Parachute, Montreal, September/October/November

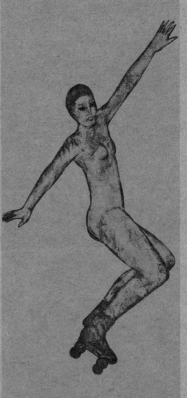

Exhibitions and projects
1988-89

The Bertha and Karl Leubsdorf Art Gallery, Hunter College, New York (group)
Cat. *Representing Vietnam 1965/1973: The Antiwar Movement in America*, The Bertha and Karl Leubsdorf Art Gallery, Hunter College,New York, text Maurice Berger

'Committed to Print: Social and Political Themes in Recent American Printed Art',
The Museum of Modern Art, New York (group)
Cat. *Committed To Print: Social and Political Themes in Recent American Printed Art*, Museum of Modern Art, New York, text Deborah Wye

Text, 'Sky Goddess/Egyptian Acrobat', *Artforum*, Vol 27, No 7, New York, March

Text, 'Nancy Spero', *Galeries*, Paris, June

1989
Contemporary Art Gallery, Vancouver, Canada (solo)

'Magiciens de la Terre',
Le Grande Halle de la Villette, Paris, **Centre George Pompidou**, Paris; (group)
Cat. *Magiciens de la Terre*, Centre Georges Pompidou, Musee Nationale d'Art Moderne, Paris, texts Jean Hubert Martin and Mark Francis

'Nancy Spero, Works from 1956-62',
Josh Baer Gallery, New York (solo)
Cat. *Rediscovered Spero*, Josh Baer Gallery, text Peter Schjeldahl

Burnett Miller Gallery, Los Angeles, California (solo)

Wall painting installation *Rebirth of Venus* at 'Prospect 89',
Cupola Schirn Kunsthalle, Frankfurt (solo)

'Anti-Utopia, Vol 1 No 3',
Bullet Space, New York (group)

'Making Their Mark: Women Artists Move into the Mainstream, 1970-1985',

Isaak, Jo Anna, 'A Work in Comic Courage', *Parachute*, No. 51, Montreal, June/August
Jones, Alan, 'The Writing on the Wall', *Arts Magazine*, New York, October
Lyon, Christopher, 'An Ambiguous and Changing Terrain... Nancy Spero and Leon Golub Talk about Art and Political Commitment', *The Museum of Modern Art Members Quarterly*, New York, Winter
Sherlock, Maureen P., 'Nancy Spero', *Arts*, USA, October
Siegel, Jeanne, 'Nancy Spero: Woman As Protagonist', *Art Talk: The Early Eighties*, Da Capo Press, Inc., USA
Wye, Pamela, 'Nancy Spero: Speaking in Tongues', *M/E/A/N/I/N/G*, No 4, New York, November
Stapen, Nancy, 'Spero's Art Explores Human Condition', *The Boston Herald*, 19 October

1989
Hanna, Deirdre, 'Spero's transcendent imprint', *NOW*, Toronto, January/February
Hume, Christopher, 'Pioneer Feminist Spero Wins Overdue Recognition', *The Toronto Star*, 10 February

Bertrand, Jean Pierre, 'L'Art des Autres et la magie des uns', *Art Press*, No 136, Paris, May

Levin, Kim, 'Mastery Exposed', *The Village Voice*, New York, 6 June
Raven, Arlene, 'In Tongues', *The Village Voice*, New York, 30 May
Smith, Roberta, 'Collages That Seek to Fuse Beauty and Feminism', *The New York Times*, 26 May
Smith, Roberta, 'Nancy Spero: Works Since 1950, Part II', *The New York Times*, 7 July

Rebirth of Venus, in progress, 'Prospect '89', Frankfurt

Cincinnati Art Museum; **New Orleans Museum of Art;**
Denver Art Museum; Pennsylvania Academy of the
Fine Arts, Philadelphia (group)

Book, *Nancy Spero: Rebirth of Venus*, edited by Edit deAk,
text Robert Storr, Art Random, Kyoto Shoin, Japan

Text, 'Twelve Artists on the Year's Books' *Artforum*,
New York, December

1990
'Notes in Time on Women',
Smith College Museum of Art, Northampton,
Massachusetts (solo)
Brochure, *To Soar II*, Smith College Museum of Art,
Northampton, Massachusetts, text Mimi Hellman

Anthony Reynolds Gallery, London (solo)

'Nancy Spero: Bilder 1958 bis 1990',
Haus am Waldsee, Berlin; **Bonner Kunstverein**, Bonn;
Gemeentemuseum, Arnhem, The Netherlands
Cat. '*Nancy Spero: Bilder 1958 bis 1990*', Haus am
Waldsee, Berlin, et al., texts Jon Bird, Thomas Kempas
and Annelie Pohlen

Gallery Hibell, Tokyo (solo)
Cat. *Nancy Spero*, Gallery Hibell, Tokyo, text Lois Tarlow

'Excerpts from the Writings of Antonin Artaud',
Galerie Maria Wilkens, Cologne (solo) Aug

'Notes in Time',
Honolulu Academy of Arts, Hawaii (solo)

Galerie Montenay, Paris, France (solo)

Lawrence Oliver Gallery, Philadelphia, Pennsylvania
(solo)

Wall painting installation as part of 'Four Cities
Project', **Well Woman Centre and Westland/Blucher**
Street Junction, Derry (group)
Cat. *TSWA Four Cities Project/New Works for Different*
Places: Derry, Glasgow, Newcastle, Plymouth, TSWA
Ltd., ed. James Lingwood

Wall painting installation, *To Soar II* and *Ballad of*
Marie Sanders, The Jew's Whore, **Smith College**
Museum of Art, Northampton, Massachusetts (solo)

'The Decade Show: Frameworks of Identity in the
1980s',
Museum of Contemporary Hispanic Art, New York

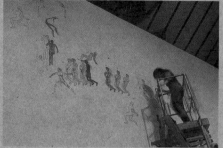

To Soar II, in progress, Smith College Museum of Art, Northampton,
Massachusetts

Ball, Edward, 'Nancy Spero', *7 Days*, New York,
25 January
Barasch, Amy, 'Nancy Spero', *7 Days*, New York, 14 June
Hess, Elizabeth, 'Bodywork', *New York Woman*,
June/July
Reid, Calvin, 'Nancy Spero: A Stream of Female
Consciousness', *Downtown*, No 157, 2 August

1990

Garlake, Margaret, 'Nancy Spero', *Art Monthly*, London,
June
Lubbock, Tom, 'Women Rescued and Released from
History', *The Independent on Sunday*, London, May 27
Withers, R. L. 'Nancy Spero', *Women Artists Slide Library*
Journal, No 35, London, July/August

Babias, Marius, 'Nancy Spero', *Kunstforum*, Cologne,
June/July
Bosetti, Petra, 'Grosse Mutter und Hure', *Art: Das*
Kunstmagazin, No 4, Berlin, April
Walinga, Ingeborg, 'Nancy Spero/Gemeentemuseum
Arnhem 8 December 1990/Januari 1991', *UIT*, Arnhem,
December

ANTHONY REYNOLDS GALLERY

NANCY SPERO

AT 5 DERING STREET
20 APRIL - 2 JUNE 1990
TUESDAY - SATURDAY 10-6

AT 37 COWPER STREET
20 APRIL - 3 JUNE 1990
WEDNESDAY - SUNDAY 11-6

PRIVATE VIEW COWPER STREET THURSDAY 19 APRIL 6-8

37 COWPER STREET LONDON EC2A 4AP TELEPHONE 01-253 5575
AND 5 DERING STREET LONDON W1R 9AB FAX 01 253 5621

NANCY SPERO
WORKS ON PAPER
EXCERPTS FROM THE WRITINGS OF ANTONIN ARTAUD

Eröffnung Freitag, 31. August 1990, 18–21 Uhr
Ausstellungsdauer 1. September – 6. Oktober 1990

Öffnungszeiten:
Dienstag–Freitag, 11–13 und 16–18 Uhr Samstag 11–14 Uhr

In Zusammenarbeit mit Galerie Rudolf Zwirner Köln

GALERIE
Maria Wilkens

Aachener Straße 23
D-5000 Köln 1
Telefon 0221/25 25 60
Fax 0221/25 25 38

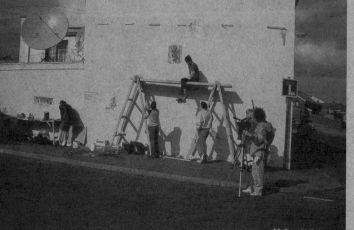

Westland/Blucher St., Bogside, Derry, Northern Ireland, in progress

Exhibitions and projects
1990-91

(group)
Cat. *The Decade Show: Frameworks of Identity in the 1980s*, Museum of Contemporary Hispanic Art, New York, texts Kinshasha Conwill, Nilda Peraza and Marcia Tucker

'Goya to Beijing',
Centre International d'Art Contemporain, Montreal (group)

Text, 'Issues and Symbolism', *M/E/A/N/I/N/G*, No 8, New York, November

1991
'As Seen by Both Sides (American and Vietnamese Artists Look at the War)',
Boston University Art Gallery, Massachusetts, toured USA and Vietnam 1990-95 (group)
Cat. *As Seen by Both Sides (American and Vietnamese Artists Look at the War)*, Indochina Arts Project and The William Joiner Foundation, ed. David Thomas

'Sky Goddess/Egyptian Acrobat' and 'Cabaret',
Josh Baer Gallery, New York (solo)

'Nancy Spero in der Glyptothek, Arbeiten auf Papier',
Glyptothek am Königsplatz, Munich, Germany (solo)
Cat. *Nancy Spero under Glyptothek, Arbeiten auf Papier*, Glyptothek am Königsplatz, Munich, texts Klaus Vierneisel and Hanne Weskott

'Small Works, Artaud Paintings, War Series',
Barbara Gross Galerie, Munich (solo)

'Sky Goddess, Egyptian Acrobat', 'Torture of Women' and 'Cabaret',
Galleria Stefania Miscetti, Rome (solo)
Cat. *Sky Goddess, Egyptian Acrobat*, Galleria Stefania Miscetti, Rome, texts Achille Bonito Oliva and Alessandra Mammì

'Devil on the Stairs: Looking Back on the Eighties',
Institute of Contemporary Art, University of Pennsylvania, Philadelphia (group)
Cat. *Devil on the Stairs: Looking Back on the Eighties*, Institute of Contemporary Art, University of Pennsylvania, Philadelphia, text Robert Storr

NANCY SPERO
"Sky Goddess, Egyptian Acrobat"
inaugurazione
giovedì 2 maggio 1991 ore 18

*Incontro con l'artista
all'Accademia Americana
nella sede di Villa Aurelia,
Largo di Porta San Pancrazio, 1
Venerdì 3 maggio 1991 ore 18*

GALLERIA STEFANIA MISCETTI·VIA DELLE MANTELLATE 14·00165 ROMA·TEL-FAX 06-4745980

Reviews and articles
1990-91

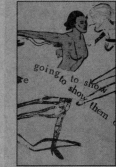

A Newsjournal of Prochoice Catholic Opinion
CONSCIENCE
Vol. XIII, No. 2 Summer 1992

The Rhetoric of Reproduction: Semantic Flash versus Honest Talk
ROBIN TOLMACH LAKOFF

She Who Creates Values: Women as Ethical Agents
EMILY ERWIN CULPEPPER

Literature and Maternal Choice
JUDITH WILT

The Tube's Taboo: Abortion's Too Hot for Prime Time
JAN HOFFMAN

Also: Alice Walker · Frances Kissling · Carol LeMasters · Lori Valencia-Greene · Nancy Spero · Signe Wilkinson

$3.50

Weiss, Allen S, 'Outside in Some New Improved Anxieties of Influence', *Art & Text*, No 35, Sydney, Summer
Wye, Pamela, 'Freedom of Movement: Nancy Spero's Site Paintings', *Arts Magazine*, New York, October

1991

Faust, Gretchen, 'New York in Review', *Arts Magazine*, New York, May
Hess, Elizabeth, 'Collateral Damage', *The Village Voice*, New York, 12 March
Shottenkirk, Dena, 'Nancy Spero: Josh Baer Gallery', *Artforum*, New York, May
Smith, Roberta, 'Nancy Spero', *The New York Times*, 8 March

14. April bis 16. Juni 1991 Glyptothek München

NANCY SPERO *in der Glyptothek*

Arbeiten auf Papier

Zur Eröffnung der Ausstellung
am Sonntag
den 14. April 1991 um 11 Uhr
sind Sie und Ihre Freunde herzlich eingeladen

Nancy Spero wird anwesend sein

Zur Ausstellung erscheint eine Publikation mit einer Einführung
von Klaus Vierneisel und einem Essay von Hanne Weskott

Vom 13.4. bis 11.5.1991
Nancy Spero: Small works· artaud paintings· war series
in der Barbara Gross Galerie München Thierschstraße 51

Glyptothek am Königsplatz
Täglich 10-16.30 Uhr · Donnerstag 12-20.30 Uhr · Montag geschlossen

Fraser, Kathleen, 'Letter From Rome: H.D., Spero and the Reconstruction of Gender', *M/E/A/N/I/N/G*, No 10, New York, November
Mania, Patrizia, 'Nancy Spero: Galleria Stefania Miscetti', *Tema Celeste*, Siracusa, Autumn

Jaeckel, Claudia, 'Der Zug der Frauen', *Dienstag*, Germany, 1 May
Lange, Jörg, 'Nancy Spero stepelt Brecht', *Wuppertaler Rundschau*, Germany, 25 April
Schmitter, Elke, 'Der Barthes ist ab', *Die Tageszeitung*, Germany, 15 May
Withers, Josephine, 'Nancy Spero's American-born Sheela-na-gig', *Feminist Studies*, USA, Vol 17, No 1, Spring

Exhibitions and projects
1992-93

1992
'Allegories of Modernism: Contemporary Drawing',
Museum of Modern Art, New York
Cat. *Allegories of Modernism: Contemporary Drawing*,
Museum of Modern Art, New York, text Bernice Rose

Ulmer Museum, Ulm, Germany (solo)
Cat. *Nancy Spero: Woman Breathing*, Edition Cantz,
Ostfildern, Germany, texts Achille Bonito Oliva,
Brigitte Reinhardt, Noemi Smolik, Robert Storr and
Klaus Vierneisel, et al.

'Hieroglyphs',
Terrain Gallery, San Francisco (solo)

'Bilder 1981-1991',
Christine König Gallery, Vienna (solo)

'Nancy Spero and Leon Golub: Works on Paper',
Traklhaus Gallery, Salzburg, Austria

'Detente',
Dum Umení Mesta Brna, Brünn, Czechoslovakia;
Mudima Foundation, Milan; **Kiscelli Museum**,
Budapest; **Moderna Galerija**, Ljubljana; **Galeria
Zacheta**, Warsaw; **Museum Moderner Kunst**, Vienna
(group)
Cat. *Detente*, Verein Ausstellungsorganization, text
Hanne Weskott

Text, 'Tracing Ana Mendieta', *Artforum*, New York, April

Text, 'Creation and Procreation', Forum: On
Motherhood, Art and Apple Pie, *M/E/A/N/I/N/G*, No
12, New York

1993
'Whitney Biennial',
Wall painting installation, *Masha Bruskina* and *Homage
to Ana Mendieta*, **Whitney Museum of American Art**,
New York; **National Museum of Contemporary Art**,
Seoul, Korea (group)
Cat. *Whitney Biennial 1993*, Whitney Museum of
American Art in association with Harry N. Abrams, text
Elisabeth Sussman

'Nancy Spero',
Greenville County Museum of Art, Greenville, South
Carolina (solo)
Cat. *1993 Emrys Journal*, Greenville County Museum of
Art and Emrys Foundation, texts Rosetta Brooks and
Keller Freeman Cushing

'Torture of Women', 'The First Language' and 'The
Hours of the Night',
National Gallery of Canada, Ottawa (solo)

'Golub/Spero, 1960s/70s',
Josh Baer Gallery, New York
Cat. *Golub/Spero, 1960s/70s*, Josh Baer Gallery, New
York, text Susan Harris

'Golub/Spero, 1990s/50s',
Josh Baer Gallery, New York

Reviews and articles
1992-93

1992

Bonetti, David, "'Hieroglyphs' Better Than Words', *San
Francisco Examiner*, 20 March

Dempsey, Terrence, 'Myths as Celebration and
Healing', *Shift 5*, Vol 3, No 1, San Francisco, 1989
Meinhardt, Johannes, 'Bilder Sprache des Weiblichen',
Stuttgarter Nachrichten, 23 April
Pabinger, Daniele, 'Die Welt Durch das FrauSein
Beschreiben', *Salzburger Nachrichten*, 29 August

Schwabsky, Barry, 'Leon Golub/Nancy Spero',
Artforum, New York, November
Smith, Roberta, 'Golub/Spero, Part II '90's/50's',
The New York Times, 7 May

Homage to Ana Mendieta, in progress, Whitney Biennial,
New York, 1993

Permanent wall painting installation, *Premiere*,
Ronacher Theatre, Vienna (solo)

'Inside Out: Eight Contemporary Artists',
Wall painting installation *The Ballad of Marie Sanders*
and *Voices: Jewish Women in Time*, **The Jewish
Museum**, New York (group)
Cat. *Inside Out: Eight Contemporary Artists*, The Jewish
Museum, New York, text Susan Goodman

Permanent wall printing installation, *To Soar II*
Harold Washington Library Center, Chicago

'Buchstäblich: Bild und Wort in der Kunst heute',
Wall painting installation,*Ballad von der 'Judenhure'
Marie Sanders (Brecht)* and *Homage to Ana Mendieta,
eine Nachschaffung von 'Body Tracks'*, **Von der Heydt-
Museum**, Wuppertal, Germany (group)
Cat. *Buchstäblich: Bild und Wort in der Kunst heute*, Von
der Heydt-Museum, Wuppertal, Germany, text
Christine Storck

'El Sueño Imperativo,'
Wall painting installation, *Minerva, Sky Goddess,
Madrid*, **Circulo de Bellas Arte**, Madrid (solo)

'The Subject of Rape',
Whitney Museum of American Art, New York (group)
Cat. *The Subject of Rape*, Whitney Museum of American
Art, New York, text Hannah Kruse

Museum in Progress, project with *Der Standard*,
Vienna

'Hotel Carlton Palace Chambre 763',
Hotel Carlton Palace, Paris (group)
Cat. *Hotel Carlton Palace Chambre 763*, Hotel Carlton
Palace, Paris, text Hans Ulrich Obrist

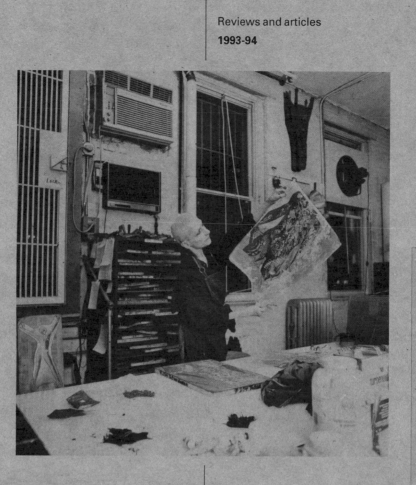

1994
'Inside the Visible - Begin the Beguine in Flanders',
Kunststichting Kanaal Art Foundation, Kortrijk,
Belgium (solo)

'War and Memory,'
Nancy Spero and Leon Golub retrospective exhibition,
The American Center, Paris; **MIT List Visual Arts
Center**, Cambridge, Massachusetts
Cat. *War and Memory*, The American Center, Paris; MIT
List Visual Arts Center, Cambridge, Massachusetts,
texts Katy Kline and Helaine Posner

NANCY SPERO

11 juni - 21 augustus 1994

Open: elke dag, uitgezonderd maandag
14 u. - 18 u.

Opening: zaterdag, 11 juni
17 u. - 18.30 u.

in het Begijnhof Sint-Elizabeth
Kortrijk, Belgium

'Nancy Spero,'
Malmö Konsthall, Malmö, Sweden (solo)
Cat. *Nancy Spero*, Malmö Konsthall, Malmö, texts Susan
Harris and Sune Nordgren

Isaak, Jo Anna, 'The Comfy Chair', interview for
'Matisse: A Symposium', *Art in America*, New York, May
Searle, Adrian, Spero,Nancy, Golub, Leon , 'Leon Golub
and Nancy Spero in conversation with Adrian Searle',
Talking Art I, ed. Adrian Searle, ICA Documents 12,
Institute of Contemporary Arts, London

1994

Wisniewski, Jana, 'Malerei, politisch relevant: Nancy
Spero und Leon Golub im American Center in Paris',
Salzburger Nachrichten, 14 December
Vetrocq, Marcia E, 'Spero and Golub at the American
Center', *Art in America*, New York, May, 1995
Temin, Christine, 'Bearing Witness', *The Boston Globe
Magazine*, 16 April, 1995
Rosen, Miriam, 'Spero et Golub accrochés au musée,
Liberation, Paris, 1 November
Francois, Alain-Henri, 'Golub et Spero War and
Memory', *Voir*, December
Stapen, Nancy, 'A Pair of Opposites, Bound by Ideals',
The Boston Globe, 23 May, 1995